Harry Benson's Glasgow

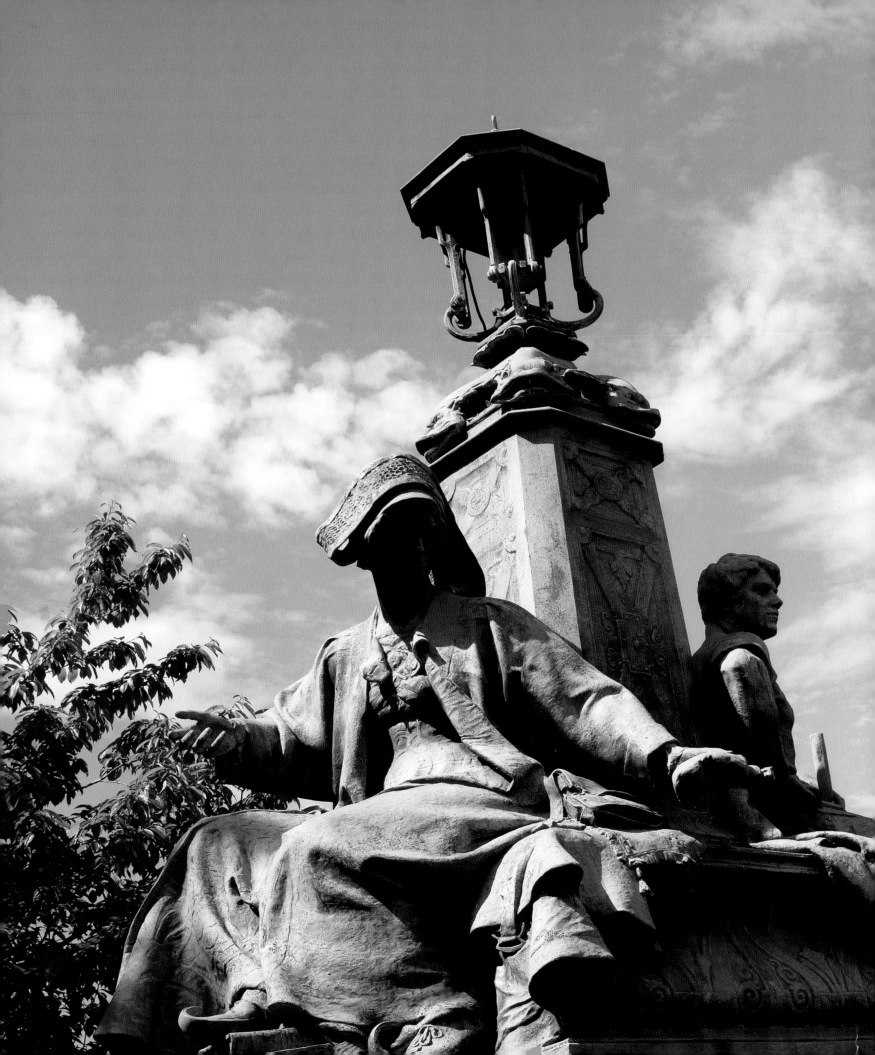

Harry Benson's Glasgow

BW

BLACK & WHITE PUBLISHING

First published 2007
this edition first published 2008
by Black & White Publishing Ltd
29 Ocean Drive Edinburgh
EH6 6JL

1 3 5 7 9 10 8 6 4 2 08 09 10 11

ISBN: 978 1 84502 236 5

A CIP catalogue record for this book
is available from the British Library.

Design and layout by Richard Budd
www.richardbudddesign.co.uk

Printed and bound in China.

Title page:
The photo of Glasgow
University was taken from
Kelvingrove Park near
the River Kelvin.

I would like to dedicate this book to the girls in my life:
my wife, Gigi;
our daughters, Wendy Landes and Tessa Benson;
our granddaughter, Mimi Cunningham Landes;
my mother, Molly Cunningham Benson;
and to my new grandson, Dominic Benson Landes.

Our home at 14 Vardar
Avenue, Clarkston.

Growing up in Glasgow

I was born in Knightswood on 2 December 1929 but I was conceived in Brooklyn, New York. My father, S. H. Benson, MBE, had thought that 1929 was a good time to emigrate from Scotland to America but he then thought better of it when the Great Depression hit. The whole family returned home to Glasgow – my parents and Stanley and Ruth who are my older siblings. My sister Joan was a later addition to the family and is, as she likes to remind us, much younger.

Although the Wall Street Crash was a good kick out the door, the real reason we returned to Scotland was not the Depression but the fact that my father missed going to football matches with all his old pals.

My mother's name was Mary Cunningham Benson but was always called Molly and she told me she had wanted to stay in America. When she visited my wife, Gigi, and me in New York, we took her round the many places she remembered – including Flatbush Avenue in Brooklyn where the family lived and the famous church in Wall Street where my mother would bring my father his lunch every day and where they would sit and talk.

In later years, my father spoke about New York as if he had lived there for years but my mother said that, in fact, the family had stayed there for only three months.

I was born and brought up in Glasgow and all my early memories and influences are from 1930s' and 1940s' Glasgow. The first photograph I remember was a picture that appeared in the *Glasgow Bulletin* of a little baby crying beside some wreckage after the Japanese bombing of Shanghai. I must

have been all of seven years old but the picture had an impact on me and the image has stayed with me over the years. That is exactly what a good photograph should do – provoke a response and make you remember it. But now, when I look at that photograph, I realise that the photographer most likely set it up.

Another photograph I remember vividly is a full front page of the *Glasgow Bulletin*. It was of another baby but, this time, it was Charles Lindbergh's twenty-month-old infant son. The famous kidnapping case came about after the boy was abducted from his home one night. The story was to have a tragic ending when, ten weeks later, a body was found just a few miles from the Lindbergh's house and it was identified

A cowboy Christmas when I was about five.

2 by Charles Lindbergh as his son. I don't know if I saw this photograph when it happened in 1932 or when the case came to trial three years later but it had a tremendous impact on me.

When I was a child, we lived in Croftfoot where I went to primary school. I remember picnics with my family at Troon. We would take the bus into town to St Enoch's Station, then get on another to Troon which was really my second home because it's where my mother was born. We would stay with my Aunt Bab and Aunt Jean, my mother's cousins. I remember my Uncle Andrew owned a rowing boat rental business and would take us boating during the summer. We had a black-and-tan dachshund, Tillie, that went everywhere with us and she loved to play on the beach.

We then moved to Vardar Avenue in Clarkston, very near the new Eastwood School that had just opened. Ian Agnew was the first pupil on the roll book and, because of the alphabetical order of the listing of pupils' names, I was the second. The last time I was home, the building was being pulled down and I photographed the wreckage. I was told my old school was going to be replaced by flats.

My mother would quite often pick me up after school and take me to the local cinema. We usually went twice a week, when the movie changed, and she would always say, 'Now, don't tell your father.' I am sure that seeing those films had something to do with my becoming a photographer – afterwards, pictures from them would form in my head. Sometimes now I see reruns on TV of a film such as James Cagney's 1935 FBI thriller '*G' Men* and I am reminded of my afternoons at the cinema when I was a boy.

Even as a child, I knew things were not perfect in the world as there was always talk of war. You could hear it every day in conversations. I remember the Duke of Windsor abdicating and my father saying he was a rat. I remember the day war was

declared when all the grown-ups were talking over the back fence to their neighbours. We certainly realised how serious the situation was when a German plane was spotted flying over Glasgow.

One day, when my mother had gone up the road to the shops, a woman threw a brick at our dog, Tillie, and called her a dirty German. After that Tillie was confined to the back garden but the incident certainly captured the mood of the time.

As I grew up in Glasgow during the Second World War, the crisis and drama that were part of my everyday life made a lasting impression. Gathering around the radio with my family, listening to Winston Churchill's speeches about the deeds of heroic men fighting great battles, I thought how exciting it would be to be a part of it, to be at the centre of things, to see for myself what was going on. I could just visualise the drama, what it would look like.

At school, we were told where to go if there was an air raid. I can remember being issued with a gas mask – there was a fear that the Germans would use germ warfare – and we were made to take the masks everywhere we went. My mother even made a nice little woollen satchel for me to carry mine in. And I remember the headmaster at Eastwood School calling an assembly for us to hear a rousing speech given by the school dux who had entered the RAF directly after leaving school. Later that year, we heard the news that his plane had been shot down and lost over Germany. Today, I will make a point of watching the History Channel on television whenever something about the Second World War is shown.

My father joined the Home Guard which was mostly made up of retired First World War soldiers. My father was a drill sergeant and he just loved it. He was on duty the night Rudolf Hess, the deputy leader of Germany's Nazi party, landed and was captured. For a while, all we knew was that some German had flown in to Scotland but my father said he was a big shot. My school pals and I went about a mile and a half up the road to a field on Floors Farm to see his plane. It was very dramatic and, afterwards, the field was always referred to as 'Hess Field'.

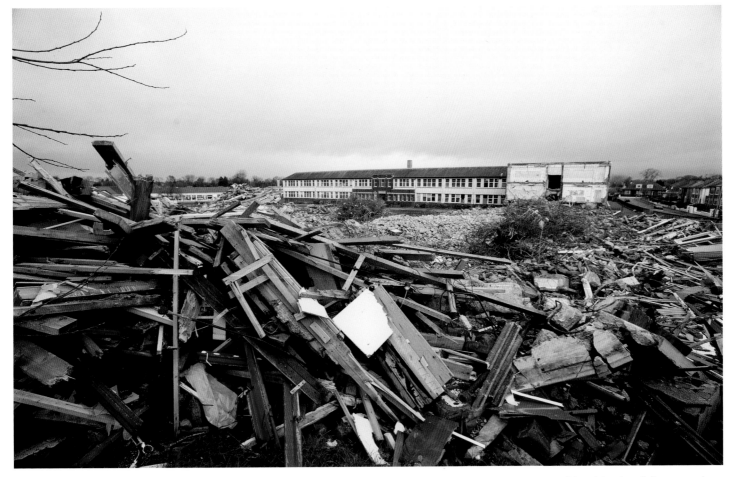

My old school, Eastwood, was being torn down, I was told, to make room for a row of flats.

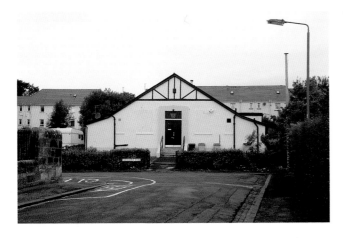

The home guard hut where Deputy Führer Rudolf Hess was taken the night he landed in a field not far from my home.

4

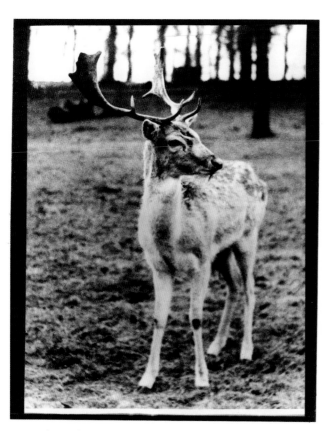

A roe deer photographed in Calder Park Zoo. It was my first published photograph.

Although there was rationing, we never seemed to go without. I especially remember the powdered egg. If it was made properly, it wasn't too bad but, if not, it had the consistency of a pudding. My mother would stand in a queue at the grocery store early in the morning to get the rations. The blackouts started right away. We had to put dark curtains up against the existing curtains and you could expect a visit from the Air-Raid Precautions (ARP) warden if you had any light showing from a window.

I remember Dunkirk when the army had to get out of France in a hurry as France had collapsed and I can also remember how French soldiers who'd managed to escape were sheltered in Hampden Park.

When the war was at its height, the Glasgow shipyards were bombed intermittently for several months. At one point, there were three or four nights of heavy bombing. We could hear the German planes roaring overhead as they targeted the shipyards and the torpedo factories in the area. It was getting so dangerous that our family decided to move to Troon for a short time but, a few weeks later when the worst of the bombing was over, we returned to Glasgow with our dachshund, Tillie.

When we got home, we had to sleep under a bomb shelter my father had bought. It was basically a big steel table that he had placed in the middle of the living room. Fortunately, it was never called into active service. I would never go in without Tillie but one night she got frightened by the noise and had an unfortunate accident – from then on, she had to sleep elsewhere.

When America entered the war, people went around saying, 'The Yanks are coming!' and we knew we were going to win the war. Interestingly, I had never seen a black man before I saw the American soldiers marching down Renfrew Street.

Near the start of the war, when I was about eleven years old, my father gave me a box camera for Christmas and I started taking pictures. I took it whenever I went to a football match and photographed the players and the crowds. I guess that was the beginning.

Finding my way

My first picture was published when I was seventeen. It was a picture of a roe deer in Calderpark Zoo, which my father had founded. As far as I can remember, he organised a committee of Scottish businessmen to raise money to establish a zoo and found a space for it in Calderpark. I, personally, have never liked zoos – I hate to see animals caged – but, on the other hand, the zoo was giving people something they had never seen before.

For the photograph of the deer, I used a Thornton Pickard camera. I gave the photo to the *Glasgow Evening Times* and waited and waited for it to appear before finally giving up hope. About three months later, I was on the train when I looked over at the man sitting next to me who was reading a newspaper. As he turned to the centre spread, I spotted the picture. I wanted to shout, 'That's my photograph!' As soon as I got off the train, I bought a copy of the paper and sat and looked at it for hours. To this day, I can't remember if they paid me for it but that wasn't important – seeing the picture in print was what mattered. That feeling has never left me.

It was just as well that I was finding things in life that interested and excited me – I couldn't stick at anything that bored me. I'd already had to leave school much too early – when I was thirteen – but not because we were poor. Latin and French in particular simply put me to sleep. To say I wasn't a good student is an understatement. I was hopeless at school – a complete disaster – but not in history and art. I loved those subjects and was good at them but the real trouble was that my head was filled with football. However, I couldn't even try out for the school's team – that was reserved for the good students and my grades were never good enough.

I often wonder what my teachers at Eastwood School would think of me now. I remember one teacher in particular, Miss McKenzie, who always said, 'I don't worry about you, Benson, you're going to be all right.' My one regret is that I cannot go back and say thank you to her.

When I was growing up, most Sunday afternoons and evenings were spent at my schoolmate Carlo Pediani's home where Mrs Pediani would make us lovely pasta and there would be much laughter and conversation, mostly about football. Those were great times and their friendship was a real blessing throughout the years when I was finding my footing and sorting out my life.

Leaving school early had been humiliating but my father helped me get a job as a messenger with Ilford, the film manufacturer. It was a long way away from being a photographer but at least it was on the periphery of what I wanted to do. After that, I worked as a messenger carting film back and forth between two local cinemas, the Embassy in Shawlands and the Tudor in Giffnock. When my mother told a neighbour that I had a job, she replied, 'That's amazing, Mrs Benson, for I always thought your lad was daft.'

I was good at art – not great but good – although I could only draw things that interested me, like soldiers and footballers. When I was sixteen, I spent a year at the Glasgow

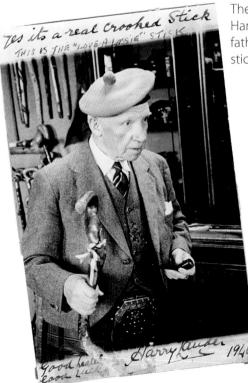

The famous comedian Harry Lauder gave my father one of his walking sticks and a signed photo.

6 School of Art. I was most likely the youngest student there and I enrolled for a commercial art course. To prepare, all I did was get a bunch of pencils and some paper and take them with me. On one of the first days of class, I went into a very large classroom. I can't recall anyone telling me where to go but that couldn't possibly have been the case. Anyway, there were a few of us in the same boat and we spent a lot of time on Dalhousie Street and Renfrew Street playing football with a tennis ball. I believe I went to art school way too soon but it was down to my father taking pity on me for having to leave school at thirteen.

As it turned out, I wasn't a great student at art school either. In class, I would sit there drawing away and then a teacher would come round and tell me I wasn't drawing leaves or trees correctly. There were a lot of pretty girls in class but they were quite a bit older than I was. I remember someone calling out one day, 'There's a life class in five minutes!' At which point, everyone got up and left the room and I just followed. I hadn't a clue what a 'life class' was. It could have been a CPR class to save lives for all I knew. They all rushed in ahead of me and the only empty seat was right in the middle of the room by a raised platform. So just as I was about to sit down there, in walked a rather plump, middle-aged woman. She didn't have a stitch of clothing on and she was heading straight for the platform – and me. I had never seen a naked woman before and was completely taken aback. I froze and couldn't draw a line because I was so embarrassed – stunned, actually.

About a year ago, I went back to the Glasgow School of Art and that room hadn't changed a bit – right down to the model. Seeing the wall of huge windows and a plump, completely naked woman sitting on the platform in the middle of the room certainly brought back vivid memories.

Being football daft, my real wish was to play professionally. When asked today what I'd like to do, I say I only gave up that idea about a year ago. I managed two trials with Queen's Park Strollers but, unfortunately, each time we played in Lesser Hampden because Hampden Park, Queen's Park's home ground, was under repairs. I have always regretted not getting to play at Hampden Park. I often say I would have given up

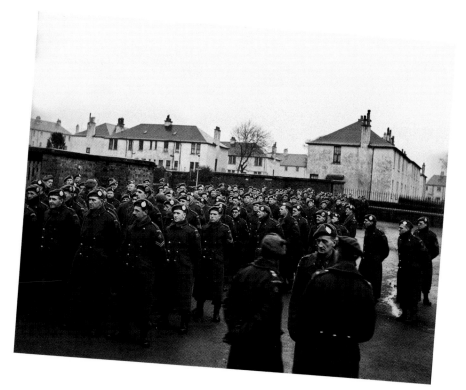

This photograph was taken by my father, S.H. Benson, at Busby School in 1940 or 1941. The majority of these men, like my father, were WWI veterans. Busby School was their headquarters and meeting place. From there they would go out on manoeuvres on the moors and farmlands because we were expecting a German invasion. These men were part of the Home Guard that captured Rudolf Hess, Deputy Führer, when he landed in Scotland.

My pal Carlo Pediani and I had ridden all night in the driving rain on Carlo's scooter with a suitcase between us. It was just after the war and Paris had not been completely rebuilt but we had a great time seeing the sights.

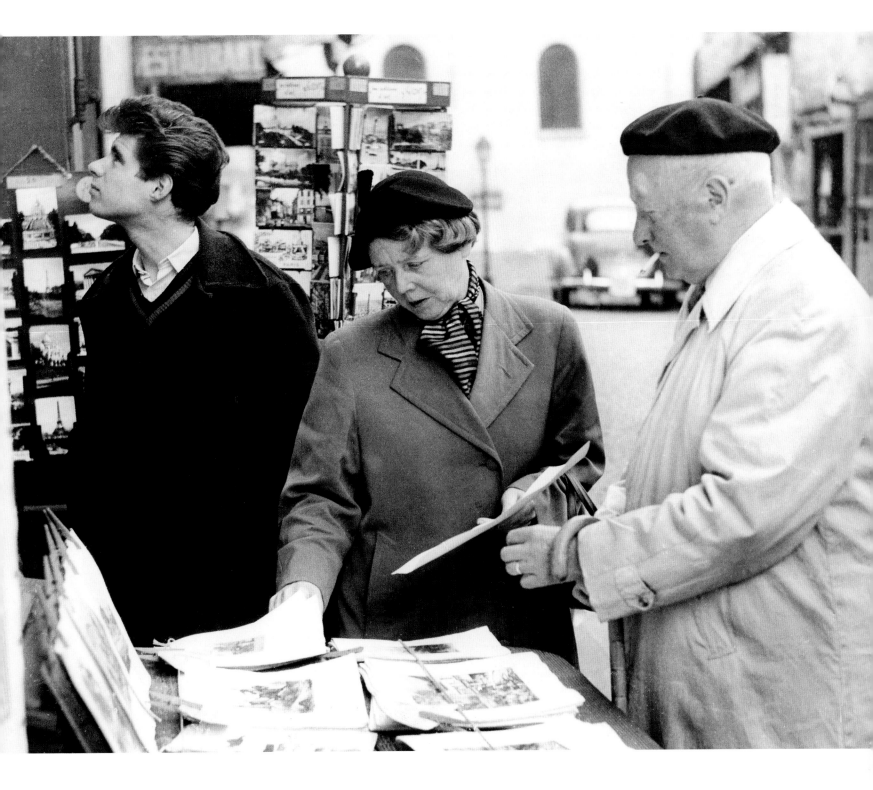

8 photography if I could have been a regular on the Queen's Park team. I will go even further than that – I would have given up photography if I had been on some junior team. But it wasn't to be so I abandoned all thoughts of it when I became the photographer for the *London Daily Sketch*. After all, I was working for a Fleet Street newspaper and covering the biggest stories in Scotland.

After leaving the Glasgow School of Art, I worked for an advertising agency, D. C. Cuthbertson, drawing scenes for their print ads. I particularly remember drawing a pair of Wellington boots walking over a puddle for a Robertson's Rubber Company ad. Then, one beautiful summer's day, I was sent to post the day's letters. On the way, I went for an ice cream at Ross's Dairy across the way and, by mistake, left the mail there. I forgot all about it until the next day when some very honest girl returned all the mail to the office. My bosses were not impressed and I got the boot. Yet, about twenty years ago, I came across a newspaper with a drawing of mine still being used in an ad for Grant's Stand Fast Whisky so maybe I wasn't all that bad at the job!

National Service

I was approaching the age for call-up to National Service and my father didn't want me to go. A friend of his, who happened to be the brother of Rangers legend Alan Morton, was in charge of the coalmines for the West of Scotland and could arrange for alternative service in the mines. Those who went to the mines were called 'Bevin Boys' after the famous Labour MP, Ernest Bevin who was Minister of Labour and National Service during the Second World War. Instead of doing under two years in one of the military services, you would do five years down in the pits. Even I could figure out that eighteen months in the RAF was better than five years digging coal. There was also the element of danger to consider as cave-ins were reported all the time.

When I heard my father had arranged for me to go into the mines for five years of service, I composed a fairly illiterate letter to the RAF with the help of my friend, Carlo Pediani. It was a desperate letter. It is so embarrassing to think of it now. I wrote something like 'I want to serve in His Majesty's service.' I posted the letter and it seemed like, by the time I returned home, I had my call-up papers.

I served in the Royal Air Force for eighteen months but when I tried to join the Squadron Camera Club, which was run by a group of English chaps, I was turned down. Thinking back, perhaps my pictures weren't good enough or, alternatively, maybe they didn't want a scruff from Glasgow in their group – I'll never know for sure.

After being discharged from the RAF, I played football for a local team in my district while trying to get started as a photographer. A Catholic priest, Father Duffy, would tell me the times of local weddings and I would get up at 4.30 on Saturday mornings and take the bus around Glasgow to photograph Catholic early Mass weddings. I'd then rush home to develop and print the photographs in my makeshift darkroom in the family garage and hurry back to sell the photos at the wedding receptions which, by that time, were in full swing. I would always hope that no brawls had ensued while I was printing the photos but, no matter how much I hoped, there were always altercations of one kind or another. Scenarios ranged from the brother of the bride duking it out with the groom to the groom's brother getting into fisticuffs with another groomsman or guest for some absurd reason that only appeared logical to the participants because they were drunk.

Becoming a Photographer

I would go round showing my pictures to newspaper picture editors but, as hard as I tried, I found it impossible to land a photography job in Glasgow. One time, I was hoping to get a job on the *Glasgow Evening Citizen* and the picture editor told me I should be feeding animals in my father's zoo. I left the

office with my eyes burning, almost in tears, but, after a few hours, that feeling turned into a determination to succeed. In a way, the rejection didn't do me any harm – it just made me more determined to prove them wrong. That feeling has never left me.

I worked a summer stint at Butlin's Holiday Camp where I snapped the holiday revellers in knobbly-knees contests and sack races. I really enjoyed it – plus it was a great way to meet girls! I had to wear a brown jacket with yellow piping and, on opening night of each camp session, the camp guides would sing their own words to the tune of 'Never Been Kissed'. The song began:

Flash Harry's that handsome photographer chap,
Seek him out, girls, and he'll take your holiday snap.
You're all in the picture and he'll never miss
For the ones that he snaps are the ones that he's kissed.
Never been kissed, never been kissed,
The ones that he snaps are the ones that he's kissed.

Then I would jump out on to the stage and start taking photos. It was a lot of fun and, at the time, I wished life would go on like that forever but it was only a summer job.

Next I began working for Letty & Glen, a local picture agency, covering the Loch Lomond area as a wedding photographer. To get there I had to take a bus into Glasgow every day, then turn around and take a bus out to Alexandria near Balloch. It took nearly two hours each way every day and I earned something less than five pounds a week but at least it was a start.

My first real break came when I was about twenty-four. I got a job with the *Hamilton Advertiser*, the largest weekly newspaper in Scotland and the newspaper that the explorer David Livingstone had sent his dispatches from Africa to. Working for the *Advertiser* gave me discipline and purpose because I knew my pictures were going to be published. I also made a lifelong friend – fellow photographer Charlie McBain who only recently retired from the paper. Spending nearly four years at the *Advertiser* under editor Tom Murray was the equivalent of a university education but I didn't need a degree.

Like any photographer, I was only as good as my last picture.

On my days off or when Charlie would cover for me, I would take the overnight train to London to try to get a job on Fleet Street where all the national newspaper offices were located at the time. Fleet Street was very competitive and there was a unique atmosphere of intrigue that doesn't exist in American journalism. The competition between the dailies was, and still is, fierce and the secrecy surrounding an assignment in order to scoop the other papers was total.

Peter Manuel – My first big break

It was 1956 and, for four years, I had been trying to get a job on Fleet Street. I'd been going down to London on the overnight train but nothing had happened. On about the ninth trip, I saw Freddy Wackett, the assistant picture editor of the London *Daily Sketch*, who said there might be an opening for a freelance photographer to cover Scotland. As I left his office, I asked if there was a real chance and he looked up from his desk and gave me a slight nod. That was all I needed.

I had only been back in Glasgow for a few days when my mother excitedly called me at the *Hamilton Advertiser*, saying, 'You are to call the picture desk of the *Sketch* immediately on Fleet Street 6000.' When I called, Freddy Wackett told me a young woman's body had been found near the fifth tee on the East Kilbride golf course and asked if I would run up there and see what I could get. It was my first assignment and I was on my way.

It was a miserable, dark, cold and damp night. By the time I got there on my Vespa scooter, the place was deserted. I found the golf course caretaker and asked him where the body had been found. He pointed and said, 'Walk straight that way until you get to the trees but watch out, son, not to fall into a bunker.'

10 When I got up the hill, there was only one lone policeman on duty. He told me I was too late and everyone had gone. I asked him to stand near the roped-off area where the body had been found and I took a photo, not knowing whether it would be usable because of the darkness.

Afterwards, I called the *Sketch* and was told to develop the photo and wire it from the Glasgow office of the *Daily Mail*, a paper in their group. I asked them to call ahead for, although the *Mail* knew who I was as I had tried to get a job there and failed, they didn't know I would be coming in as a stringer for the *Sketch*. The call was made and in I went. Although they were in no hurry to help, the *Mail*'s night staff grudgingly let me use their darkroom to develop the photo and then wire it to London.

As I was leaving, I was told to wait – the London *Daily Mail* and the Scottish edition wanted to use the photo as well. I said I would have to ask the *Sketch* as it was an assignment for them. The *Sketch* first said no but then Freddy Wackett said, 'OK, go ahead and let them use the picture as you'll be using their offices a lot from now on.'

It seemed that all the other newspapers' reporters and photographers who had got to the crime scene earlier than me had been held back about 300 yards off the green and I had managed to get the only photo of the golf course. I was the only one who had photographed the exact spot where the victim, Anne Kneilands, had been found. It was my first assignment for the *Sketch* and something of a coup at that. All the other photographers got their asses kicked for leaving the scene too early.

The *Sketch* started calling regularly and my career on Fleet Street had begun. Within a few months, I was able to buy my first car, a Fiat 600, which I dearly loved. Although my days at the *Hamilton Advertiser* had been a pleasant experience and I had made a friend for life in Charlie McBain, I left my staff job and began covering the whole of Scotland for the *Sketch*.

More murders occurred. In Lanarkshire, Marion Watt, her daughter Vivienne and her sister Margaret Brown were wiped out while Marion's husband was away on a fishing holiday and the whole community was up in arms. At first, the husband was accused of coming home from his fishing trip and killing them but he was cleared of all charges and released.

I was given information by some of the hardened criminals I had met along the way and this helped me to get the exclusive that was to bring me to London – and it was all because I loved watching boxing matches. Boxing had always fascinated me. I was the only one in my neighbourhood who actually wanted to go to a fight. Others were satisfied just to read about them in the papers but I wanted to be there and take photographs. Sammy Dougherty, a boxing promoter I had got to know well in Glasgow, was one of the hardest men I have ever met. He was also a bookmaker and knew everyone in Glasgow, including a lot of underworld types. That friendship helped me with my first big exclusive for the *Daily Sketch*.

I used to visit Sammy in Cowcaddens where he had his office and bookmaking operation. He was always busy arranging fights while the bookmaking was being done and none too secretly either. When I was there, it wasn't unusual to see a police inspector being given a 'gift' for turning a blind eye to what was going on. The cop would have his overcoat over his arm and Sammy would shove an envelope under it. It was always interesting being around Sammy – you never knew what was going to happen next.

At the time, Scottish thugs were so absolutely fearless that the London gangs would employ them to come down and do their dirty work. Afterwards, they would return to Glasgow in new, shiny suits.

The talk around Sammy's office was all about the recent murders and how a man called Peter Manuel had committed them. Everyone thought it was Manuel. Known mainly as a fearless jewellery burglar, he also had some priors for indecent assault and rape. I told Sammy I had been trying to find Manuel but he was in hiding.

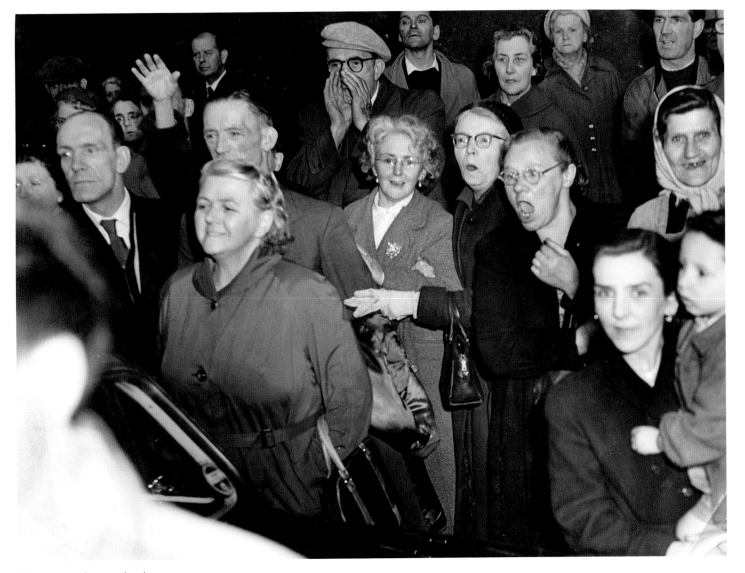

These people watched
and jeered as Peter Manuel
was returned from the
courthouse to prison after
he was convicted of murder
and sentenced to death
by hanging.

12 Finally, when he was arrested on 14 January 1958, Manuel was taken into custody and brought to Uddingston Police Station. I remember exactly what a police detective told the waiting press in a sombre tone that night outside the station. 'A man has been arrested for the crimes of Uddingston,' he said. He didn't have to tell us who it was because we knew it was Peter Manuel. Every felon in Scotland knew it was Manuel. He was sent to Barlinnie Prison on the east side of Glasgow and charged with multiple murders, including those of Anne Kneilands, Isabelle Cooke and the members of the Watts family. He was also accused of murdering the Smart family, a mother, father and little boy, at their home in Uddingston.

With Manuel now locked up, Sammy said, 'Now that he's in jail, we can get to him – I'll fix it.'

The criminals all knew each other and Sammy introduced me to Alex Milligan. Known mostly for breaking and entering and for fearlessly taking on the police, Alex was possibly the hardest man in Glasgow. If someone beat him up one night, that someone would have to be prepared because Milligan would keep coming back every night until he got his revenge. Everyone stayed away from him.

Milligan had been in prison with Manuel in another Scottish jail, Peterhead near Aberdeen, and he told me Manuel was a complete nutcase. He said, 'I came down with Manuel on the prison bus. I was sitting beside him and he was shouting out the window at women. I thought he was a complete headcase and knew he would be going back in at some point.'

Sammy got Milligan to send a note into the prison. A couple of days later, I was at Sammy's office when in walked Milligan who announced, 'I've got a visit for both of us.' He then pulled a small slip of yellow paper from his pocket. He showed it to me and I could see it had '2 Visitors' written on it so off we went to Barlinnie.

From the roadway, it is a very grim-looking prison. There were photographers and reporters camped out in front and, when they saw me going inside, they were beside themselves. They simply didn't know what hit had them. It was a terrific feeling walking into the prison while my colleagues were standing outside behind a barrier.

We walked up a slight incline and knocked on the door. Alex Milligan and I were searched and escorted down a corridor to a small, nondescript room no larger than nine feet by twelve. There were two chairs on one side of a big wooden table and one chair on the other side. There was one warden in the room. He was a young chap but there were no pleasantries, nothing like that – he just stood there. Manuel was quickly escorted in. There was no guardrail between us which surprised me but Alex said that was the way it was done with untried prisoners because they could be innocent. Alex introduced me by saying I was his friend and that I was also a good friend of 'the wee man', meaning Sammy Dougherty. When Manuel came into the room, a second warden came in and stood behind him and stayed in the room with us. Manuel, who I have to say was quite good looking in a tough corner-boy sort of way, looked me straight in the eye and denied everything.

Wee Willie Gourley was also friend of Sammy Dougherty and he arranged another visit to Barlinnie for me because Sammy had told him to. Wee Willie had been on some serious jewellery heists with Manuel so he knew him better than Alex did. Wee Willie was the best safe cracker in Scotland and, during the Second World War, he was parachuted behind enemy lines to work with the French Resistance, opening German safes to obtain information for the Allies. A decorated war hero, his signature calling card was to dynamite a safe without damaging the contents.

After Willie had contacted Manuel, I got a series of visits. During our meetings, Manuel would tell me how they had the wrong man and that he was innocent. To support this, he'd weave intricate stories about where he was on the night of a certain murder.

When we left one day, Willie said to me, 'You know what he's doing, Harry? He's trying out his alibi on us to see our reaction – to see if we believe him. I know it's all lies, Harry. When someone looks you straight in the face, they are always lying to you. What he's saying is a load of shit.'

Once, when I was visiting him, Manuel said, 'Harry, why did you not get me the magazines I asked for in my letters?'

And I said, 'I didn't get any letters from you.'

He said, 'I've been sending them to Vardar Avenue in Clarkston.'

Then it dawned on me – my mother must have been getting the mail and throwing the letters away because Manuel was accused of murder. When I asked her if she had destroyed the letters from Barlinnie Prison, my father answered. 'You're bloody right we did,' he said. 'We can't have scum like that writing to our home. Why can't you be like other photographers and not associate with the worst elements of society? It's a disgrace.'

I tried to explain to them that it was an exclusive story and I was the only person to have it but they were having none of it.

When I visited Manuel again the next day, I said, 'Do me a favour. My mother doesn't like your letters coming to our house so would you send them to my friend Carlo Pediani on Union Street?'

Manuel said he understood mothers like mine and so that was where the letters were sent from then on.

Another friend of Sammy Dougherty was Neeley O'Donnell who was in Barlinnie Prison but had not been indicted. He was in charge of the prisoners' visitors, including Manuel's. This was because he had privileges for good behaviour and he was also very articulate and very well read. Unlike many of the prison's inmates, he was up on a burglary charge not murder. Each week, O'Donnell would show me the list of visitors' names scheduled to come in to see Manuel and I would score off the names of any reporters and other photographers and basically leave only the priest and Manuel's mother on the list of visitors. Manuel would say to me that he couldn't understand why I was the only press person who

came to see him when the others wrote letters begging to visit and I would just shrug in bewilderment.

One spring evening during the middle of his trial, I went to see Manuel with Wee Willie. We went into the prison and were escorted to a tiny room to wait for Manuel to be brought in. The place was about the size of a closet. Manuel came in with his tabby cat – the guards let him have it to shut him up. Manuel sat on the bench and started talking. There was one guard behind us and one behind him. When Manuel started to talk about the case, one of the guards screamed, 'You cannot talk about the case! Visit over! Visit over!'

Manuel jumped up and punched the guard in the mouth, shouting, 'I'll tell you what is fucking over!'

The other guard jumped in to stop Manuel from getting beaten up because they couldn't have him turning up in court all black and blue. Wee Willie and I just sat there trying to get out of the way in this tiny room while watching a serial killer go after a guard. A real fight was going on.

Having witnessed the violence, Willie and I were both a bit shaky as we left. After we signed out at the first guard post, we walked a few yards and were stopped and told that the governor wanted to talk to us. The governor said, 'Mr Benson, I want a favour from you. I would appreciate it if you forget about what you have seen here today. The guard was wrong to stop Peter from talking about the case. He can talk to you as long as he wants.'

14 So back in we went. Willie said he would try to help by saying they were together at the time of one of the murders. Manuel said, 'You're talking about jewellery and there are bodies strewn all over. Keep out of it, Willie, or you know what will happen? You'll be going home one night and the police will stop you and they'll shove some gelignite in your pocket and you'll get five years.'

Ironically, about a year and a half later, when I was working in London, my father sent me a clipping from the *Glasgow Evening Times* saying just that – Willie Gourley was caught with gelignite and sentenced to five years.

Manuel always talked about girls writing to him in prison – he even said some of them wanted to marry him. He said he could always talk women into doing whatever he wanted and told me he kept looking at the women on the jury, hoping this would help his case. He asked me where I went dancing. I told him I liked the Glasgow dancehall called the Locarno. Saying he had been there, too, he added, 'Harry, when I get out of here, we'll have lots of fun.'

My last visit came after Manuel had been sentenced to death. He was convicted of seven murders but there were at least fifteen and maybe even more. He was devastated by his

mother's testimony, telling me, 'What she said . . . Oh, my mother . . . The things she said . . .'

Willie Gourley told me Manuel's mother had gone to her priest who told her she must tell the truth. She admitted in court that her son was not at home on the nights the murders were committed and she refused to corroborate his alibis. That was when he first confessed to me. He mentioned the Isabelle Cooke murder and told me how the police had dragged him in handcuffs, from place to place, looking for the body. But, by this time, he had moved the body to a freshly ploughed field that the police had already searched, knowing that the cops wouldn't look there again. He didn't understand why the police couldn't find the body without his help as he said he hadn't buried her very well in the ploughed field.

Manuel told me how he had met the first woman he killed, Anne Kneilands, by accident. She had gone to the Willow Tea Room in East Kilbride to meet a boy. She'd waited outside but the boy never turned up so she began walking home and that's when Manuel spotted her. Manuel was on the prowl and started talking with her. Having been stood up, Anne must have already been feeling very vulnerable and she was his first victim.

Although no photographs were allowed in the prison, all of my visits were reported in the *Daily Sketch*. Despite the fact that I was probably the most inexperienced of all the journalists covering the case, my stories were front-page news each day – I was the only one with the access and the only one who got to him. And that's the bottom line – I got the story.

I was only twenty-eight when Manuel was hanged on 11 July 1958 – he was the last man to be hanged in Scotland. His story had been my first major exclusive and I had had it all to myself. I like to think I still have the ability to get the scoop. Being turned down over and over again when I was trying to get my first job has something to do with it. Never give up, never give in and beat the bastards at their own game – that might sum it up quite nicely!

Form No. 259. **Untried Prisoner's Letter.**

NOTICE CONCERNING COMMUNICATION WITH PRISONERS.

LETTERS.

All letters are read by the Authorities, who may keep them back if they think it right to do so. Every letter will be kept back in the following cases:—

1. If it is *crossed*, or otherwise not written in a plain manner, so as to be easily read.
2. If it contains indecorous or improper matter.

No unpaid letters will be received at the Prison.

Each letter must have on the back the registered number of the prisoner, as well as the name.

Register number **450** Name **P. Manuel**

The Prisoner's writing to be on *the blue lines only*.

H.M. PRISON, **Barlinnie**

11 - 5 - 1958.

Dear Harry,
Got your welcome letter - glad to hear I can rouse one cheer anyway.

I got the books — and the cigarettes. I sent you and Willie a visit for Wednesday night. I sent it to Pedian's as I am not sure of Willie's address. I think its 68 Lumsden St, but not sure.

I sent you a further visit for Friday which will Willie. So between the two you should manage something. I see in the

Wt 70478/146 30,000 6/56 D. & Co.

Pic today some clown is selling hair - saying it's mine. It seems young birds are buying it. If I get slung they can have all the hair I've got gratis.

Well Harry tomorrow sees things starting to roll. Not before time either - I feel real cooped up.

I do not know how long they will take each day. Everyone who has anything to do with proceedings seem not to know. It seems the decision lies with Cameron.

But I need visits, so something will have to give, unless they want to give me visits during the trial.

I got a letter from a screwball today who wants to marry me. It seems that an acquittal will open up pleasant possibilities here. I might need a couple of stand-ins.

All for now, and thanks for the books,
Yours Sincerely
P. Manuel.

16

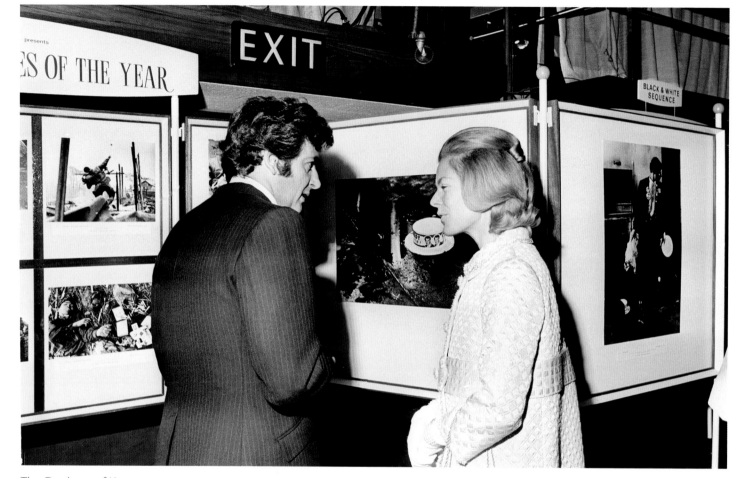

The Duchess of Kent
presented me with the
First Place Award in the
Encyclopaedia Britannica
Photographer of the Year
Awards for my photographs
of Robert Kennedy's
assassination taken at the
Ambassador Hotel in
Los Angeles in 1968.

From Glasgow to New York

Another early assignment was to photograph Queen Elizabeth II while she was staying at Balmoral Castle. She was in a nearby store and her detectives came out to ask who I was and why I was waiting there. I told them my name and that I was from the *Sketch*. Her little Corgi was running around barking when the Queen came out and she said something like, 'Well, Mr Benson, what can I do for you today?' Completely overawed at being spoken to by the Queen – who rarely addressed the press directly – I just stuttered and stood there smiling. I got no pictures to speak of and so I learned very quickly that it is very hard for an inexperienced photographer to get good pictures in a situation when you have only a short time with someone like the Queen. I was determined not to let that kind of opportunity slip by again.

One of the biggest scares I ever got came from an early *Sketch* assignment. An earl, a member of the landed gentry from one of the border counties, had caught a poacher fishing on his private river. He shot the poacher in the backside with buckshot and proceeded to march him several miles to the gamekeeper's lodge. The poacher nearly bled to death and there was a big uproar about the case in court. To everyone's surprise and pleasure, his lordship was charged and convicted. My reporter was in the packed courtroom but I wasn't able to get inside even for a moment to see what the poacher looked like. I relied on my reporter to point him out to me as they were leaving the court after the trial.

My photo appeared on the front page of the *Sketch* the next day. I felt so proud until a phone call came from London, asking if I was happy. When I said yes, very happy, the picture editor said, 'Well, stop being so happy because the poacher's solicitor has been on to us and is going to sue. He wants some sort of satisfaction.'

It turned out that my reporter had pointed out the poacher's solicitor instead of the man himself. I'm still not sure whether he did this on purpose or not. Yet, I couldn't put the blame on the reporter. Even if he did mislead me, it was still my fault – I should have made absolutely sure that I'd got the right person. I was devastated to have made such a terrible blunder when I was just starting out but, luckily, the solicitor was not unreasonable and it was handled amicably.

To this day, I think that's why, when I am on assignment, I like to go alone without a reporter. Ever since that incident, I have been doubly careful as I've never forgotten that time when I got it wrong. I'm glad it happened at the beginning of my career because it made me aware of how important it is to identify your subjects correctly. It was another very good lesson learned and, from that day on, I have never taken what anyone has told me for granted without verifying the information for myself.

After that, things went more smoothly and, looking back, I think one of the happiest times in my life was covering Scotland for the *Sketch* – everything was new and it really was an adventure. In my 1957 Fiat 600, I travelled all around the country, taking pictures. I could go wherever I wanted and suggest any story I thought was interesting.

That first year, 1958, I tied for second prize as Photographer of the Year in the *Encyclopaedia Britannica* awards. In doing so, I became the first person from Scotland ever to achieve that distinction. The *Sketch* then asked me to come to London where I was put on the staff.

In Fleet Street, there were lots of very good photographers, all competing to get the best shots. I loved it but, when new photographers arrived in Fleet Street, they were not welcomed with open arms – they had to earn their place in the field.

18 I had thought things were competitive in Glasgow but I wasn't prepared for what I was about to encounter in London. Any newcomer is considered an upstart and treated accordingly. If, for example, you arrive early and are positioned in the front of the group waiting for the Queen to pass and a veteran of thirty years arrives, he will just walk up and stand in front of you. I wasn't prepared for that and I had to learn the hard way. On my first day on the job in London, I was photographing some East German movie star when an older photographer came over and hit me twice in the back of the head with his Speed Graphic. Needless to say, I hit him back which resulted in the photographer calling the editor of the *Daily Sketch* to complain. It was touch and go whether they were going to fire me but, afterwards, whenever I turned up for a job, the other photographers gave me a wide berth because they knew I hadn't taken the harassment lying down.

With my brother Stanley and sisters Ruth and Joan, 2006.

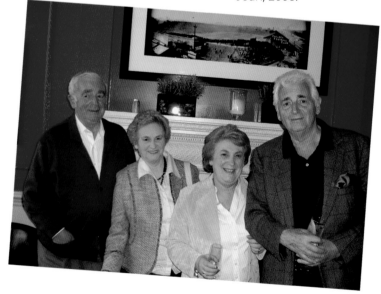

After about a year, I moved to the *Daily Express*, then worked for *Queen Magazine*, a women's fashion magazine, before returning to the *Express*, mainly because they had a bureau in America and they'd assign photographers and reporters there for two-year stints.

In January 1964, an event occurred that changed the course of my life. I'd been given an assignment in Africa. I'd had all the necessary inoculations and, late at night, I was packing for the trip when the phone rang. It was the night editor on the *Express* saying I was to go to Paris the next day to photograph a new group called The Beatles. I said I was all ready to leave for Africa on a major news story and didn't want to photograph a relatively unknown pop group. I thought that was that and I hung up the phone but, a few minutes later, the phone went again and the night editor said, 'The editor says you are going to Paris.'

I arrived in Paris quite late in the afternoon and immediately drove to an auditorium on the outskirts of the city where The Beatles were performing. I walked in as they were singing 'All My Loving' and, when I heard the music, I knew the editor had made the right decision. Later that week, we found out that 'I Want to Hold Your Hand' was number one in the American charts and that the band would be going to America to appear on the *Ed Sullivan Show* . . . and I was going with them.

We arrived in New York on 7 February 1964 and I have lived there ever since. But I have always kept my ties with Glasgow. When our daughters, Wendy and Tessa, were growing up, my wife, Gigi, and I would take the girls to Glasgow each year to visit their grandparents. I am always happy when I am on my way back to Glasgow for a visit as I can see my pals, go to a football match, walk on the beach at Troon, have fish and chips and play a game of golf. And, although I have lived in New York for forty years, I still call Glasgow my home.

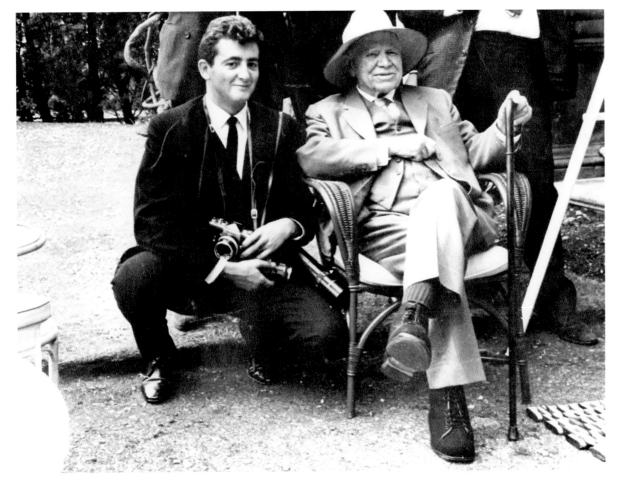

With Lord Beaverbrook,
proprietor of the *Daily
Express*, at his home outside
London. He was the finest
journalist I have ever met.

From Harry's Scrapbook

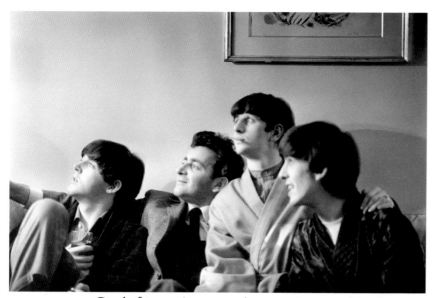

Paul, Ringo, George and me photographed by John with my camera, Paris, 1964.

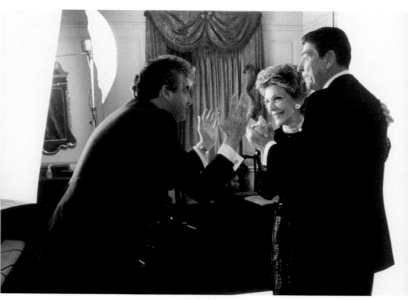

At the White House with President and Mrs Reagan in 1985 to photograph them for the cover of Vanity Fair magazine.

With Paul at his farm in Peasmarsh, East Sussex, 1992.

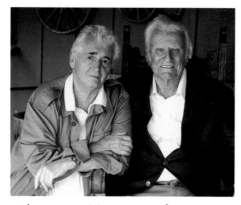

We were at the home of Reverend Billy Graham in Montreat, North Carolina, 2003. What impressed me most about the distinguished man was that he could name parts of Glasgow that I thought only the natives knew about.

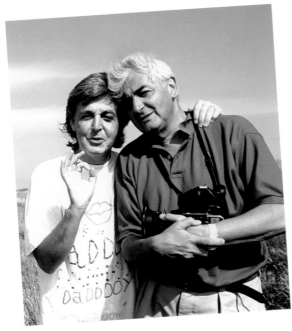

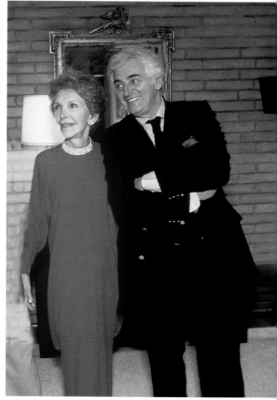

With Mrs Reagan at her home in Bel Air, California, 2000.

Photographing John Kennedy Jr and his sister Caroline at the John F. Kennedy Library in Boston, 1984.

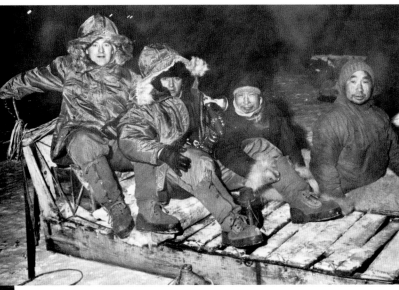

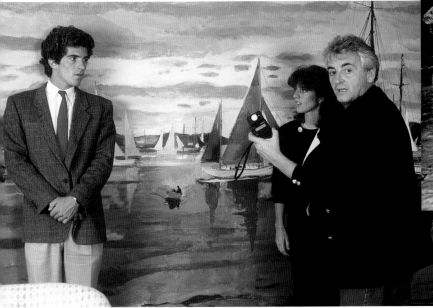

With Daily Express colleague Andy Fyall in 1968 at Thule Air Force Base, Greenland, after a B-52 crashed while landing and four nuclear weapons detonated, contaminating the area.

With President Clinton in Kosovo to spend Thanksgiving with the troops, November 1999.

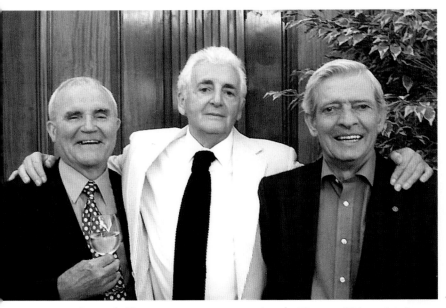

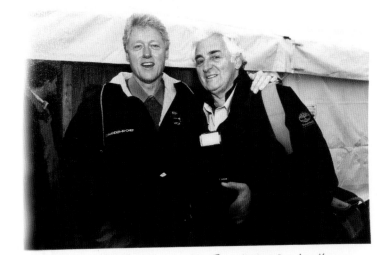

With fellow photographers and pals Tommy Fitzpatrick and Charlie McBain in Glasgow, 2006.

To Harry Benson— It's a long way from New Hampshire— but Kosovo was worth being cold for. I know you captured the image of our good our young Americans and their allies doing there— Thanks— Bill Clinton

22

From Harry's Scrapbook

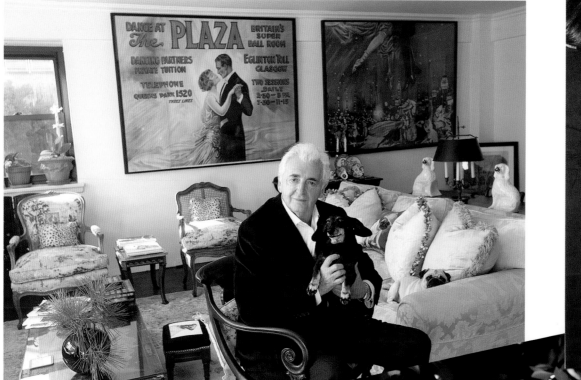

At home in New York in 2006 holding Tillie while Daisy rests on the couch. The poster from the Plaza Ballroom in Glasgow is in the background.

Gigi and me in New York, 1968.

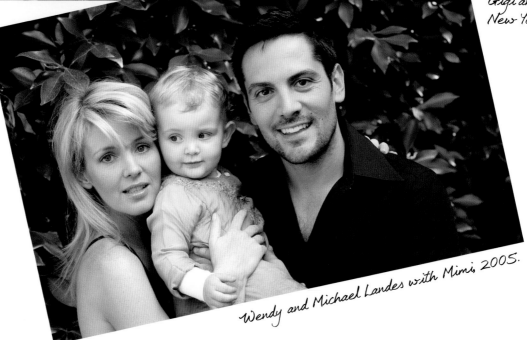

Wendy and Michael Landes with Mimi, 2005.

Granddaughter Mimi Landes with her baby
brother Dominic, April 2007

Gigi and me at
the opening of the
exhibition of my
photos at the Scottish
National Portrait
Gallery, August
2006. Photo by
Gary Doak.

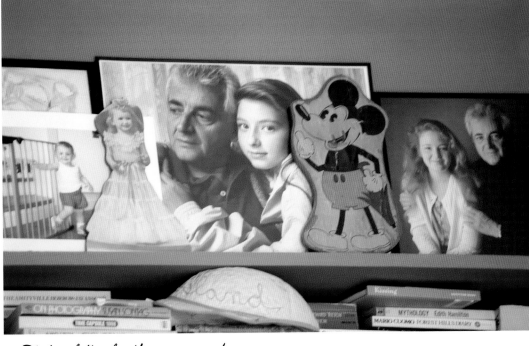

Photos of the family are propped
up on the bookcase in our bedroom
in New York.

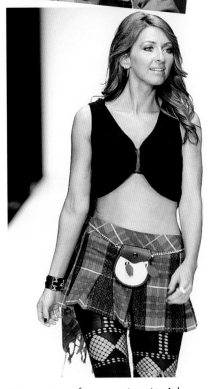

Tessa in a 'Dressed to Kilt'
fashion show in Los Angeles,
2006. Photo by Lloyd Bishop.

Two Children, Southside of Glasgow, November 1971

Walking along looking for photos for a story I was doing on Glasgow for *Time* magazine, I came across these children sitting outside an old tenement building. Properly dressed, healthy, with angelic faces, they could have come from anywhere but they were from the southside of Glasgow.

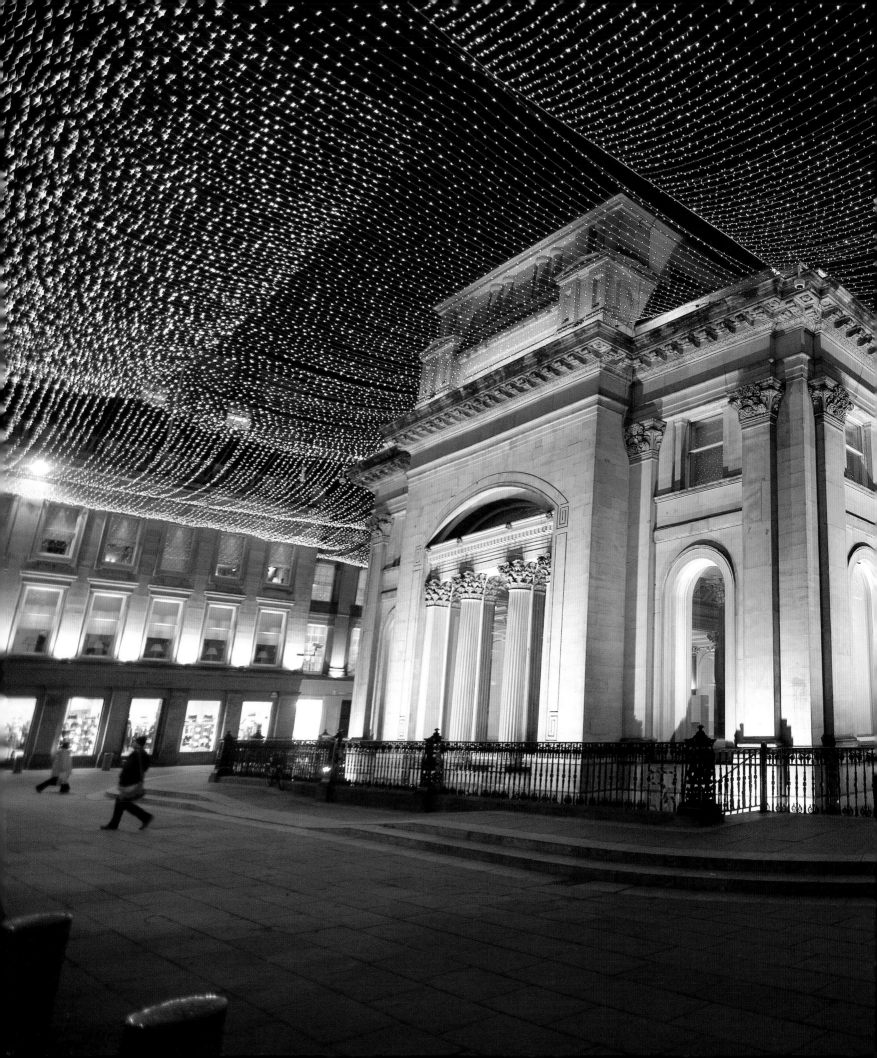

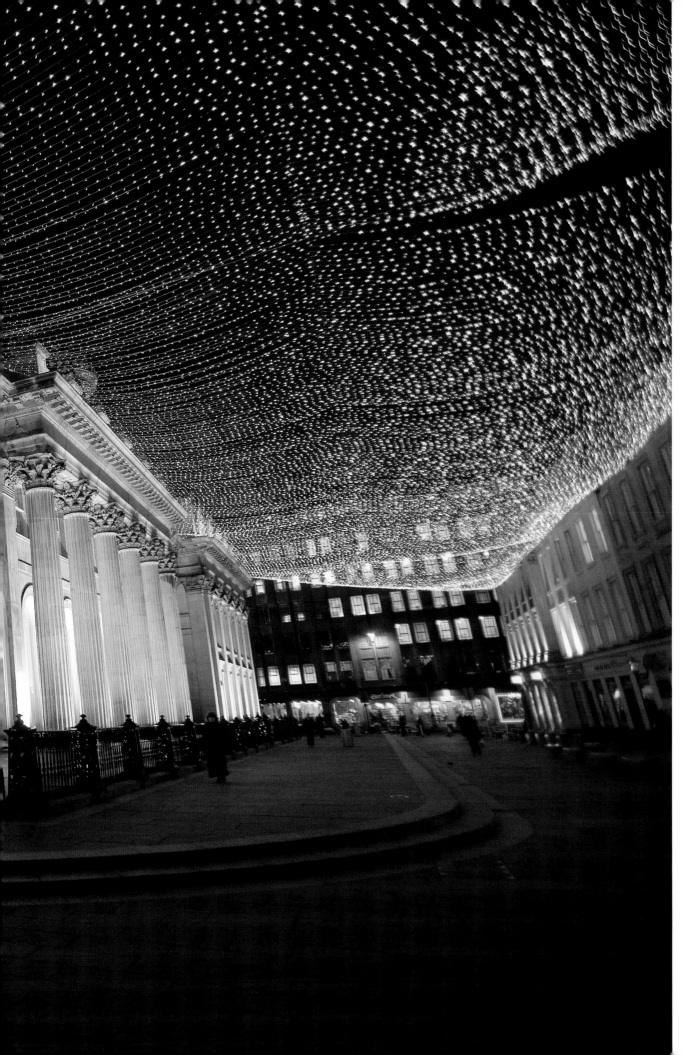

**Royal Exchange Square,
February 2007**

The lights shining on the
Gallery of Modern Art
made the square a
wonderful sight at night.

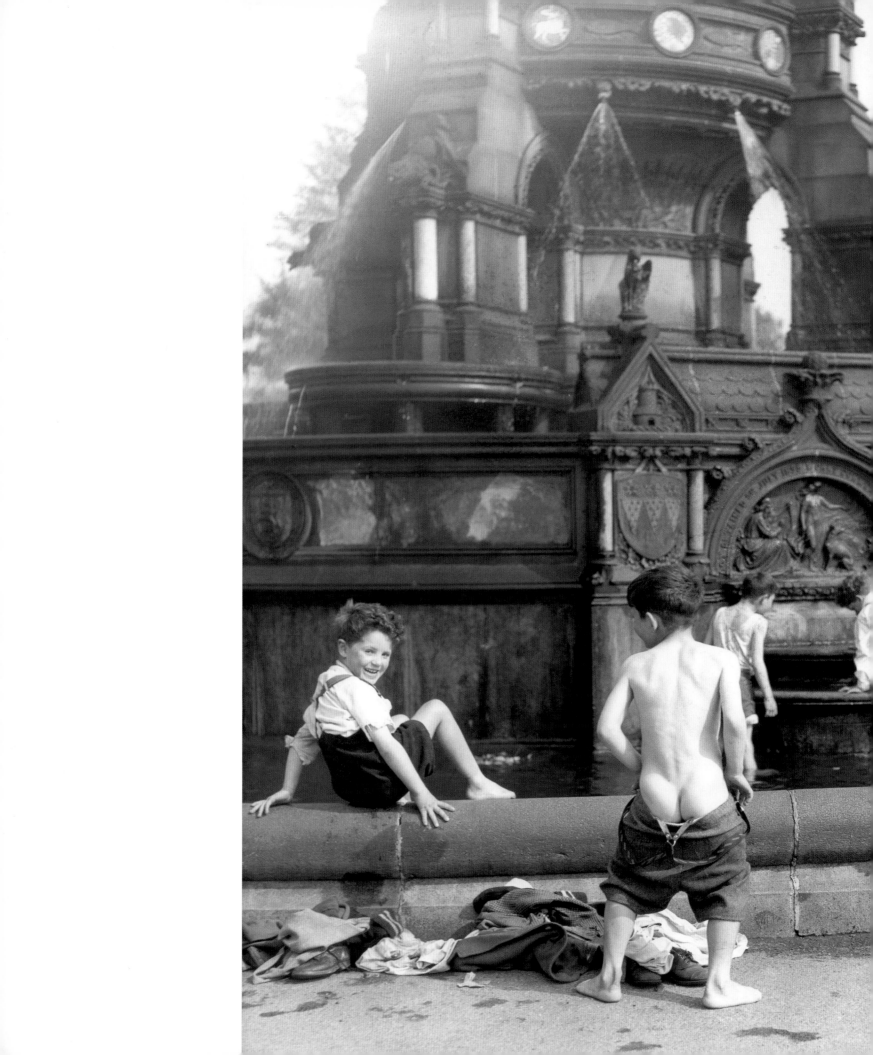

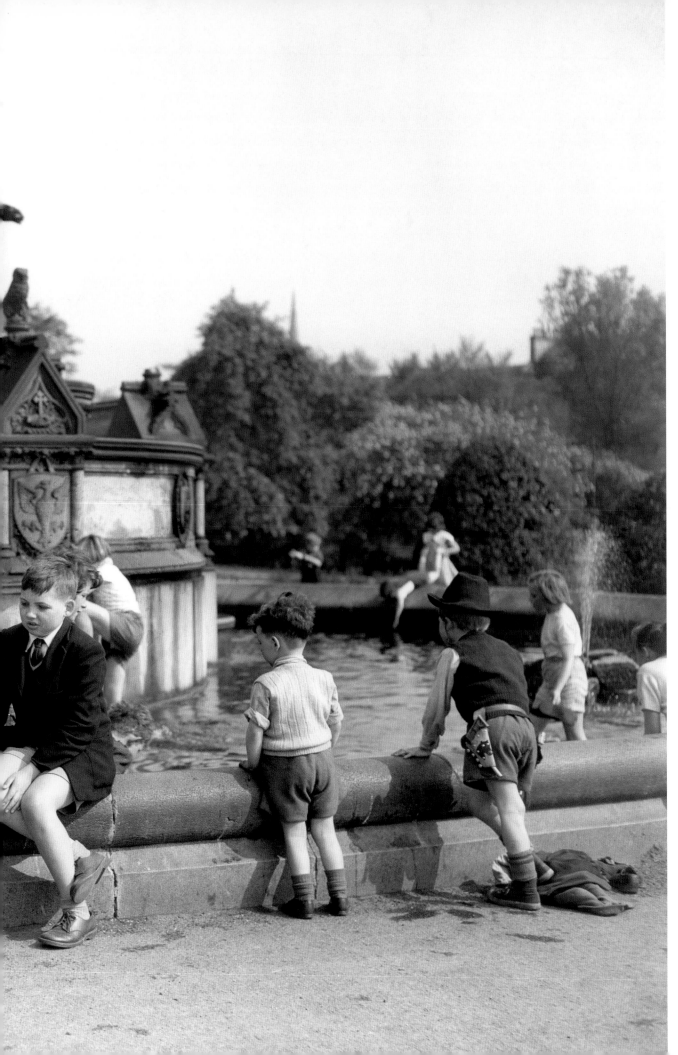

The Stewart Memorial Fountain in Kelvingrove Park, 1956

One afternoon I was walking around the park and happened upon a group of schoolboys up to some mischief. They were cooling off during what the newspapers called a 'Glasgow heat wave' although the temperature was only around 75 degrees. The fountain, designed by architect James Sellars and sculpted by John Mossman, is one of my favourite spots in Glasgow. It was erected in 1872 to commemorate Robert Stewart of Murdostoun who was Lord Provost of Glasgow from 1851 to 1854.

Following page:
Buchanan Street, June 2006

Walking around Buchanan Street where my mother used to shop, I saw three teens wearing bright red stockings and crowns. They were having a good time and gave me a wave.

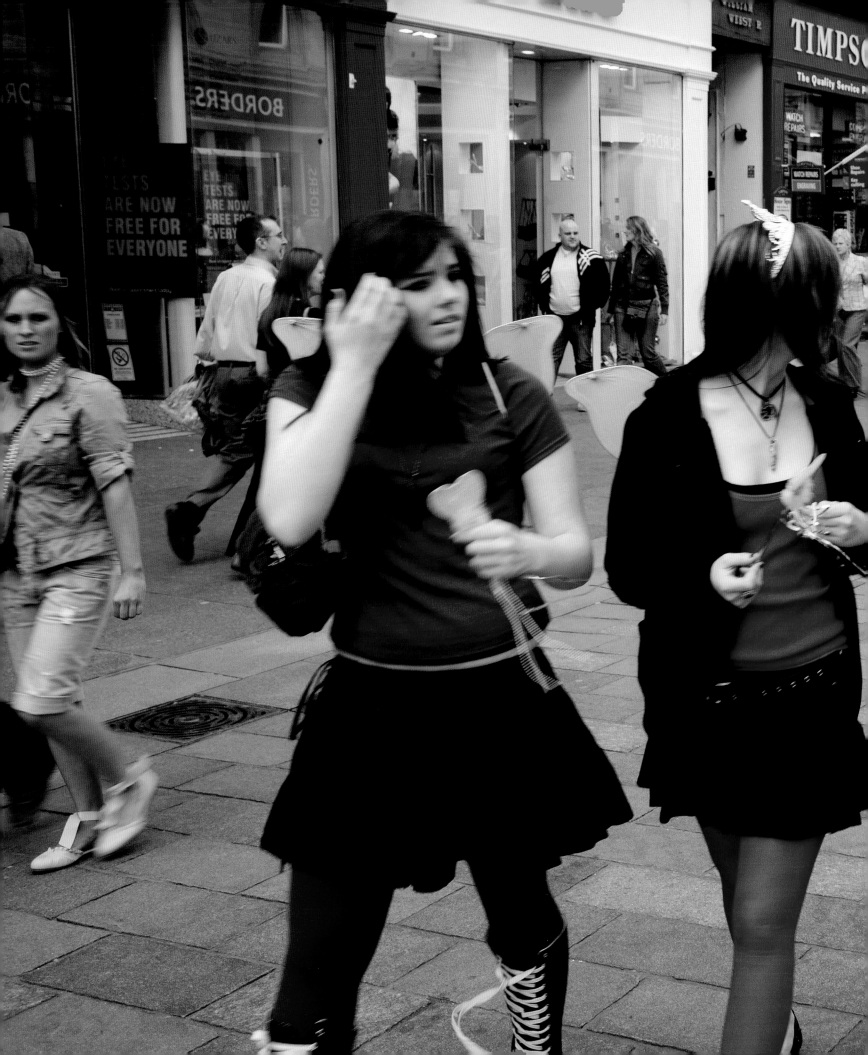

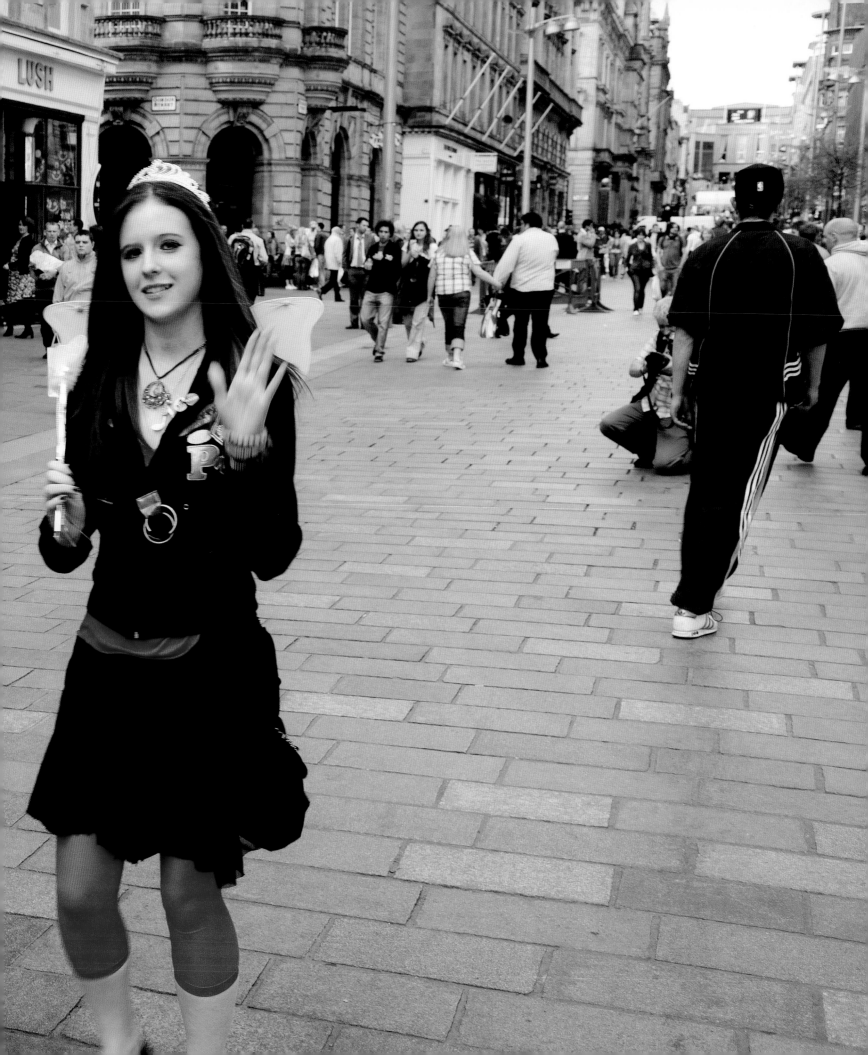

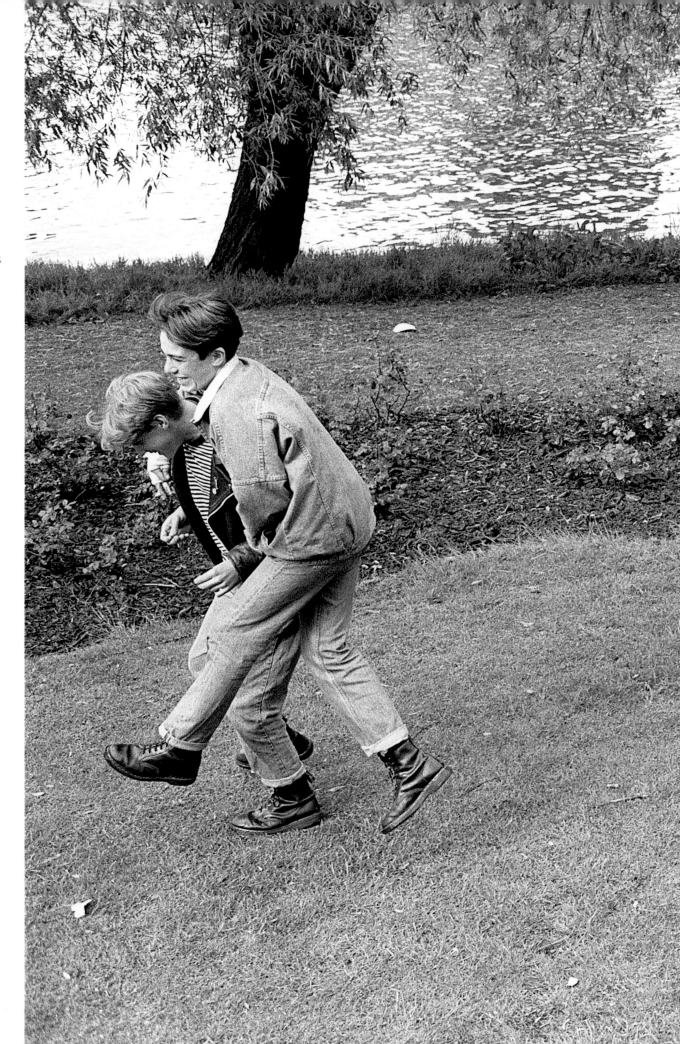

Kelvingrove Park, 1990
Again, teens were having a great time with their pals near the River Kelvin.

Following page:
Plaza Ballroom, 1990
Glasgow has always been a dancing city. Here are some men and women lined up, waiting to go inside the Plaza Ballroom for an afternoon of ballroom dancing.

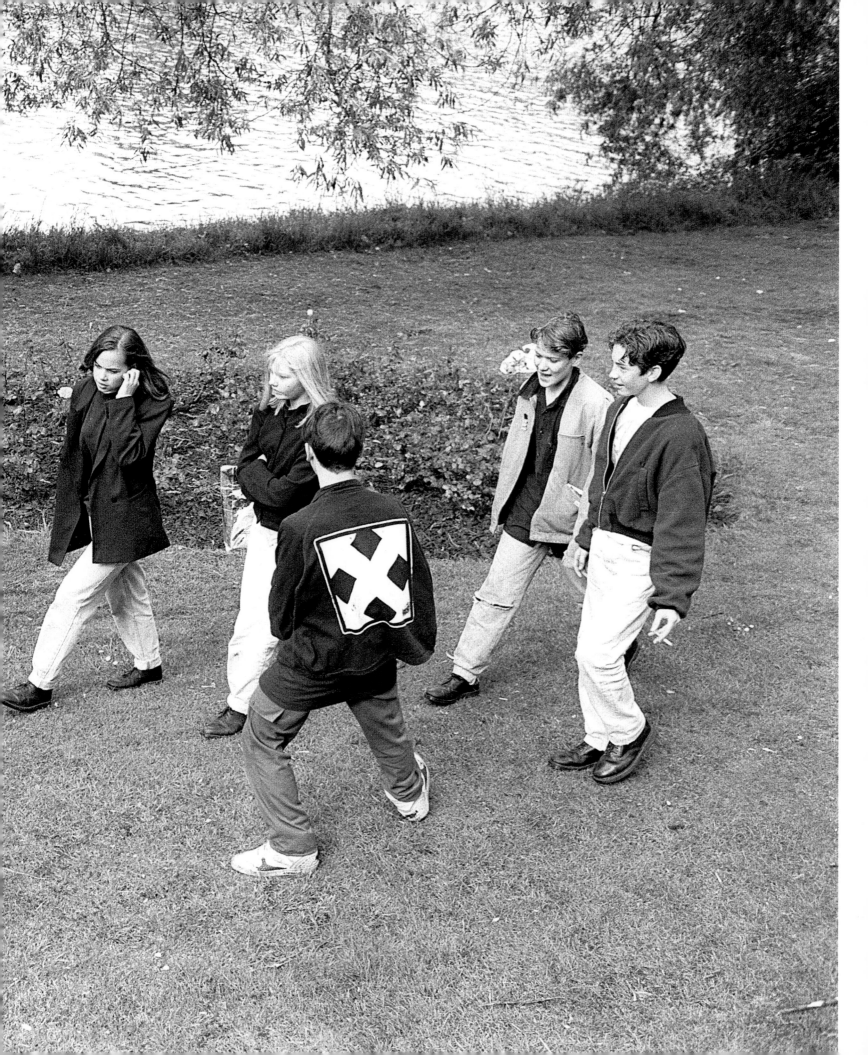

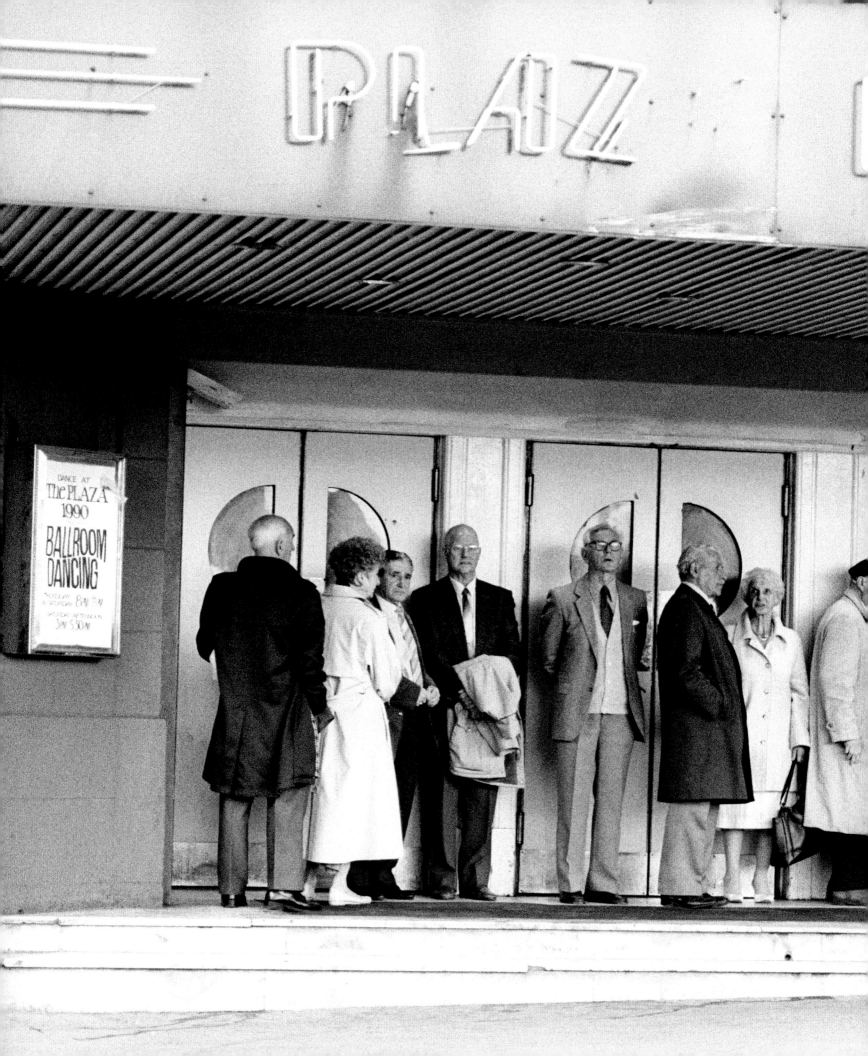

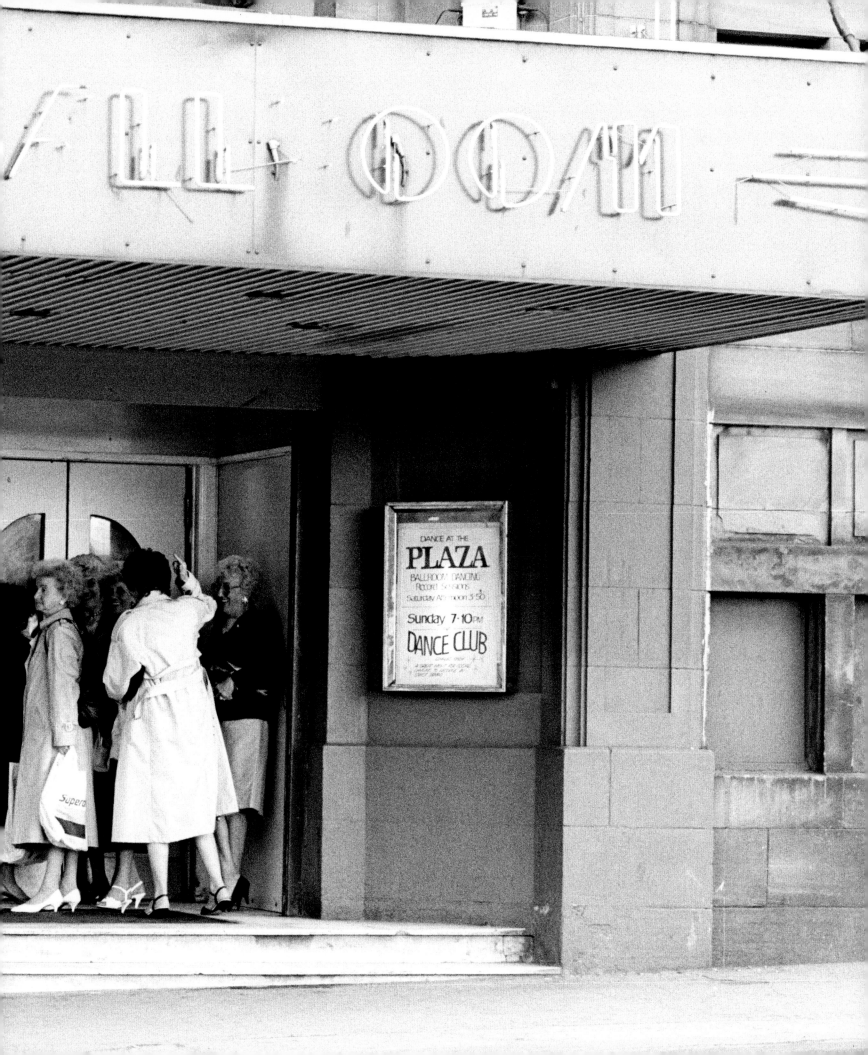

Plaza Ballroom, 1990

The ladies were having fun putting on their dancing shoes. As a child, when we rode the tramcar into town, I would see a large colour poster outside near the front entrance. I asked the manager about it when I was there photographing in 1990. He told me he had only two left and gave me one. I think it was a wonderful gift and have it hanging in my living room.

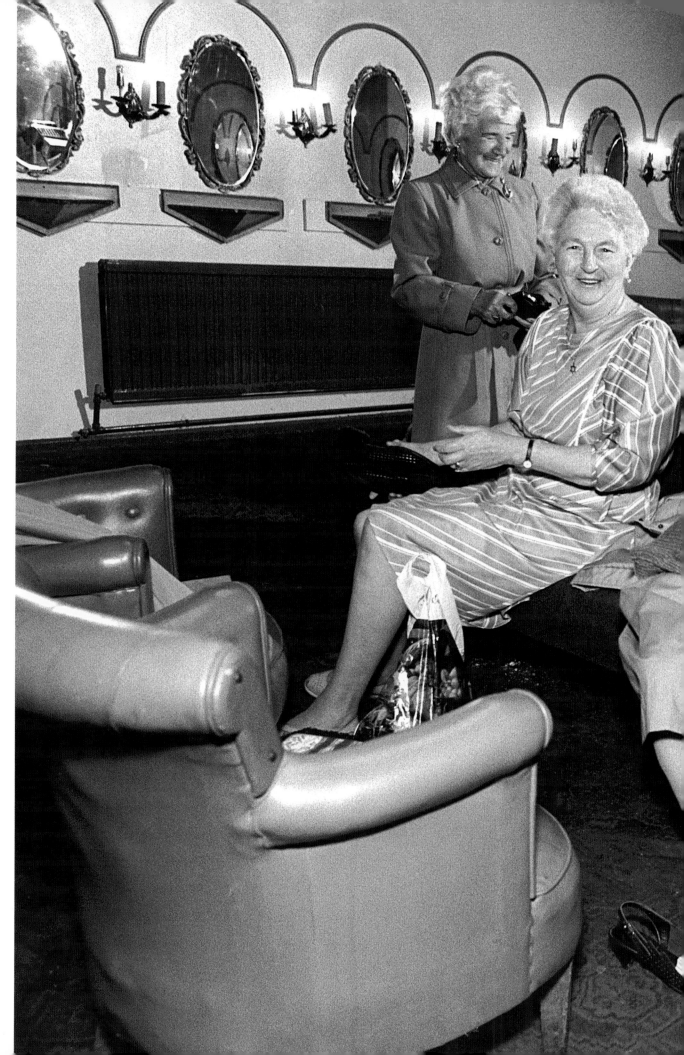

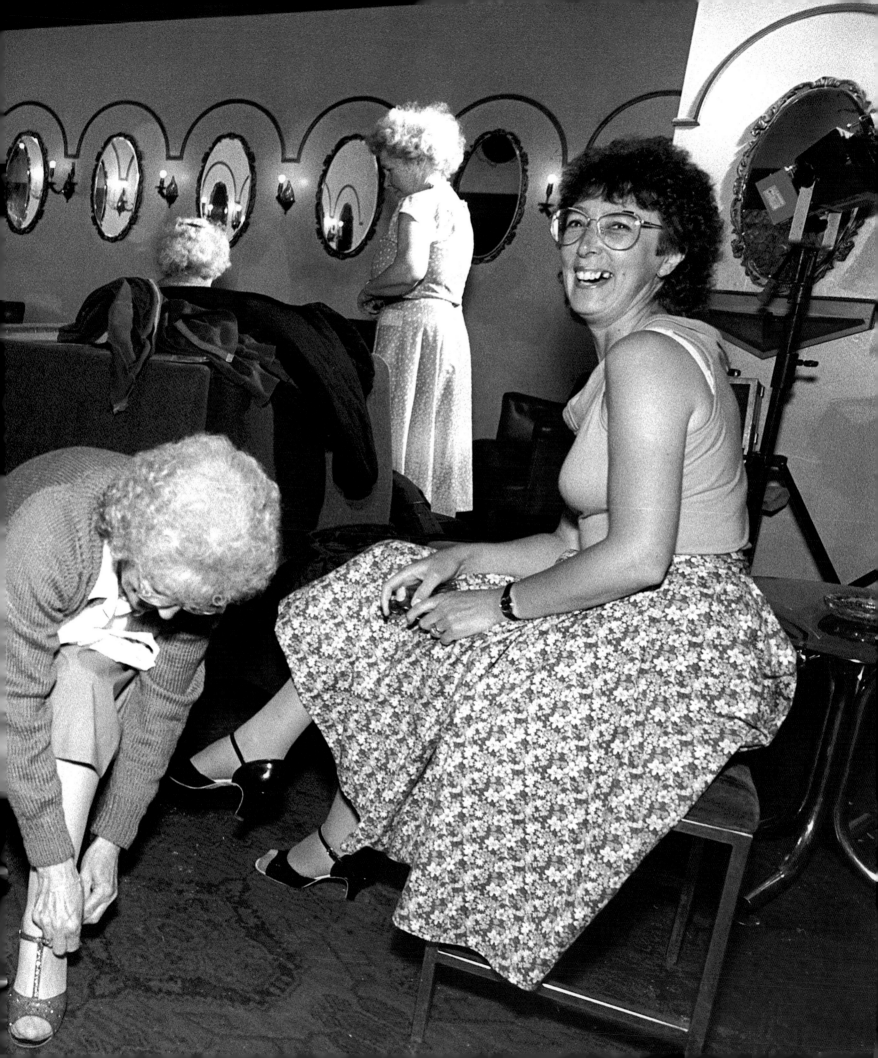

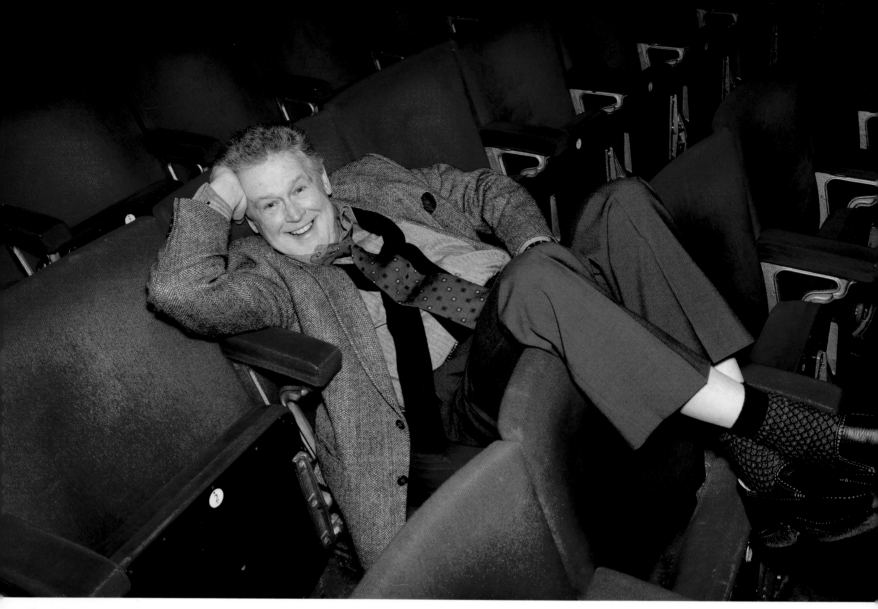

**Tony Roper,
February 2006**

The comedian and author
was in a relaxed mood
at the Pavilion Theatre
where his play *The Steamie*
was box office sell-out. He
has also appeared in many
of Scotland's best-loved
TV comedy series, including
Scotch and Wry, *Naked Video*
and *Rab C Nesbitt*.

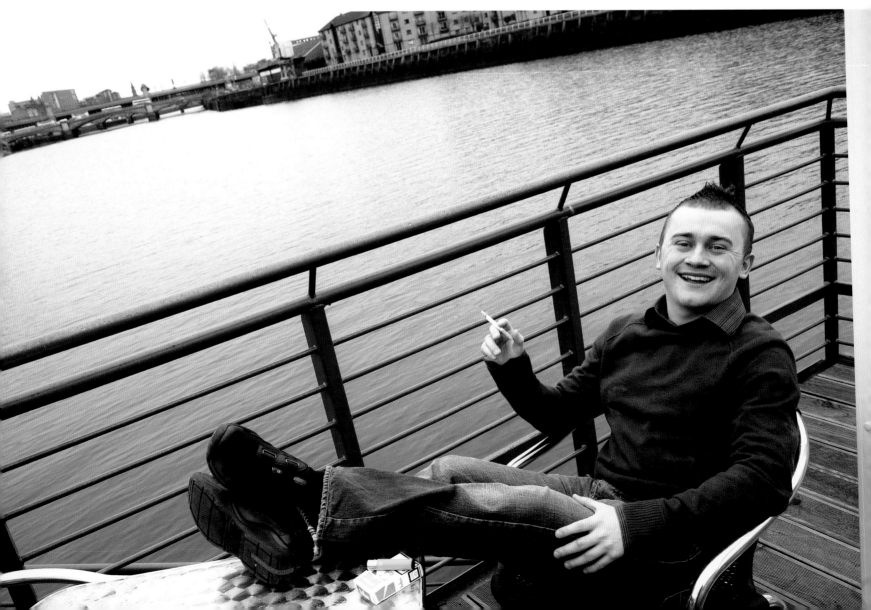

**Stephen Purdon,
February 2006**

The television star, who plays Shell Suit Bob in *River City*, was relaxing on the Renfrew Ferry.

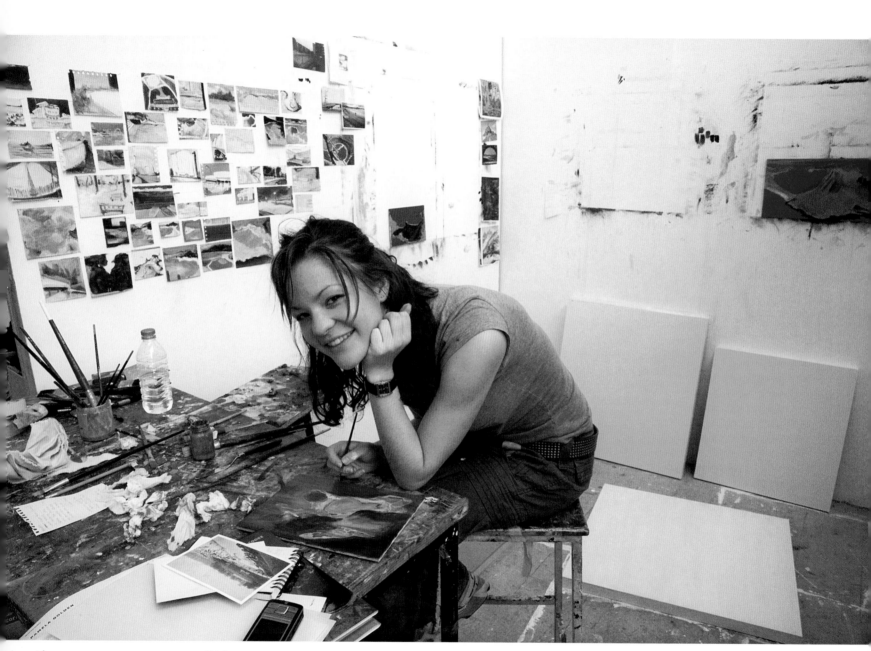

Above:

**The Glasgow School
of Art, April 2006**

I was pleased to be back
in the art school that I
had attended as a teen.
It brought back memories
of my time there.
Students were happy and
working hard on a variety
of creative projects.

Right:

**West End Festival
Parade, 11 June 2006**

The day was perfect.
Everyone was in a festive
mood and the annual
parade brought out young
and old alike.

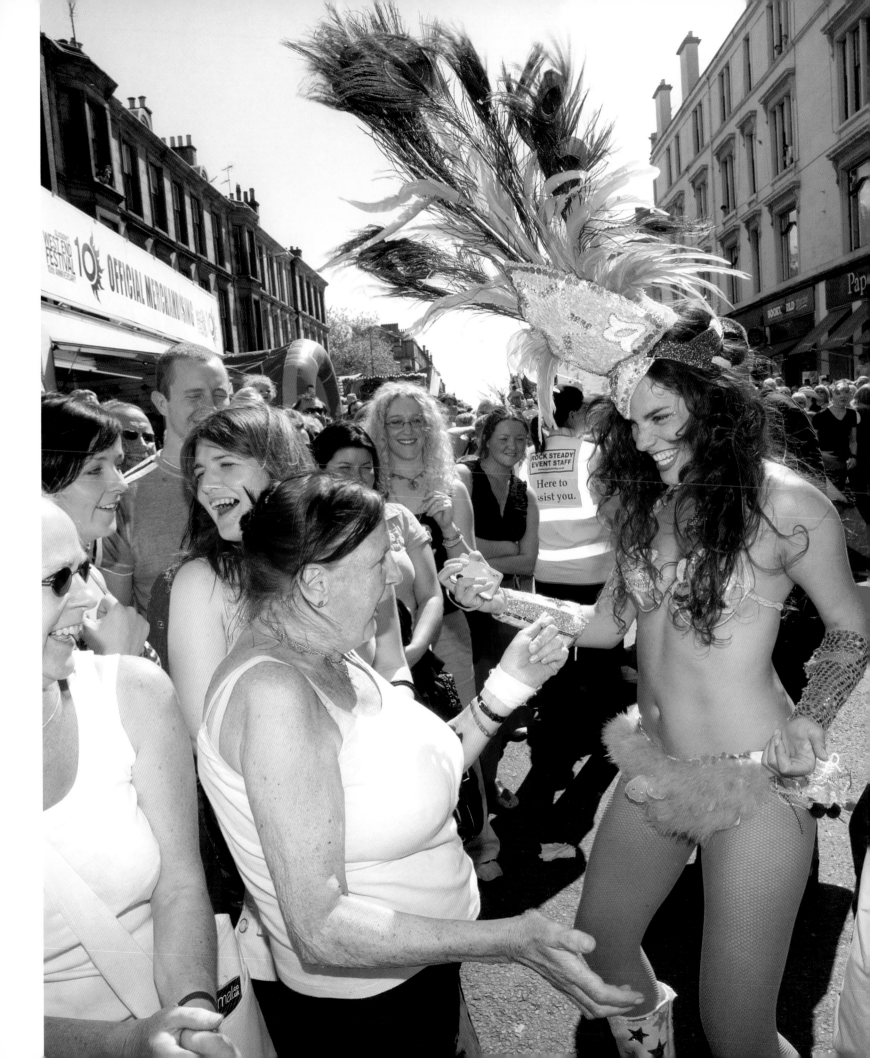

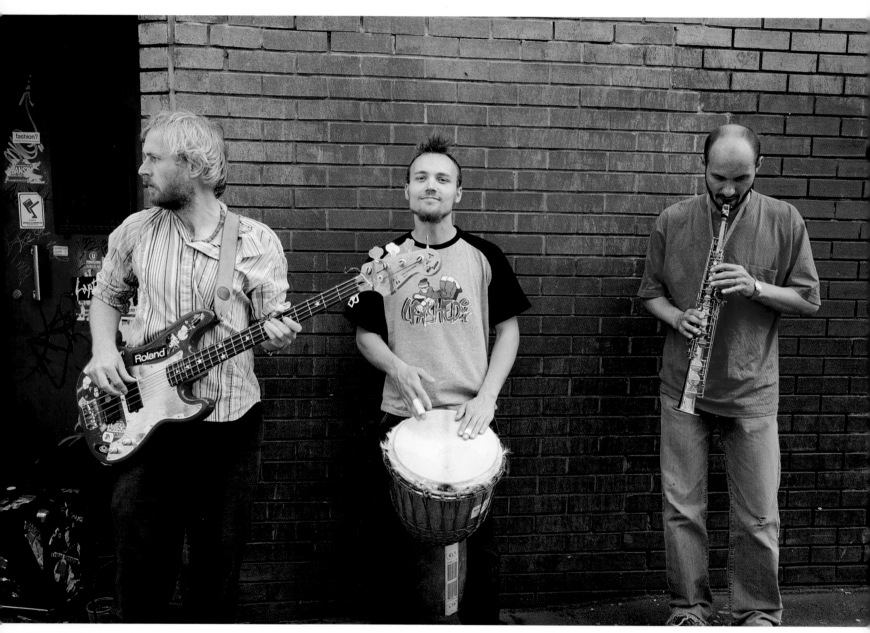

**West End Festival
Parade, 11 June 2006**

The celebration was in full
swing. Hundreds of
people filled the streets.
There was something for
everyone including street
musicians and girls with
purple balloons.

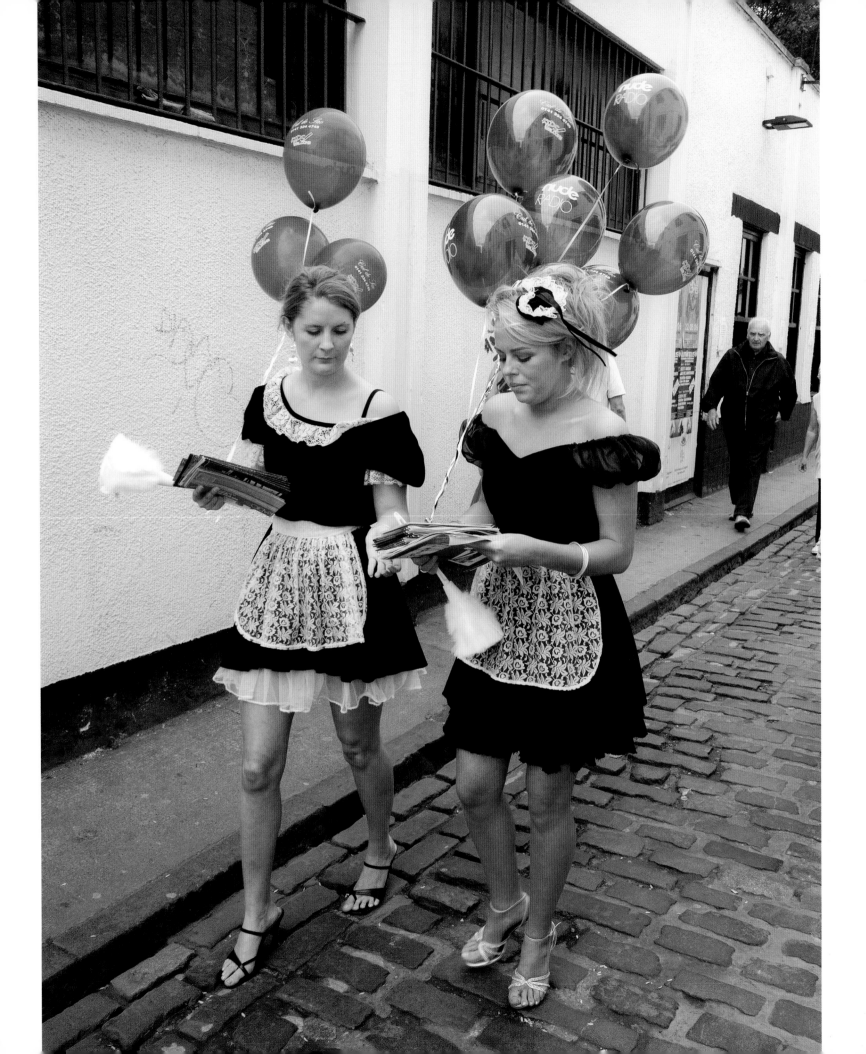

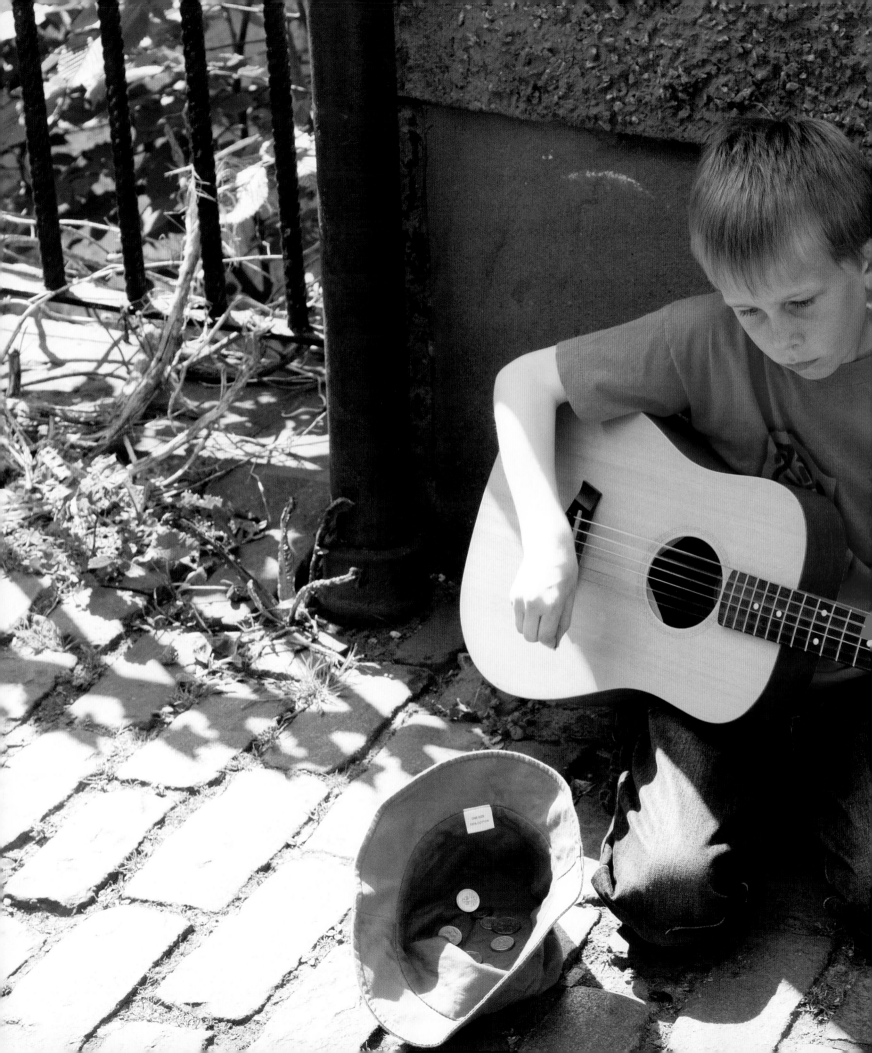

**Boy with Guitar,
11 June 2006**

While the West End Festival Parade was in progress, I happened upon a young boy playing a guitar near Byres Road. His mother was about five yards away at the corner of the lane watching him. I saw people putting money in the cap next to him on the ground and I put some in myself. I don't know if he was collecting the money for charity or what. I walked on a few yards and, when I turned back, they had vanished.

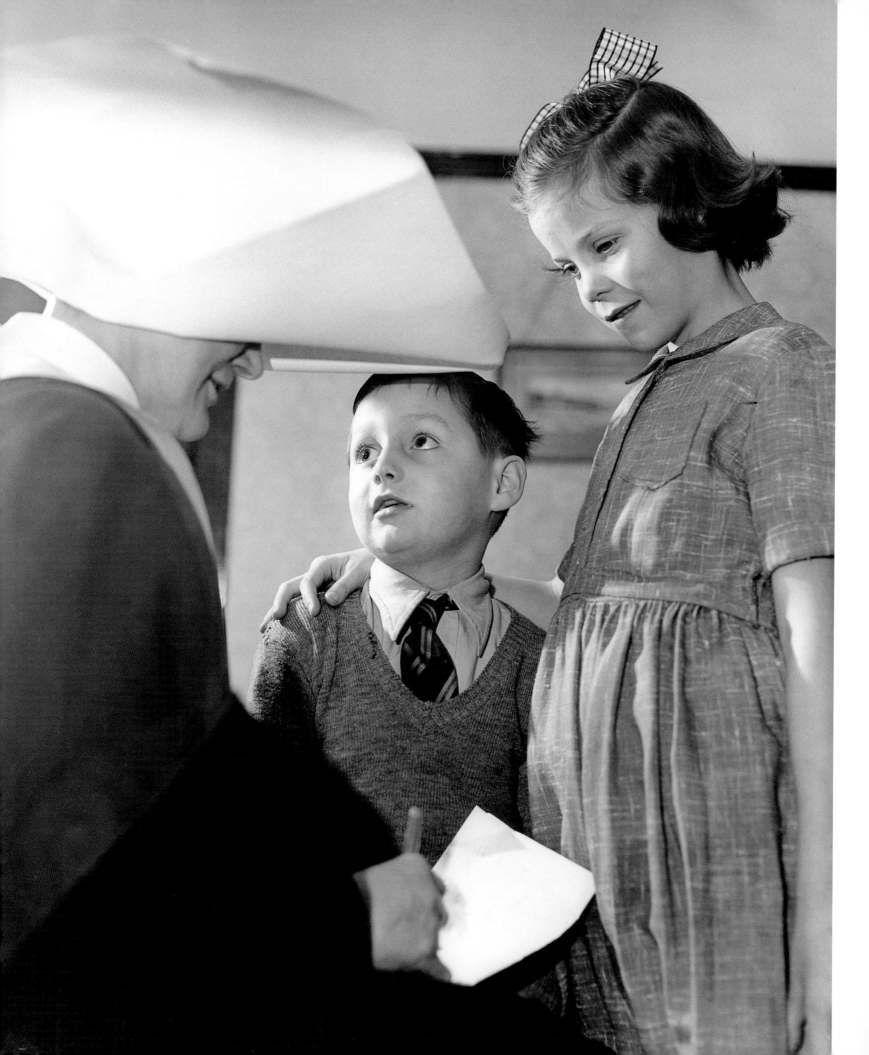

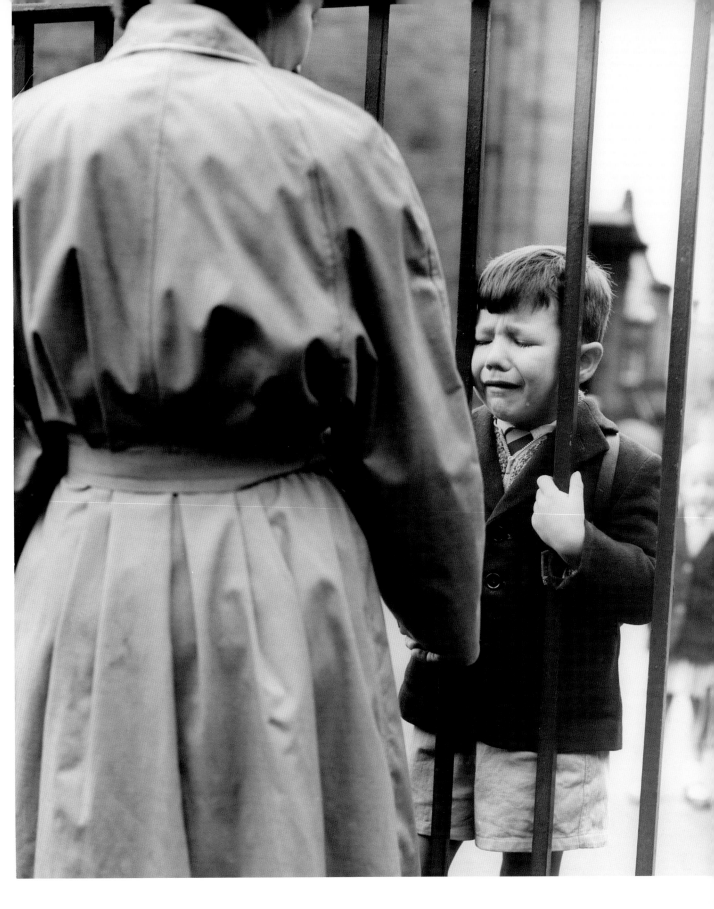

First Day of School, 1957
The first day at school is always an event. It was a bit traumatic for some of the children, who seemed terrified to leave their mothers for the first time. These two photographs were part of the portfolio that won me second place as Photographer of the Year in *Encyclopaedia Britannica* Photography Awards – the first person from Scotland to win this award. Soon afterwards, the *Sketch* asked me to go on staff and move to London.

Following page:
Lord Provost Susan Baird and Grandchildren, 1990
In her office at the City Chambers, the Lord Provost's charming grandchildren were having a great time.

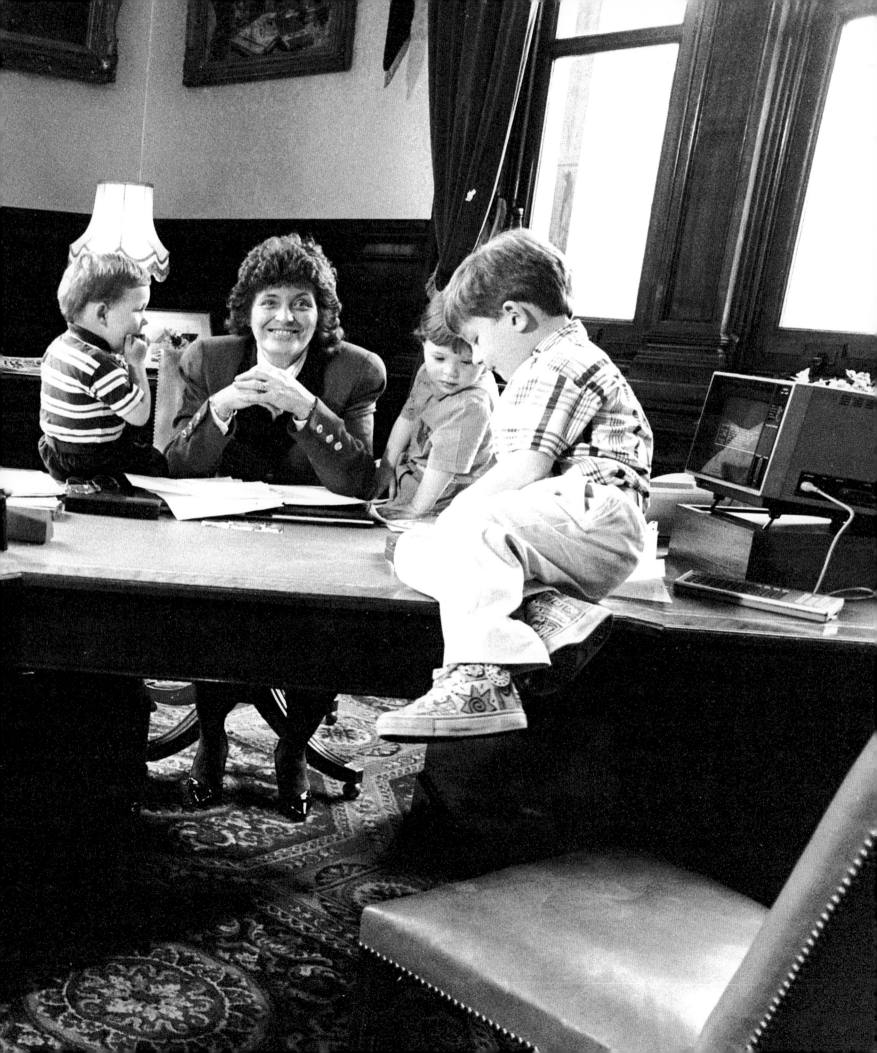

Bridget McConnell, August 2006

The Executive Director of Culture and Sport for the Glasgow City Council very graciously stood in the Kelvingrove Art Gallery and Museum's Life Gallery next to Sir Roger the elephant, one of the most popular exhibits in the museum. Earlier, when she sat on a Charles Rennie Mackintosh chair for another photo, one of the security staff who didn't recognise her hurried over to tell us very politely that no one was allowed to sit on the antiques. We all had a laugh when she introduced herself to the security person.

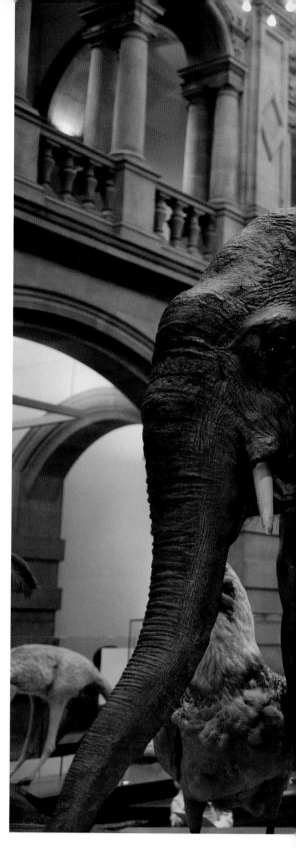

Kelvingrove Art Gallery and Museum, September 2006

Curator Jean Walsh stood in front of the magnificent painting by Salvador Dali *Christ of St John of the Cross*. I remember the controversy in 1952 when the painting was first purchased for something like £8,200. Its worth is now estimated in the millions. I hadn't seen it for a long time and remembered it as being much larger than it actually is.

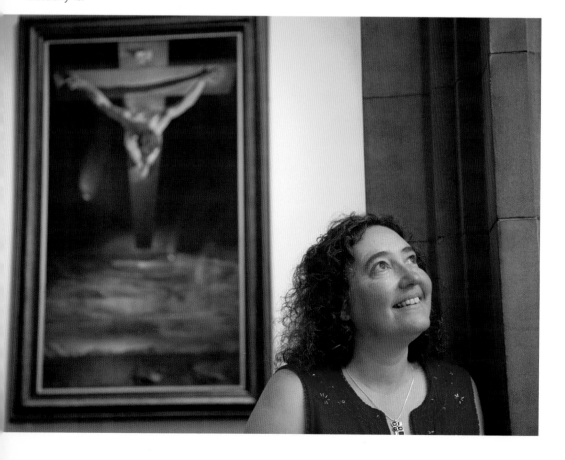

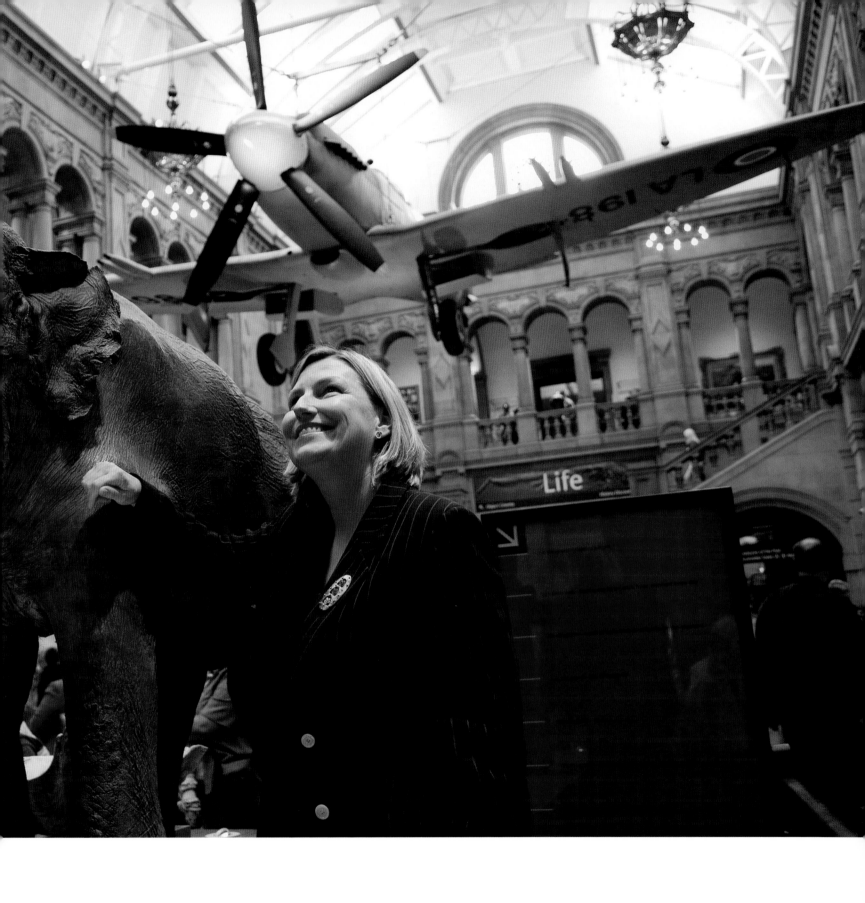

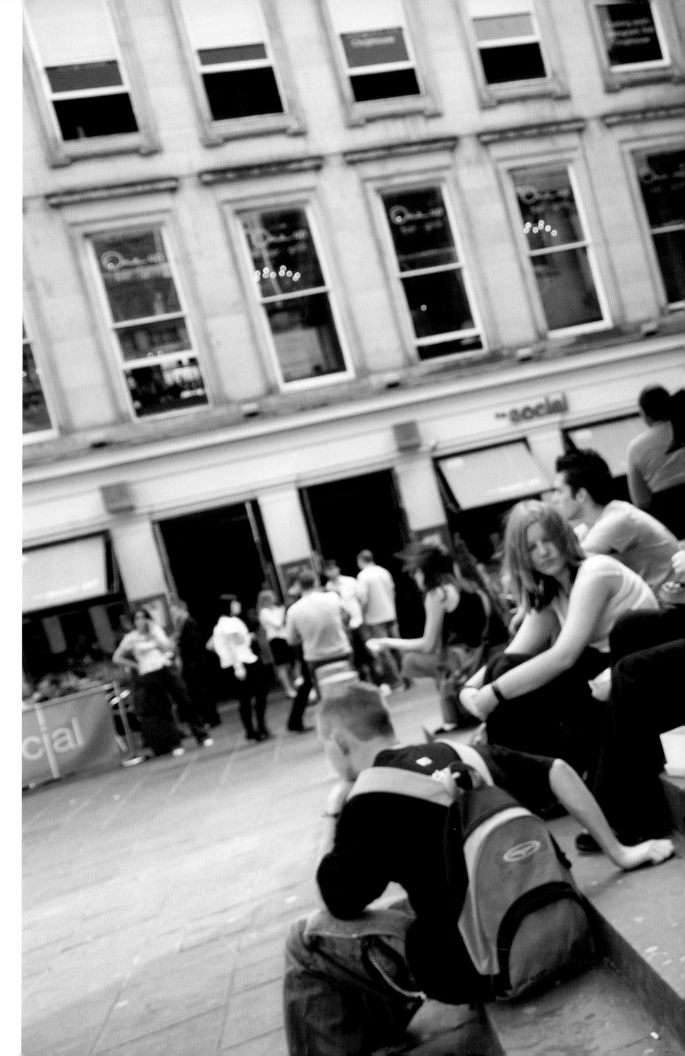

**Willie McIlvanney,
Exchange Square,
June 2006**

The brother of Hugh and
another old friend is the
well-known best-selling
author Willie McIlvanney.
He and I had just finished
a nice glass of Merlot in
the Rogano, my favourite
restaurant in Glasgow.
After the photograph, we
decided to go back and
have another glass.

Following page:
**Royal Exchange Square,
June 2006**

When photographing
Willie McIlvanney, I noticed
some young people
with interesting faces
sitting nearby.

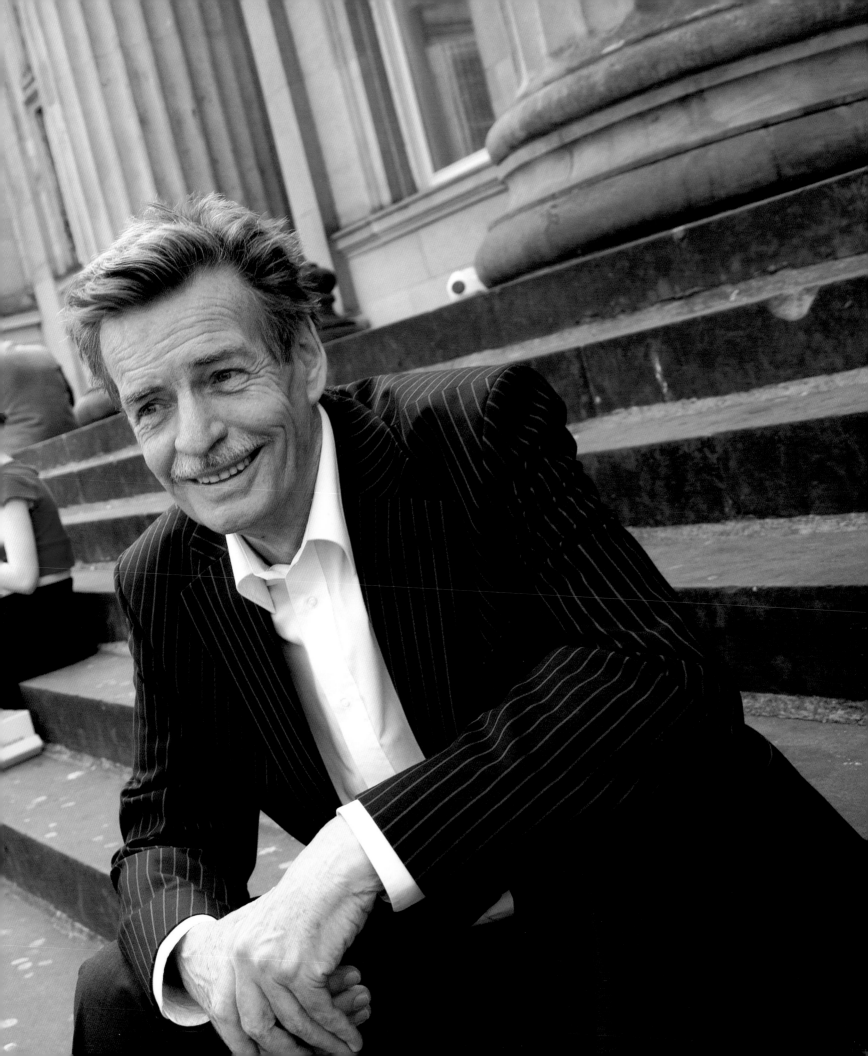

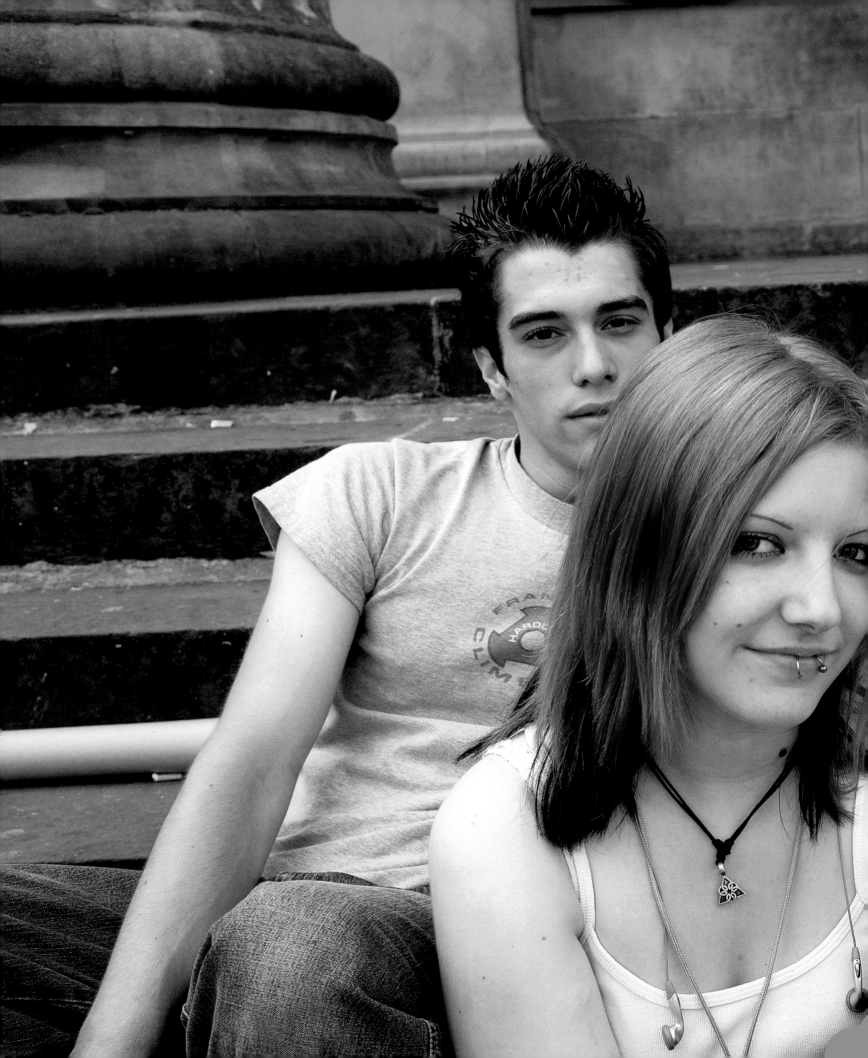

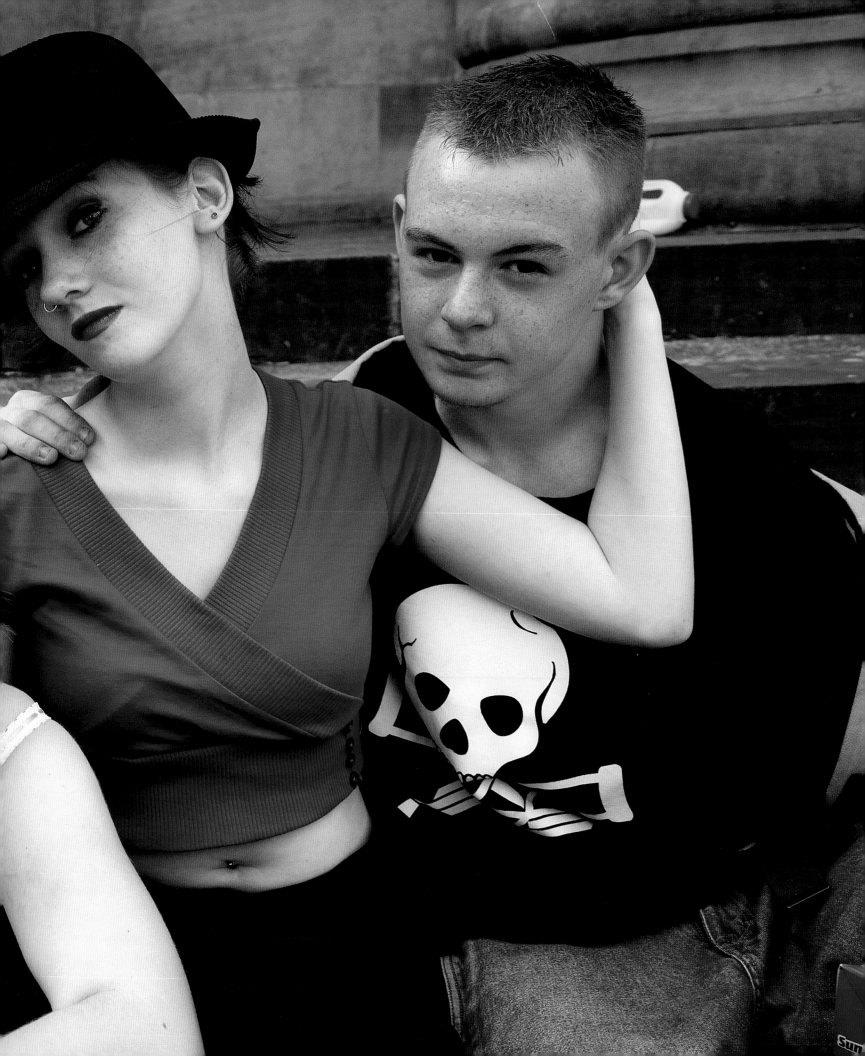

**Aisling Friel,
June 2006**

The lovely Miss Scotland
2005 posed on the
suspension bridge over
the Clyde, holding a replica
of her crown.

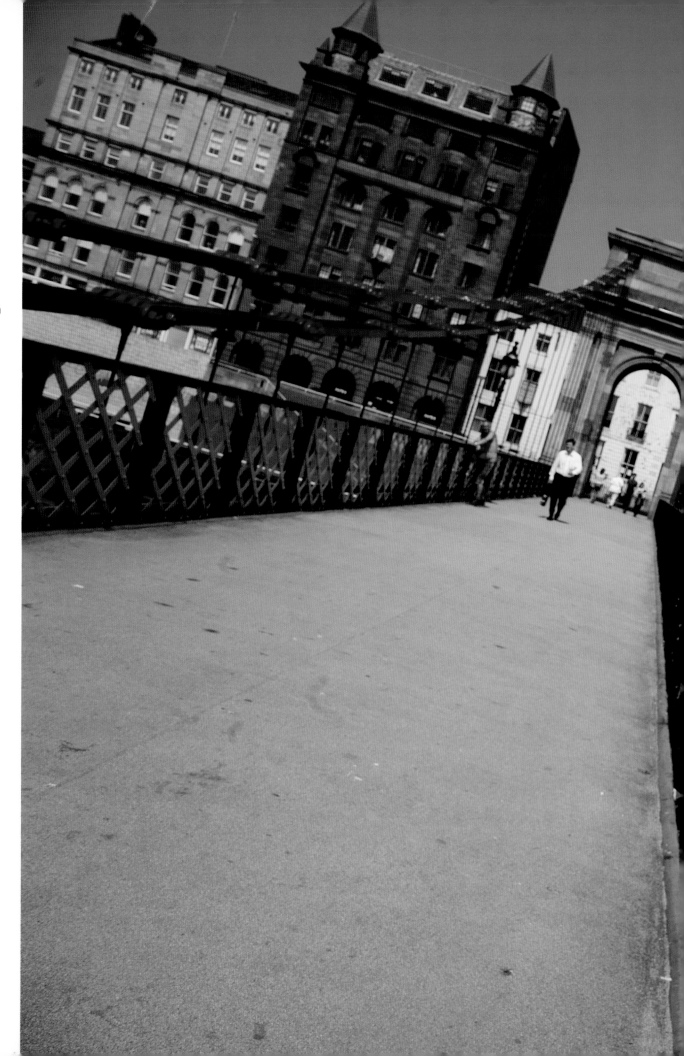

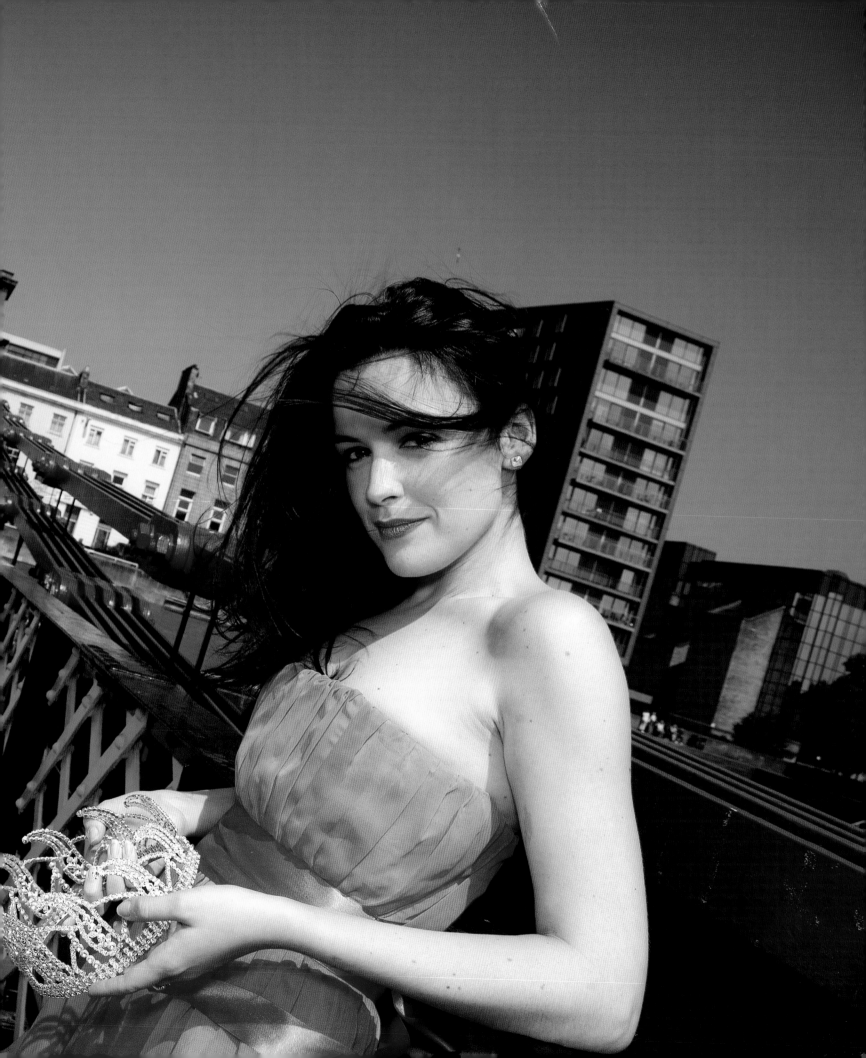

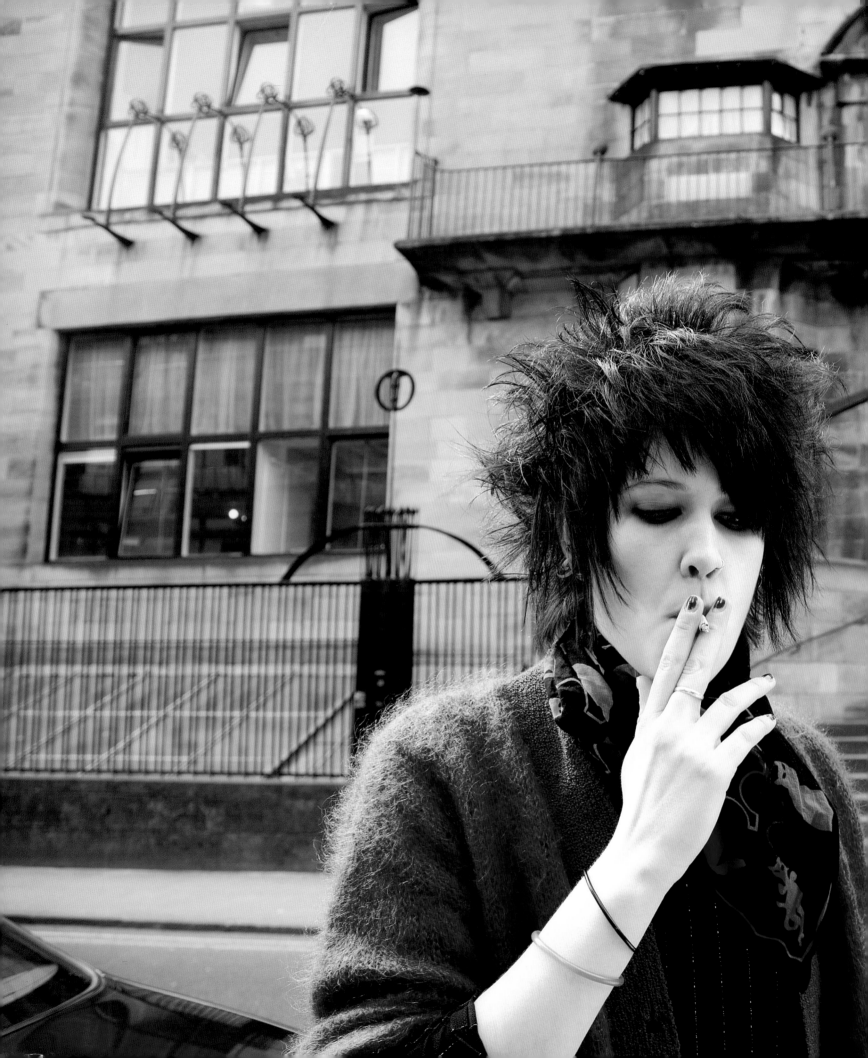

The Glasgow School of Art, April 2006

I noticed an interesting-looking student leaving the building and asked if she would mind having her photo taken. She pleasantly complied.

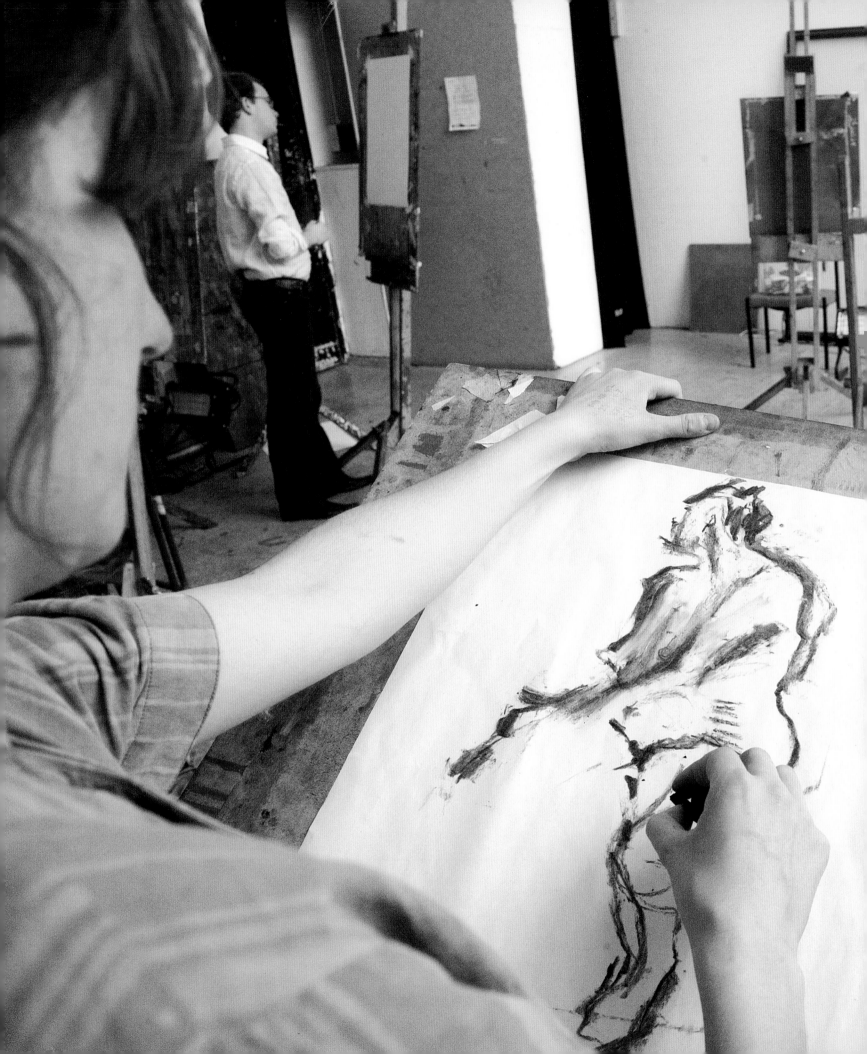

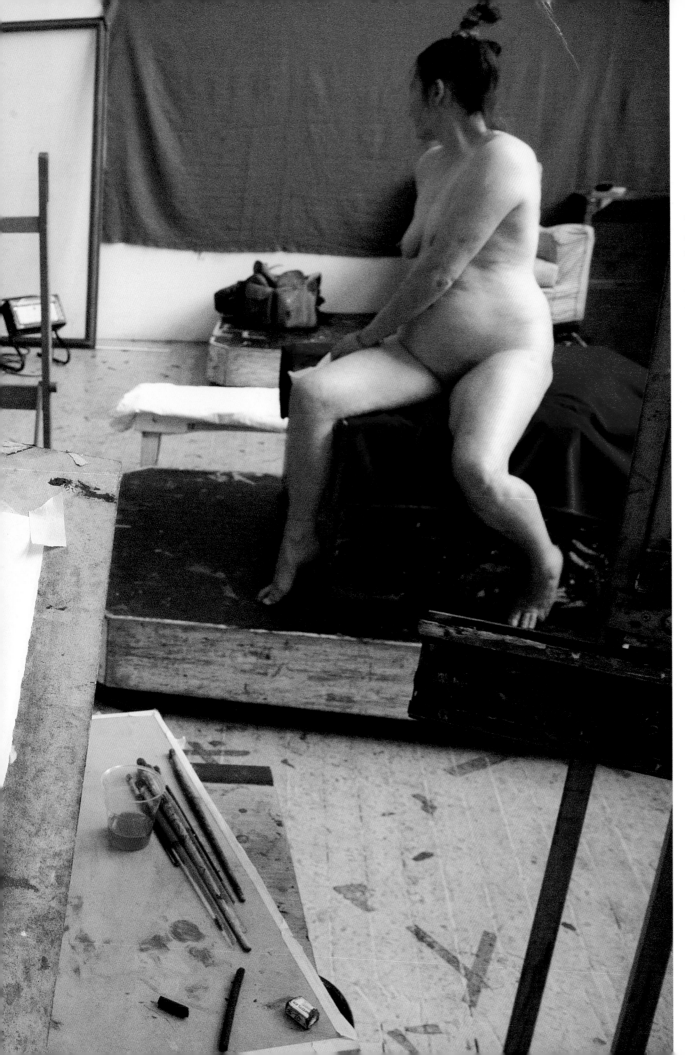

The Glasgow School of Art, April 2006

Visiting a life-drawing class brought back memories of my first introduction to a life-drawing class in that same room over fifty years ago when I had been left completely speechless.

Following page:
Prince Philip, Duke of Edinburgh, 1957

The *Daily Sketch* sent me from London to Edinburgh to photograph the Duke of Edinburgh being made Chancellor of Edinburgh University. The ceremony became a riotous affair with the students showing their appreciation by throwing toilet paper from the balcony. I always enjoyed assignments in Scotland for that meant a chance to visit Glasgow.

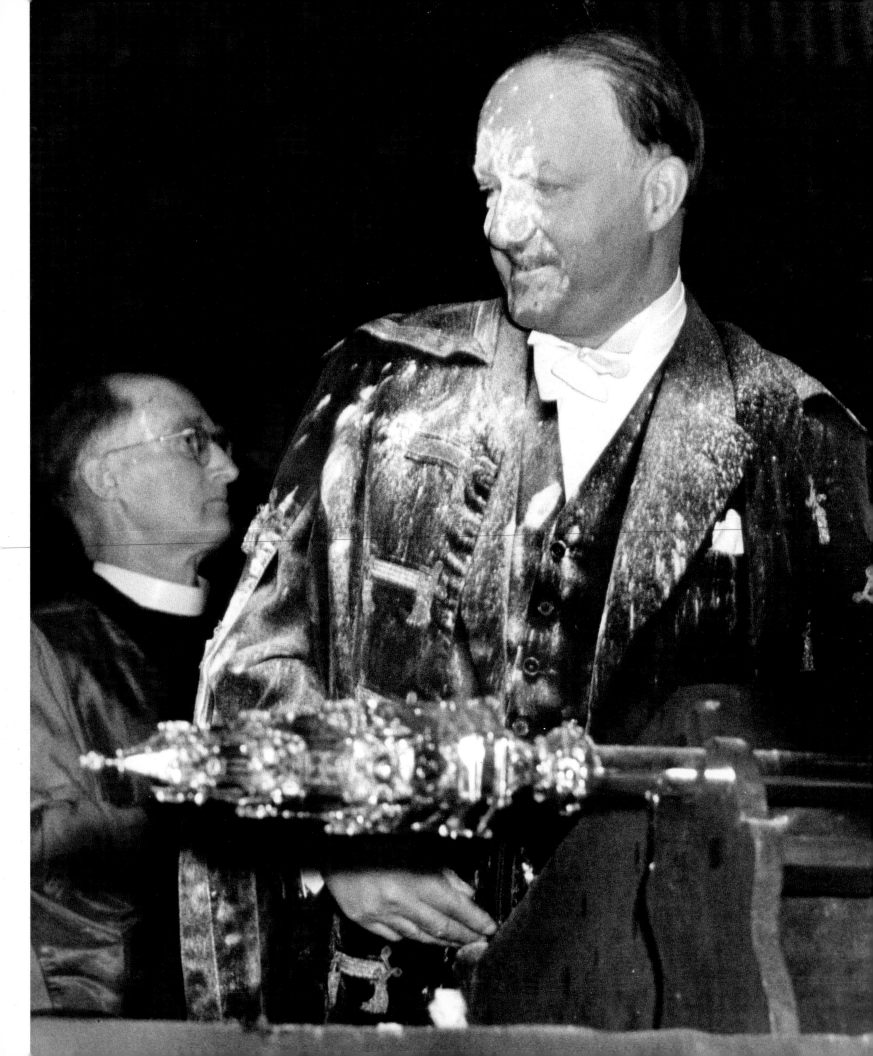

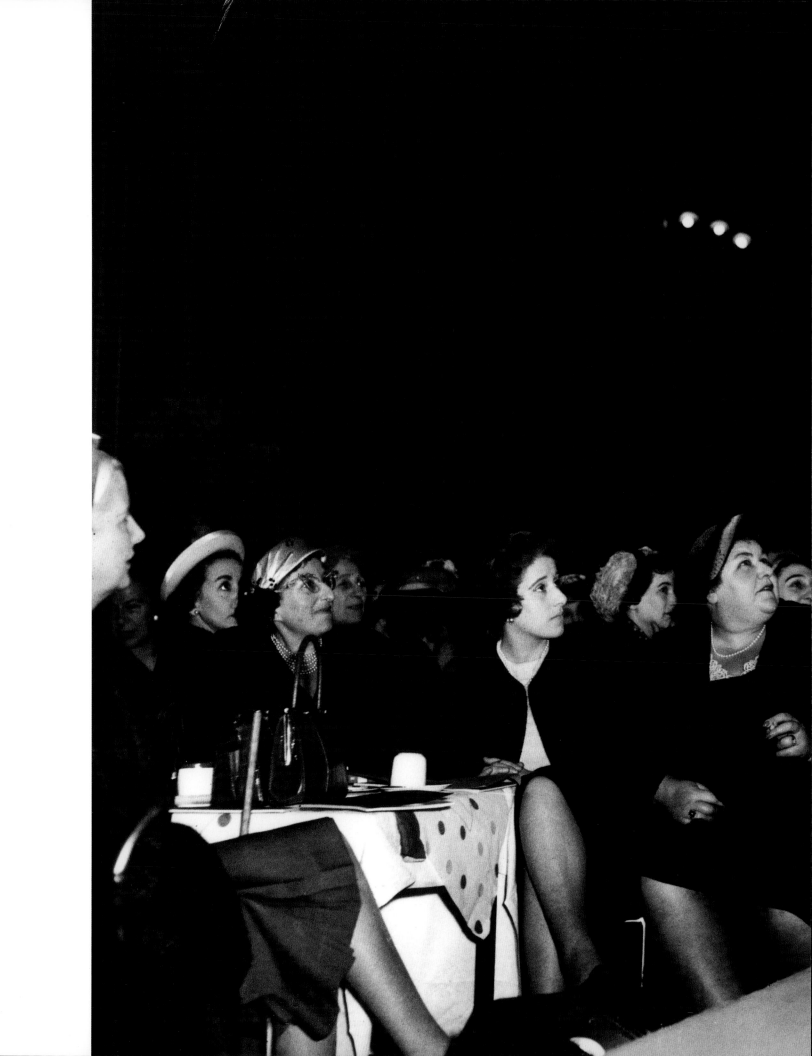

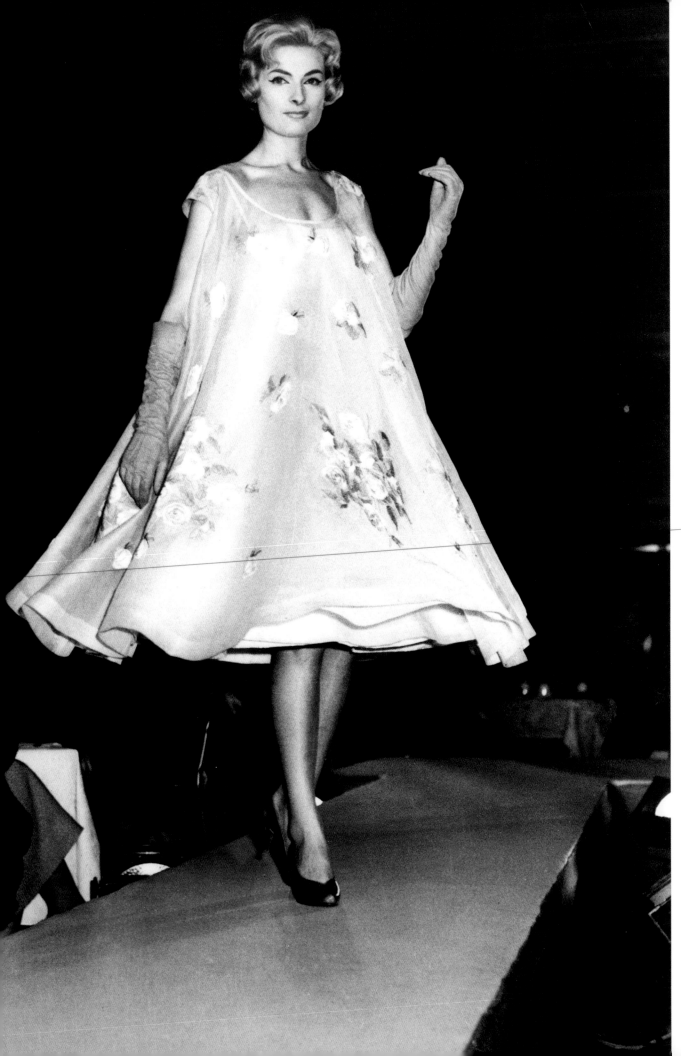

Daly's Department Store, Buchanan Street, 1957

Photography in Glasgow in the 50s was a lot of fun and very, very competitive. There were lots of good photographers around. This photograph for the *Daily Sketch* was taken when the Dior trapeze-line dress first appeared. The new style had caused a sensation all over Europe and America.

Previous page:
R. A. Butler, 1957

The Home Secretary was speaking to Glasgow University students when they started pelting him with flour. The front-page headline of the *Daily Sketch* read something like 'Undergrads – Under Louts'. This was the day after the ceremony for the Duke of Edinburgh and it meant I had photographs of national importance in the paper two days in a row which really pleased me. These were two of the pictures from my magazine-photographer-of-the-year portfolio. I was so proud and felt then that I could finally make it. Not only had I never won anything before, it was the first time anyone from Scotland had ever won second place in the competition.

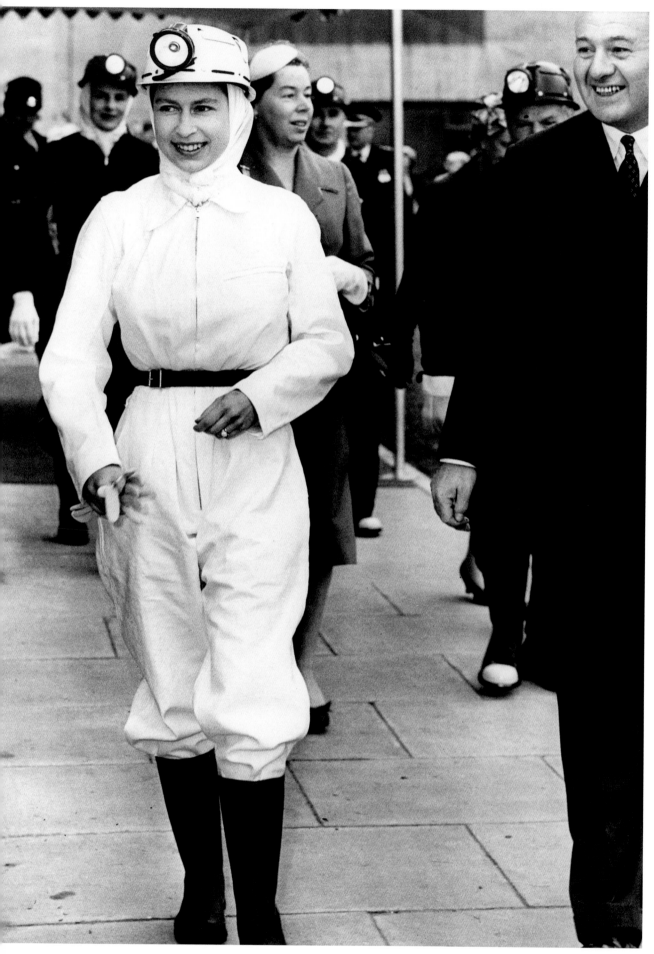

HRH Queen Elizabeth II, 1957

The Queen had come to Scotland on an official visit to open a coal mine and she dressed for the occasion. It was one of the first times I had photographed her and, to this day, I have never seen her looking better.

Princess Diana, June 1992

On an official visit to Glasgow, the Princess visited Erskine Hospital, where soldiers who had been injured during the wars were treated. I was standing outside the hospital with a group of photographers when one said to me, 'Save your film. Don't bother taking pictures until she gets to that little girl. I guarantee she'll kneel down and we'll get a picture.' And that's just what happened.

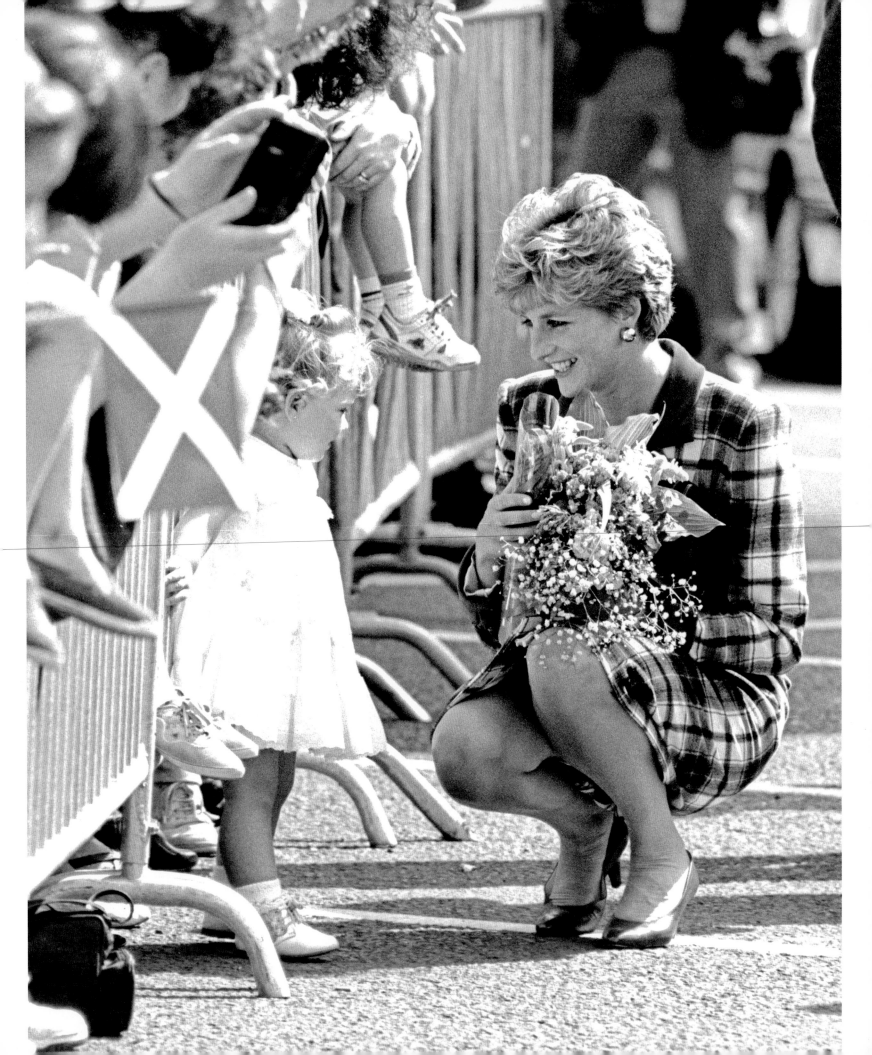

**Kelvingrove Park,
April 2006**
I liked the way the bicycle riders seemed dwarfed by the expanse of the cement bowl in this photograph.

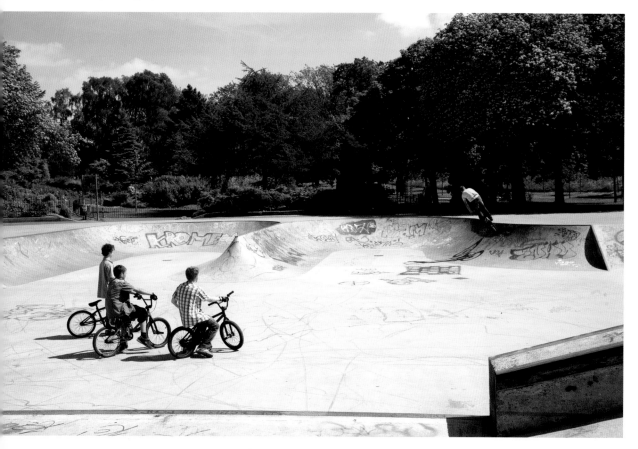

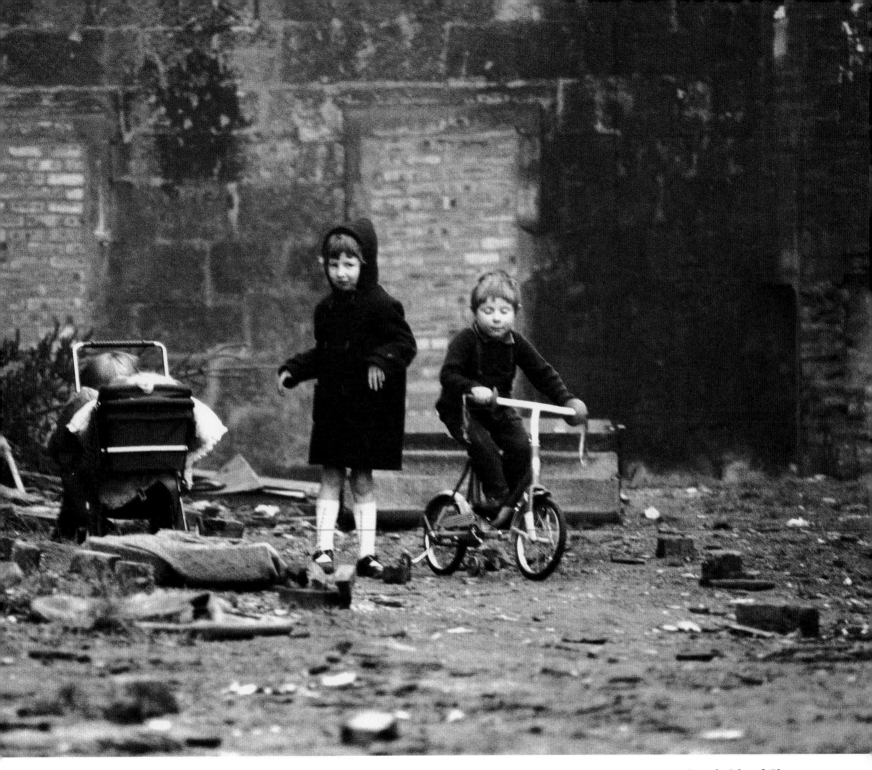

Southside of Glasgow, November 1971

In contrast to Kelvingrove Park, these children were riding a bicycle and playing in the rubble in the southside as there was no park nearby and they had nowhere else to play.

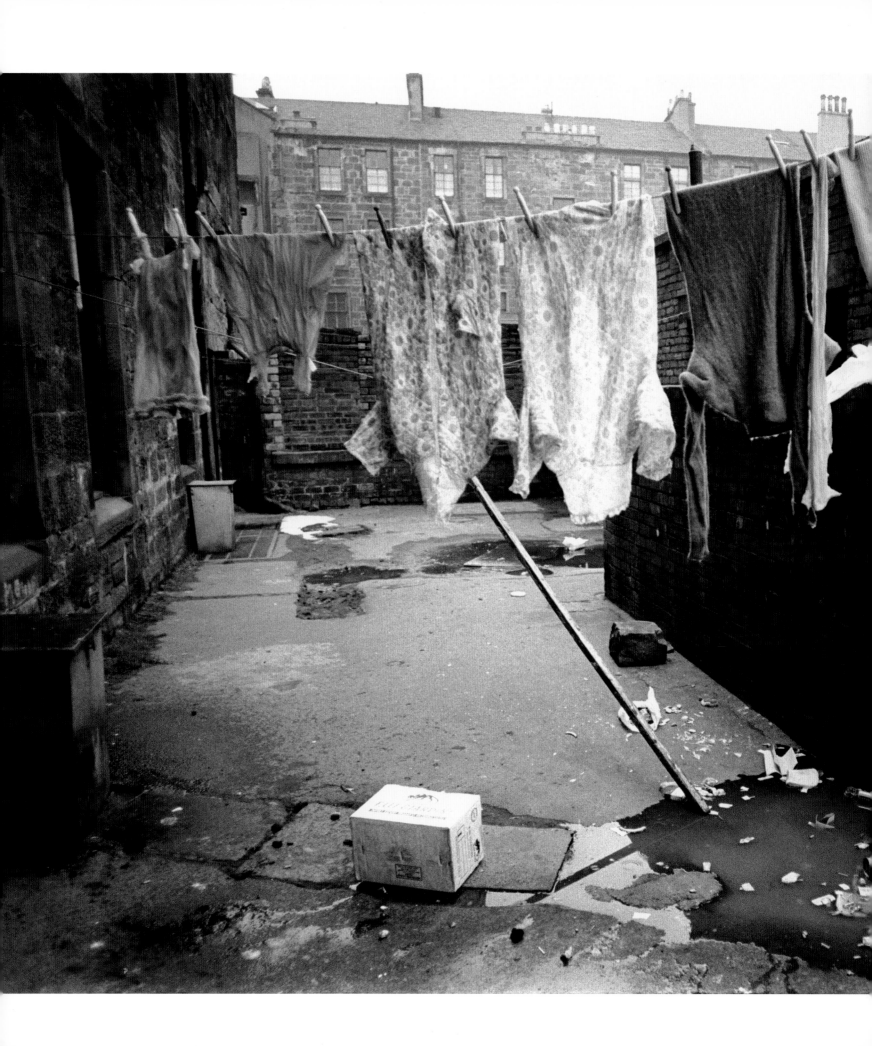

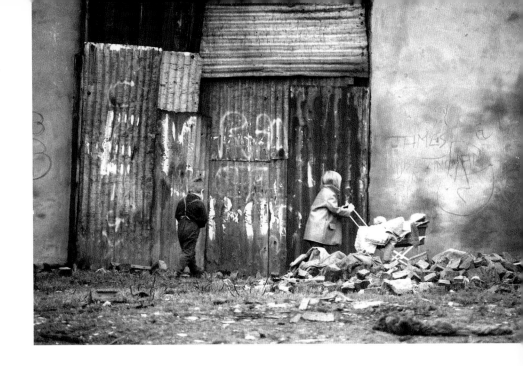

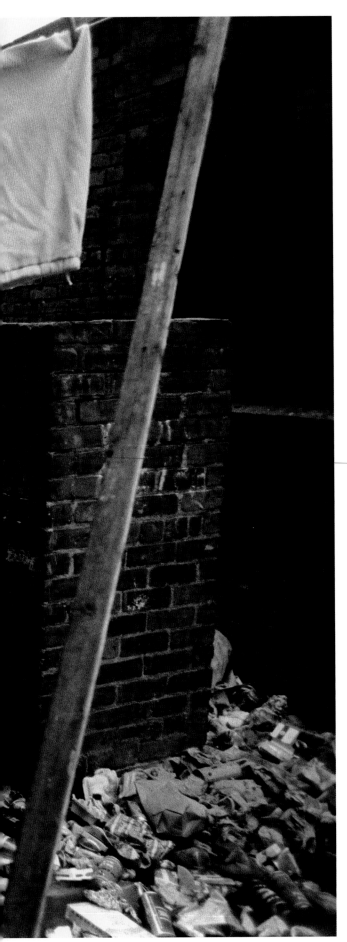

Southside of Glasgow, November 1971

Children were happily playing outside, seemingly unaware of the rubble, while washing hung limply on the line nearby, above a pile of rubbish.

Following page:
Southside of Glasgow, November 1971

The graffiti on the wall reads 'Let Glasgow Flourish in Filth and Slums' and was a rewording of the well known Glasgow coat-of-arms inscription 'Let Glasgow Flourish'.

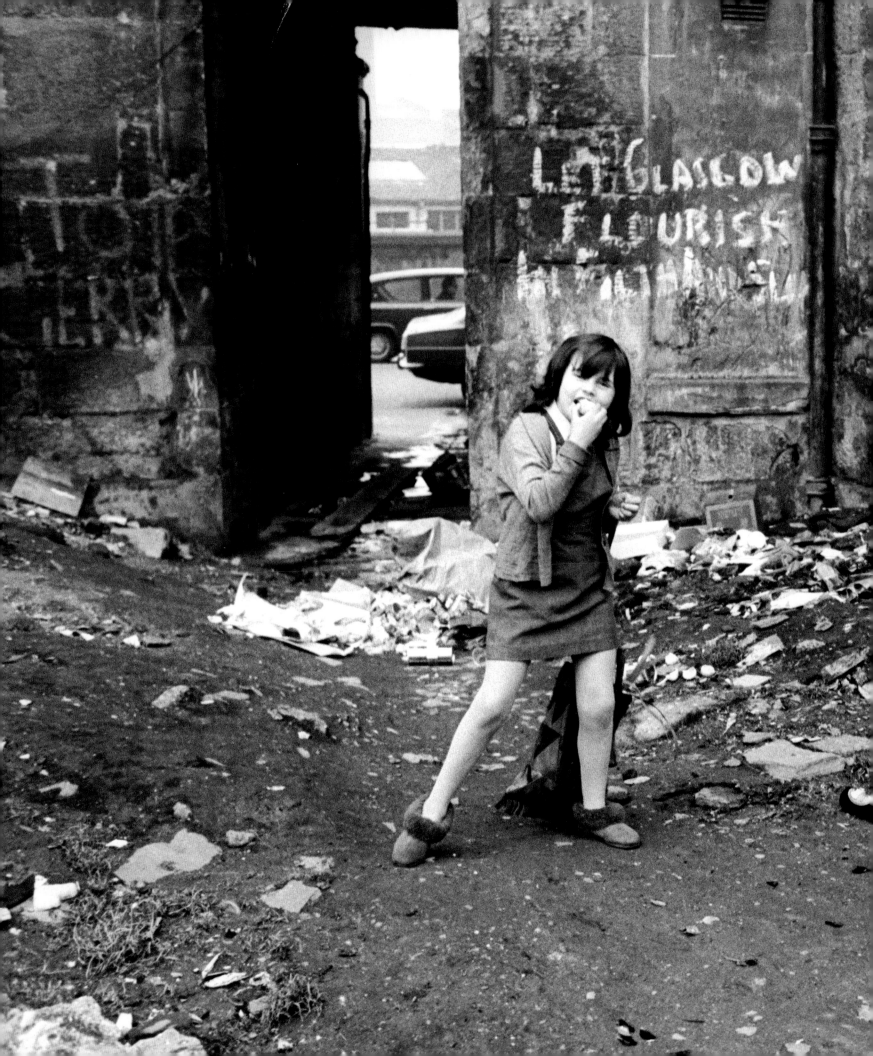

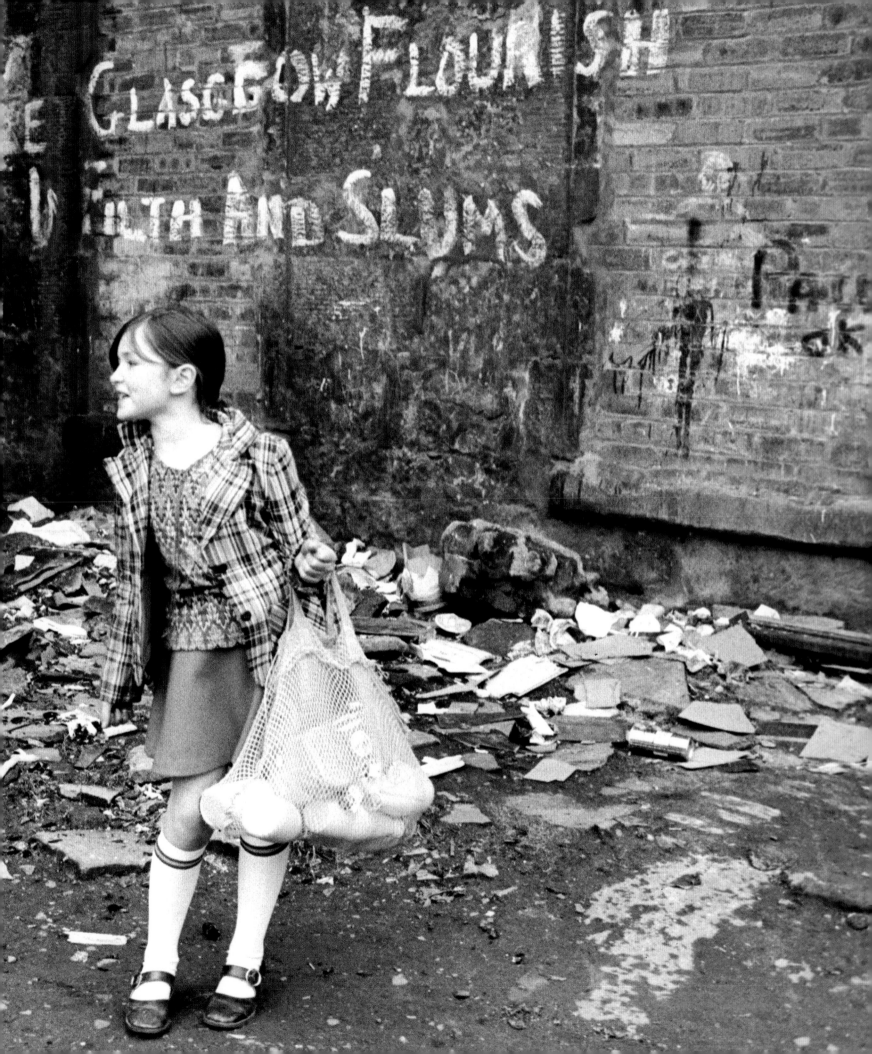

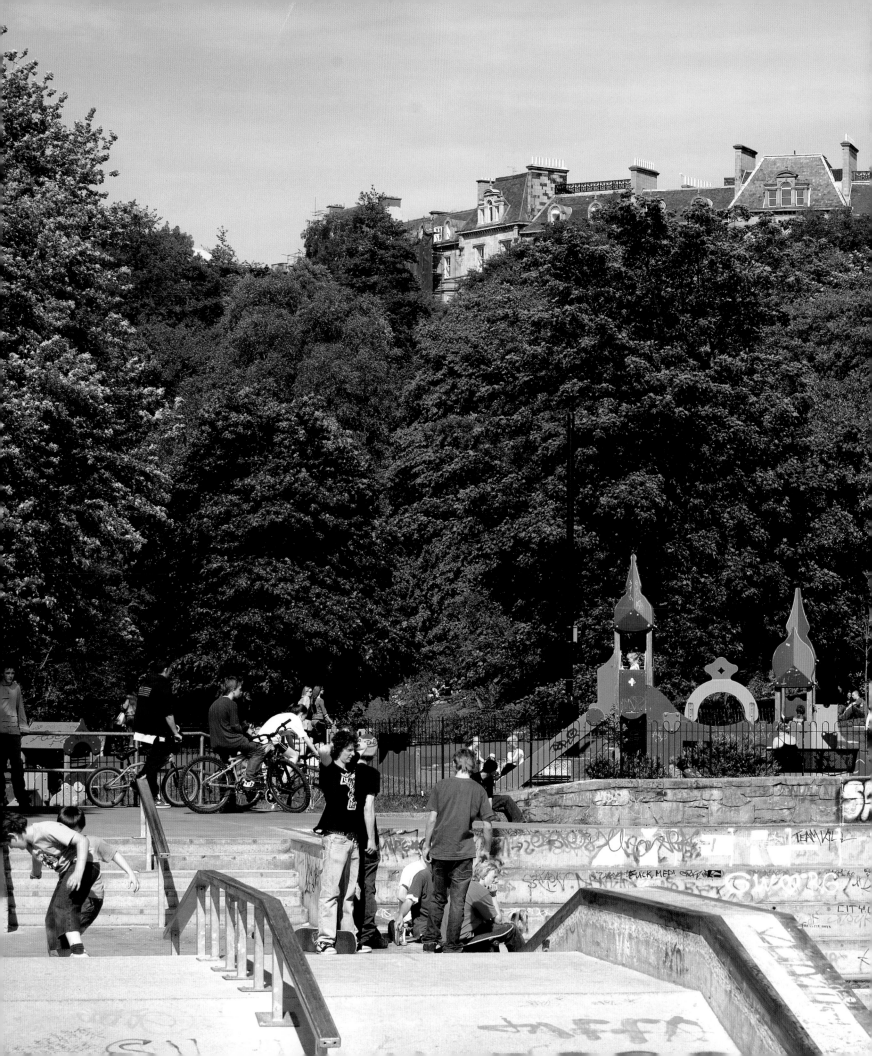

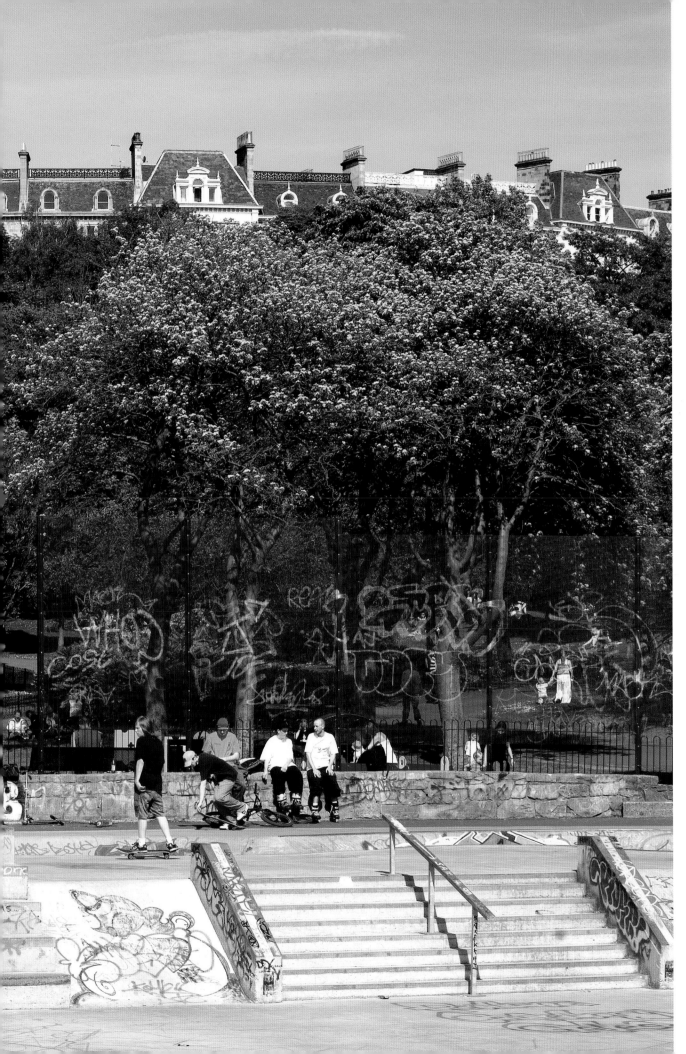

Kelvingrove Park Children's Playground, April 2006

In the background on the hill, you can see the famous Queen's Crescent, which is considered one of the finest examples of residential architecture in Britain.

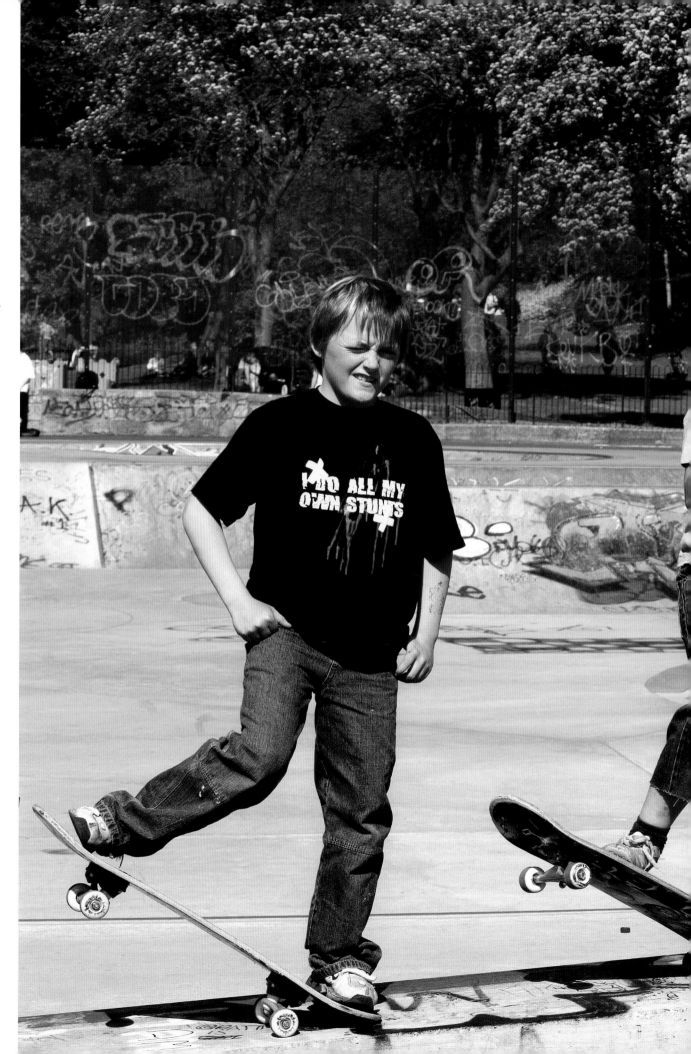

**Kelvingrove Park,
April 2006**

Four young boys with their
skateboards were having a
good time in Kelvingrove
Skate Park near Kelvingrove
Art Gallery.

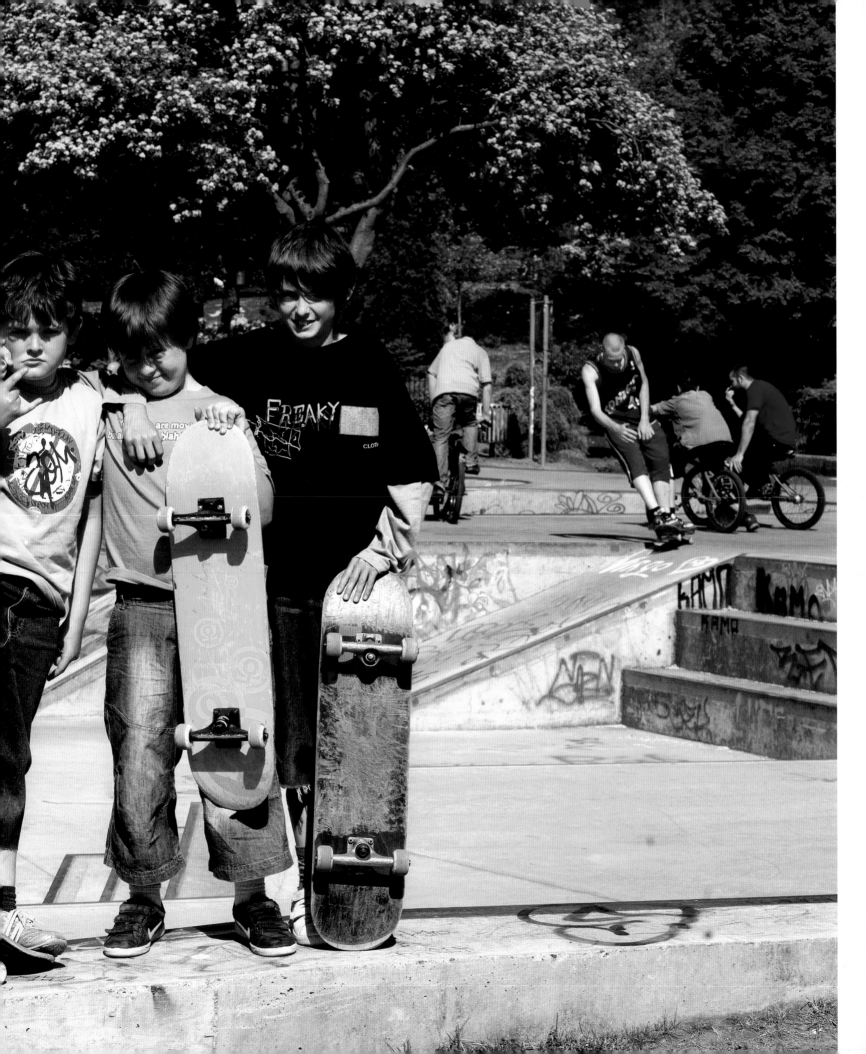

Southside of Glasgow, November 1971

Walking around the buildings on the southside, I happened upon a pretty girl standing outside smoking. I asked if I could take her photograph and she obliged.

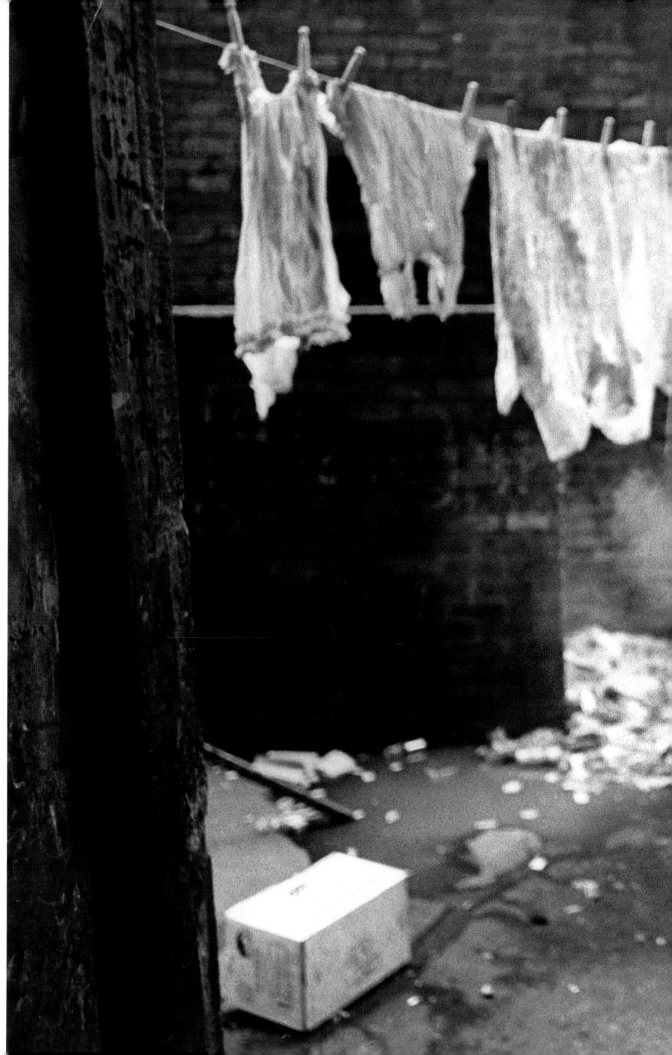

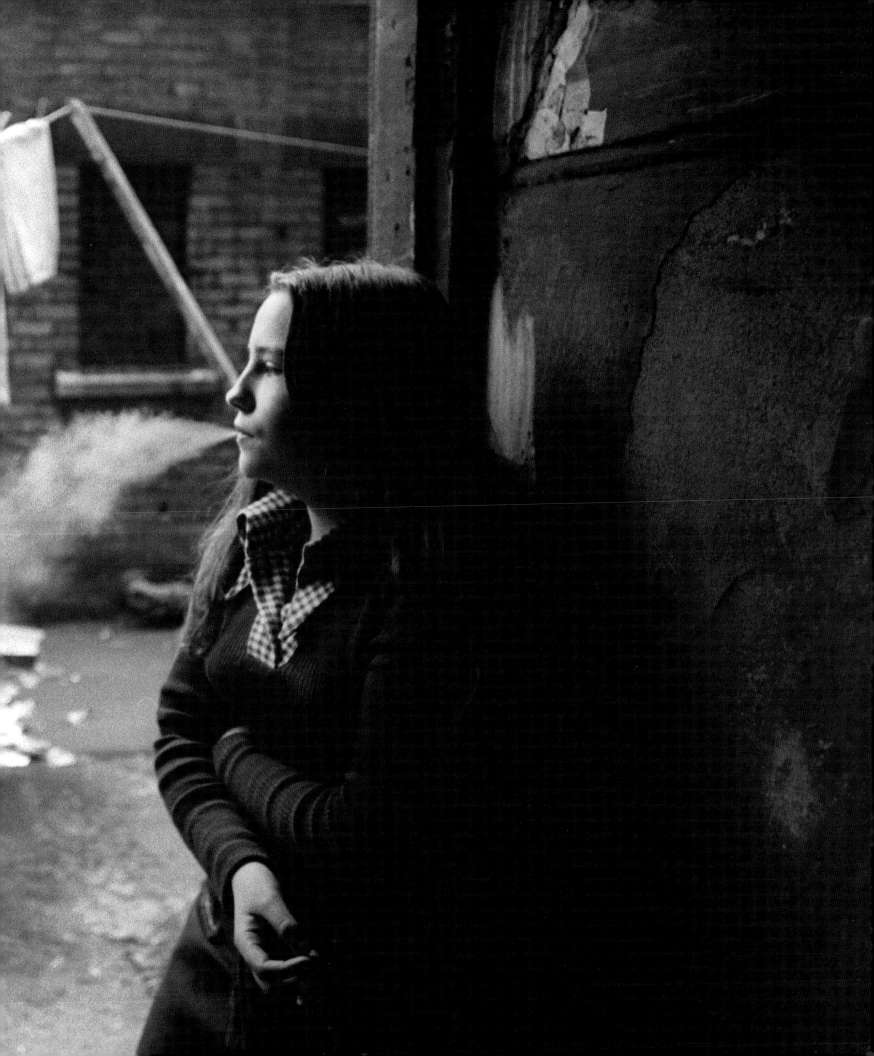

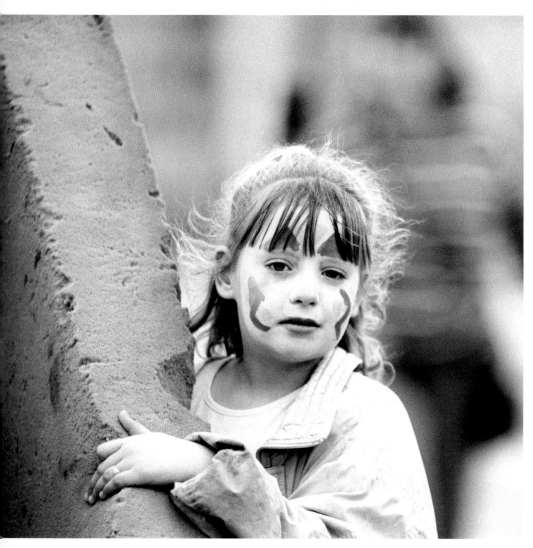

Young Girl with Painted Face, 11 June 1990

Everyone comes out for the fun at the annual West End Festival Parade. The young girl had just had her face painted and seemed pleased with the result.

Sheena Easton, New York, 18 March 1981

The Bellshill-born Grammy award-winning singer/actress was in New York to promote her new album *Sheena Easton* which rose to number twenty-four in the US charts. She wanted to see New York and I suggested a ride on the Staten Island Ferry which she appeared to enjoy.

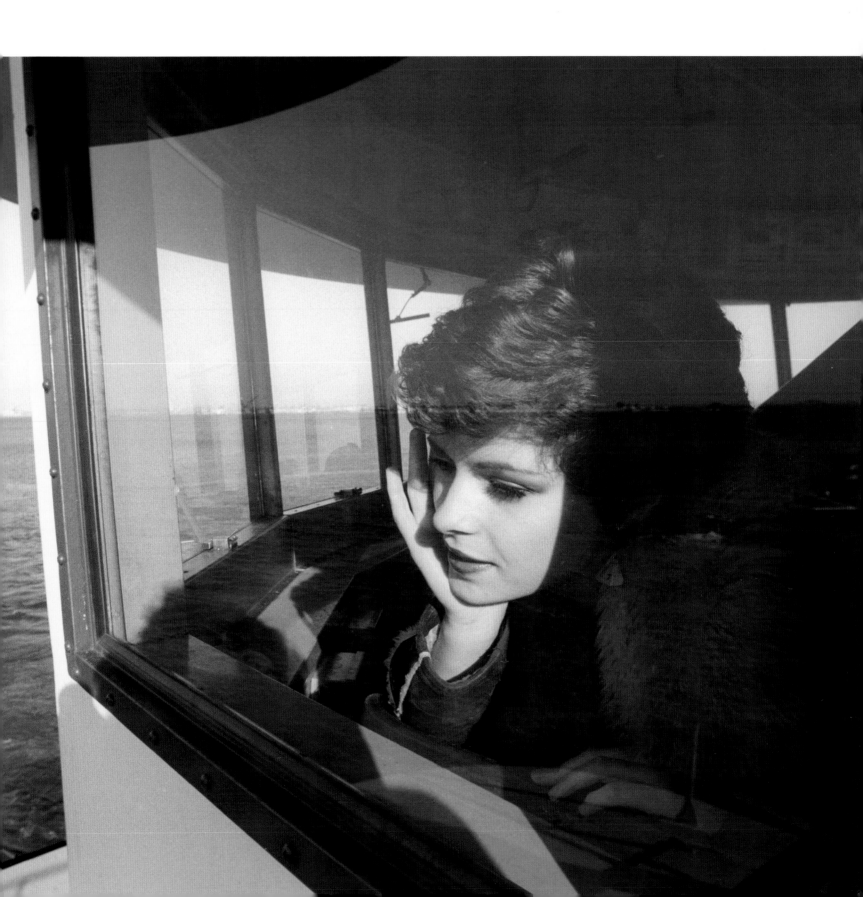

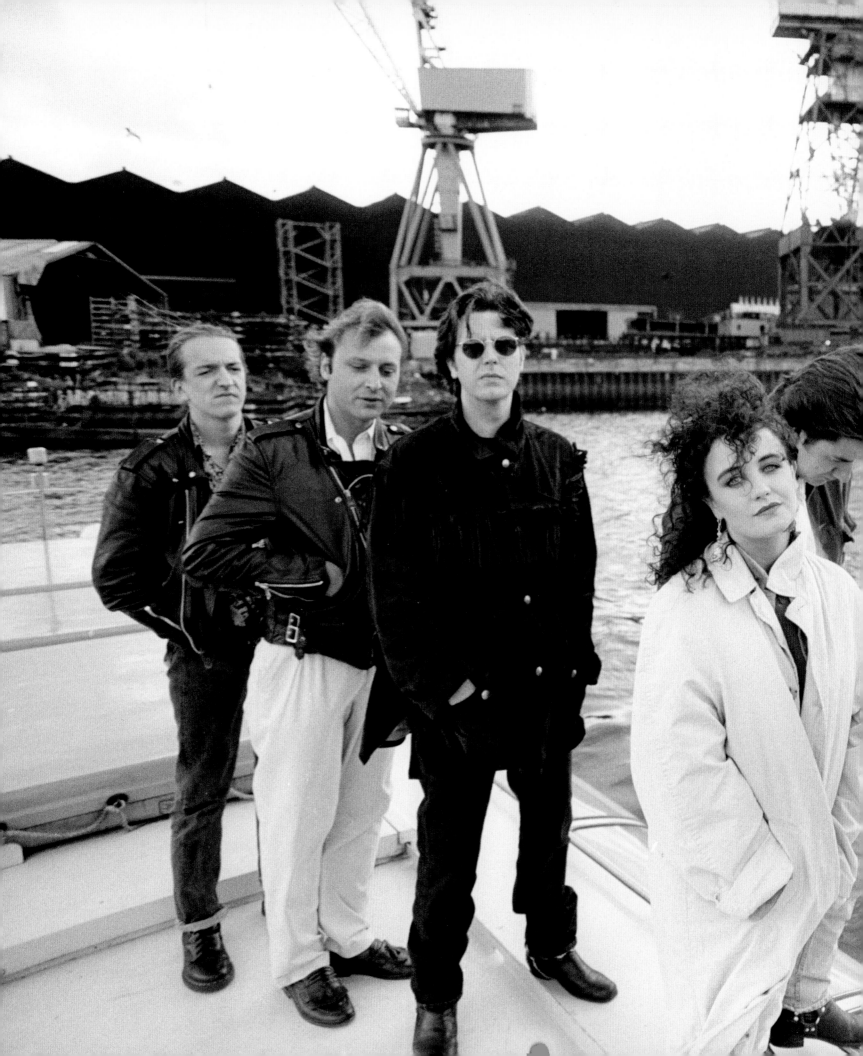

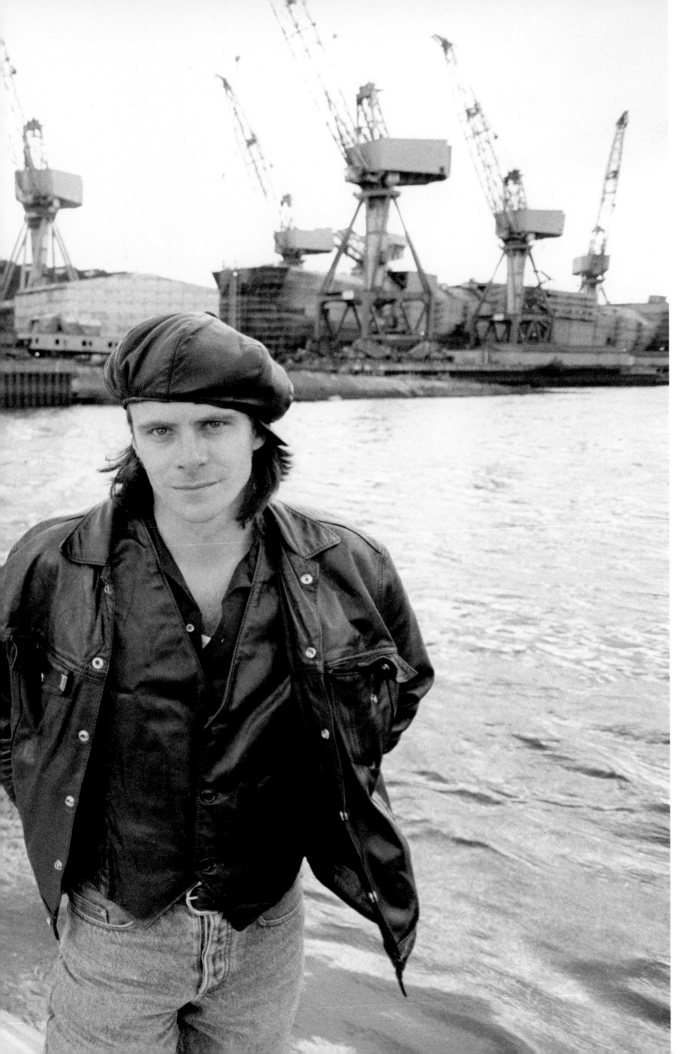

Deacon Blue, 1990
Ricky Ross, Lorraine McIntosh, James Prime, Dougie Vipond, Ewan Vernal and Graeme Kelling, members of the popular top-selling UK band of the 80s and early 90s posed on a barge on the River Clyde.

Eddi Reader, 1990

The popular singer, well known for her work with Fairground Attraction, whose first album, *The First of a Million Kisses*, won best album at the 1989 Brits, began her career busking in Sauchiehall Street. Awarded an MBE in the 2006 New Year's Honours List, her albums include *Sings the Songs of Robert Burns* (2003) and her eighth solo album *Peacetime* (2007). She had recently had a son, Charlie, when this photograph was taken on the suspension bridge over the River Clyde.

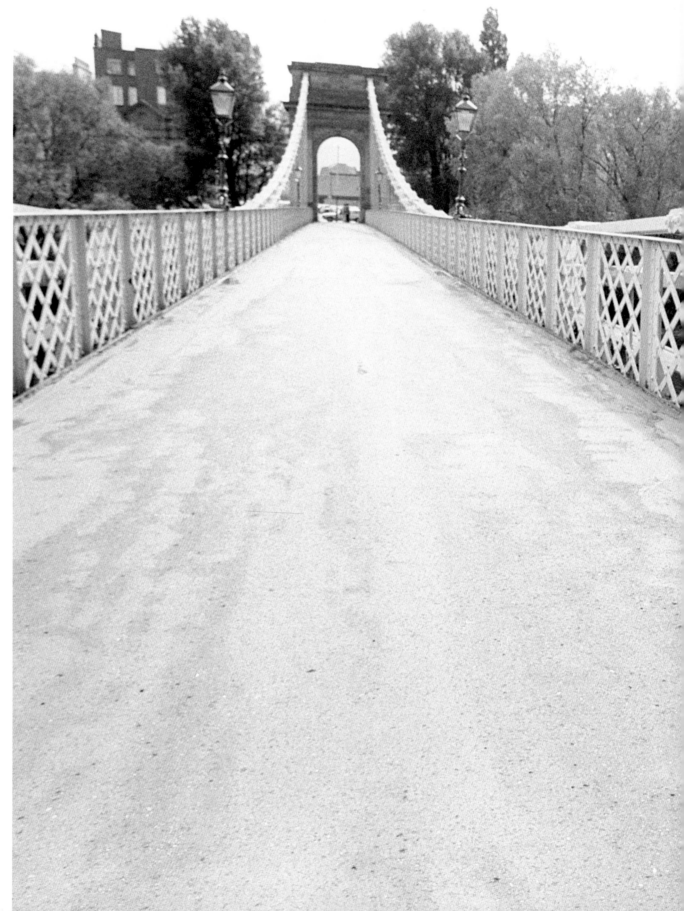

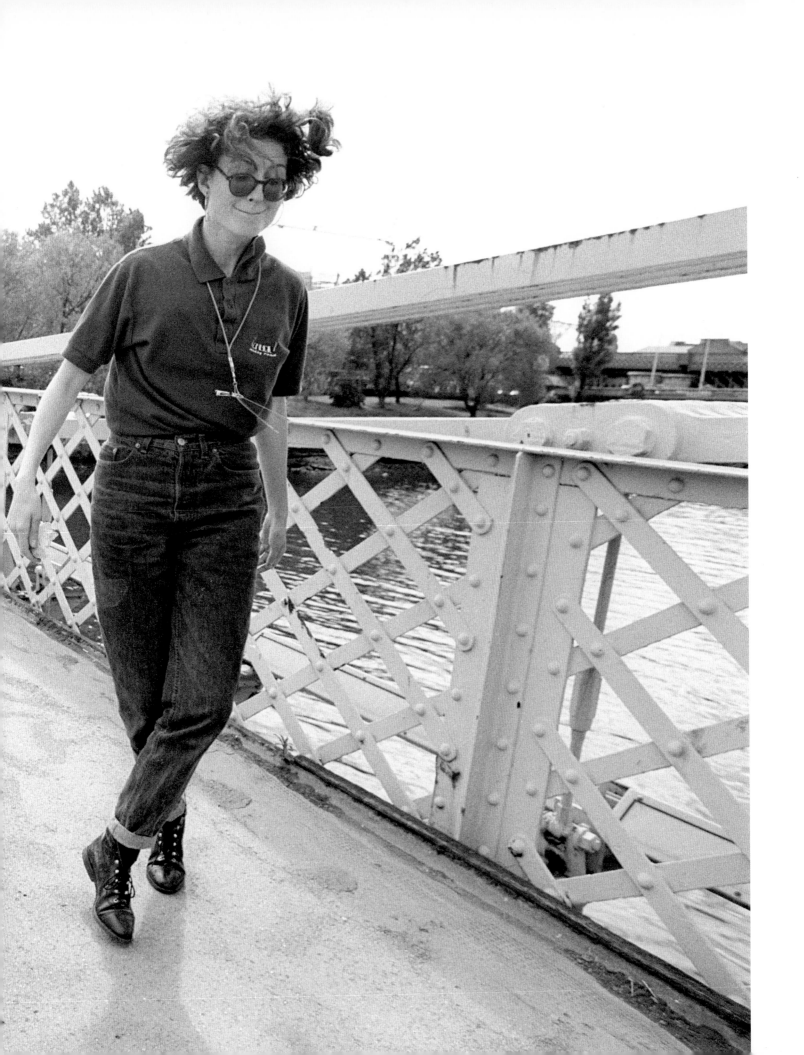

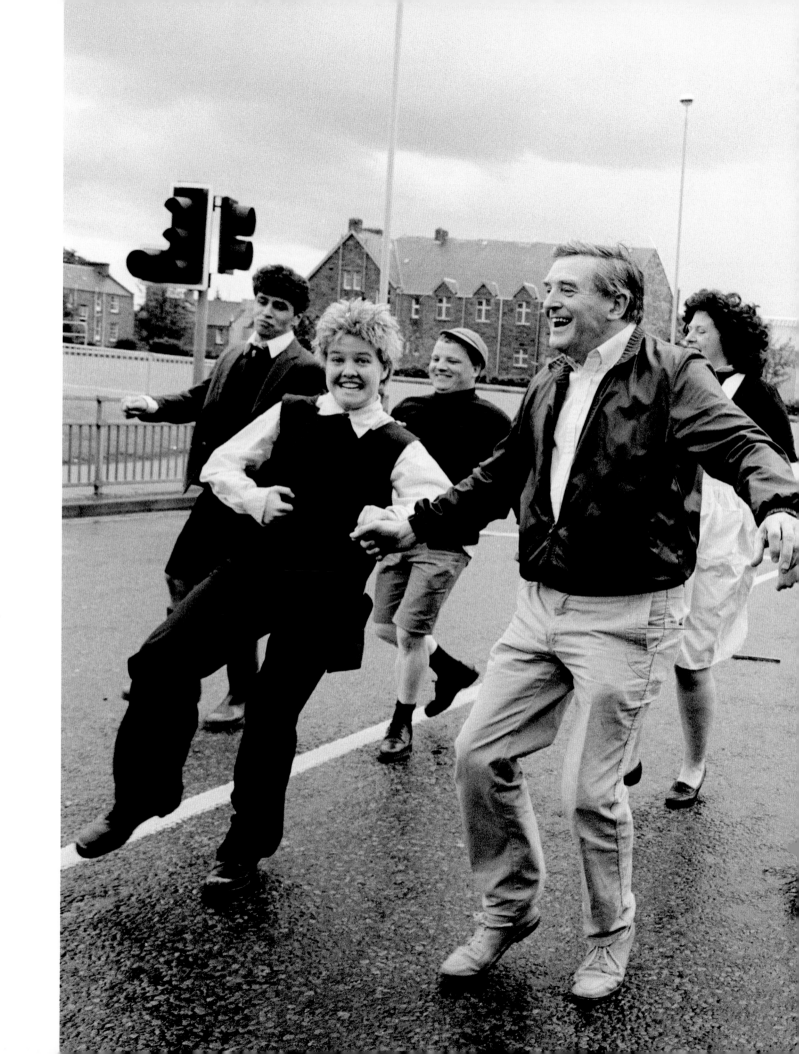

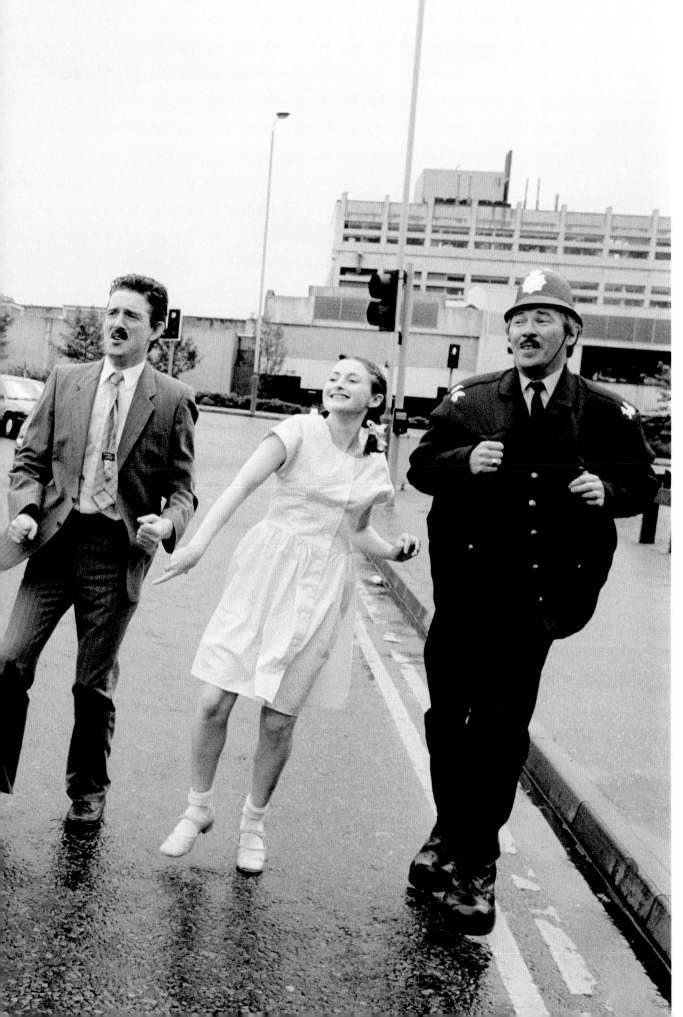

Jimmy Logan, 1990
The Glasgow comedian and pantomime star was as energetic as ever, running through the street with a troupe of actors he was directing in a play about the *Sunday Post* character Oor Wullie.

**Ballet Students,
April 2006**

The graceful students were focused and diligent during the Junior Associates class at the Scottish Ballet under the tutelage of Penny Withers.

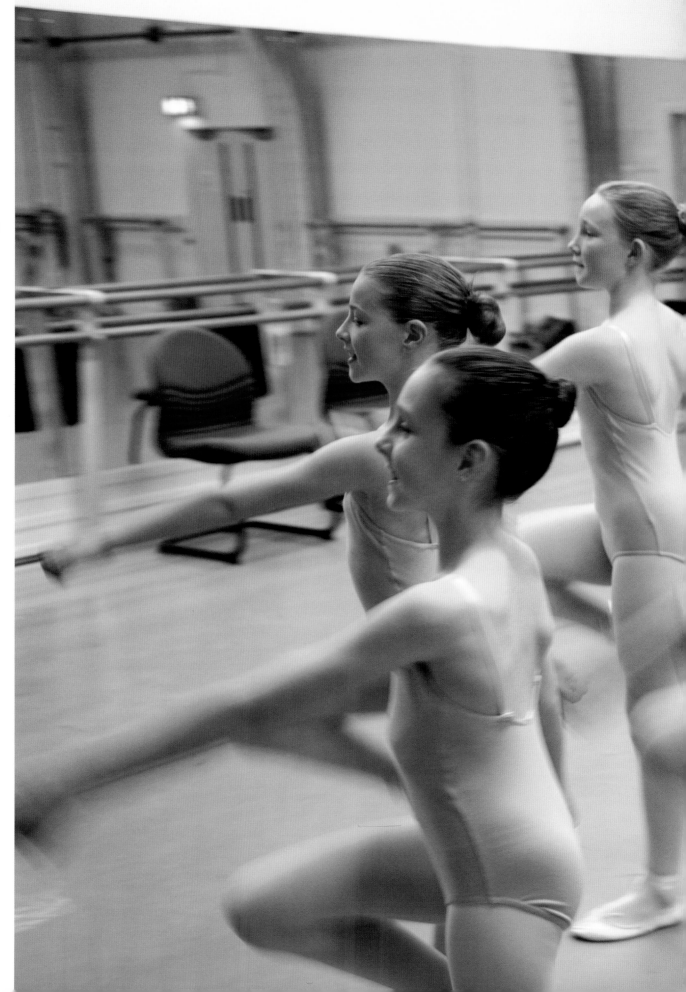

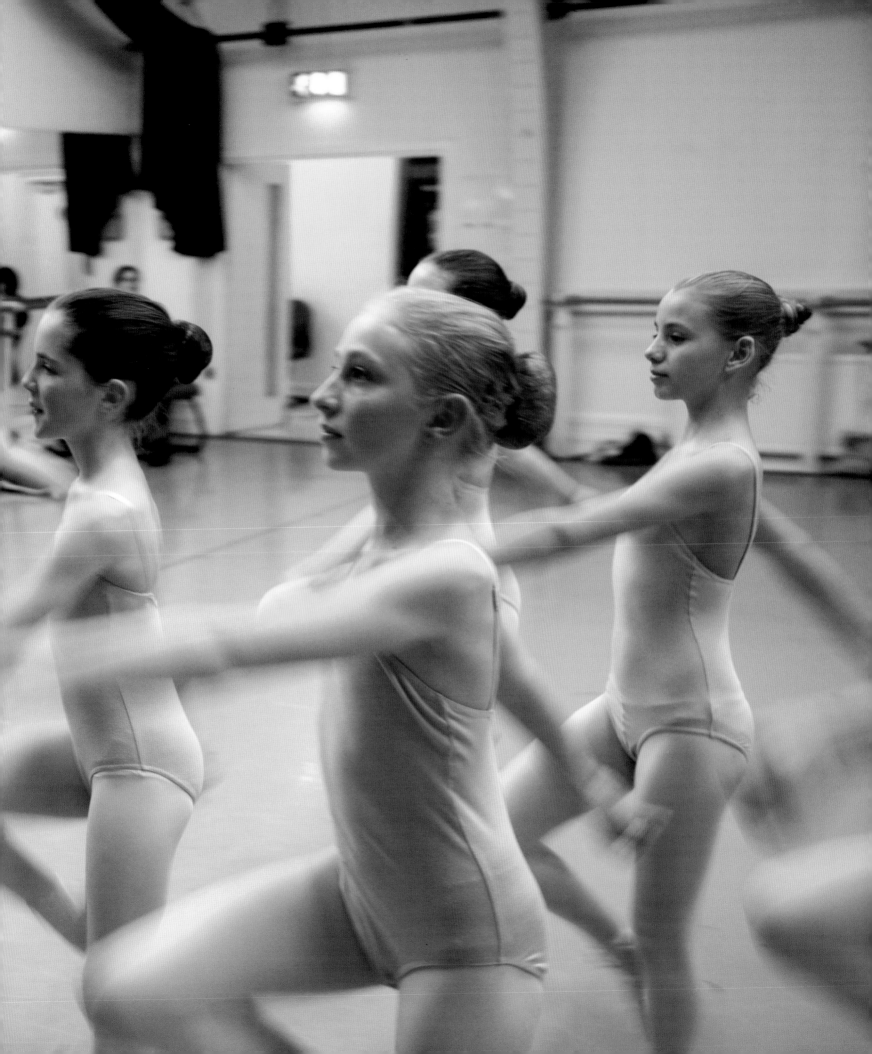

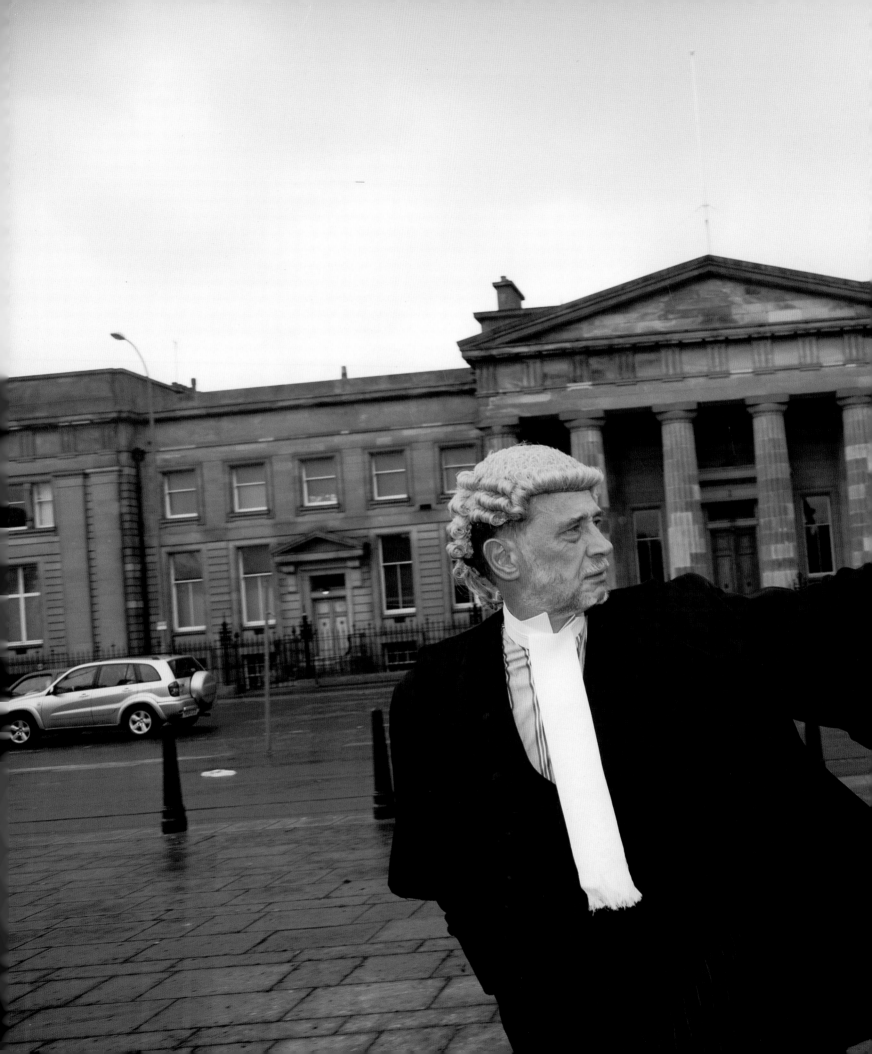

Donald Findlay QC, July 2006
The distinguished QC kindly agreed to wear his wig and robes outside Glasgow's High Court for this photograph.

**Paul Ferris,
August 2006**

After a very high-profile trial, Paul Ferris was acquitted at Glasgow's High Court on charges of murdering Arthur 'The Godfather' Thompson's son, 'Fatboy'. I asked if he would pose outside the court for this photograph and here you have it.

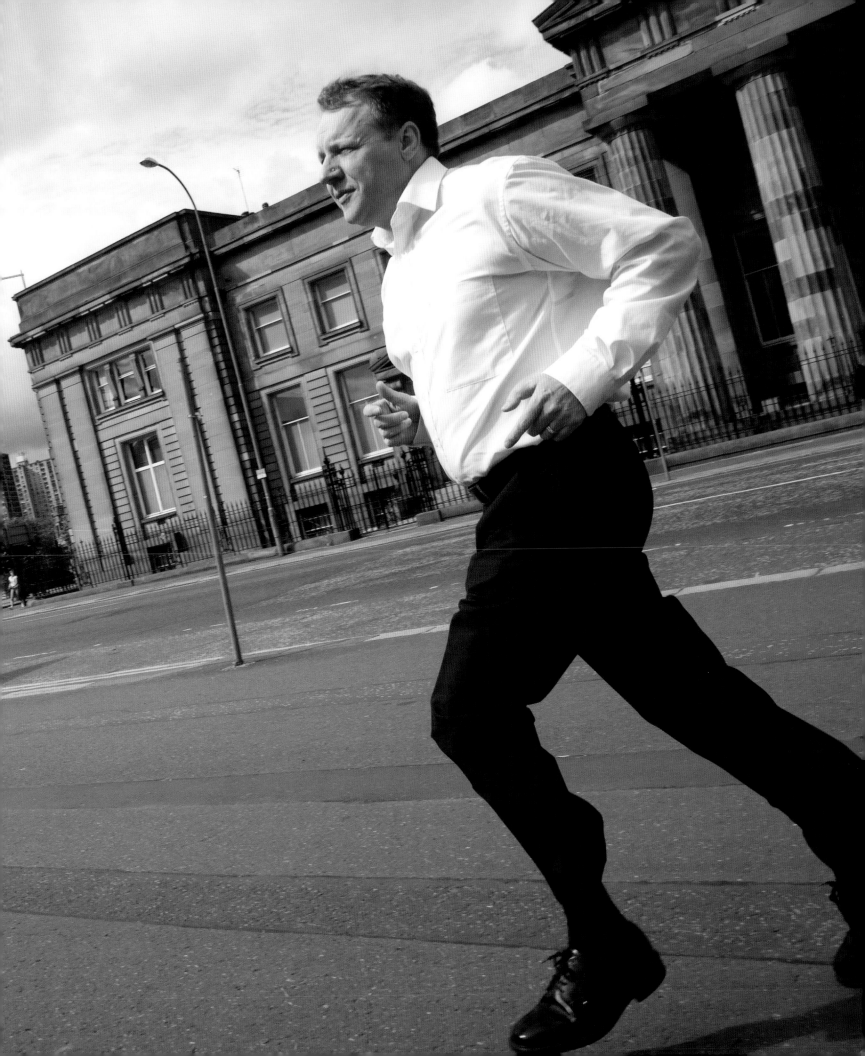

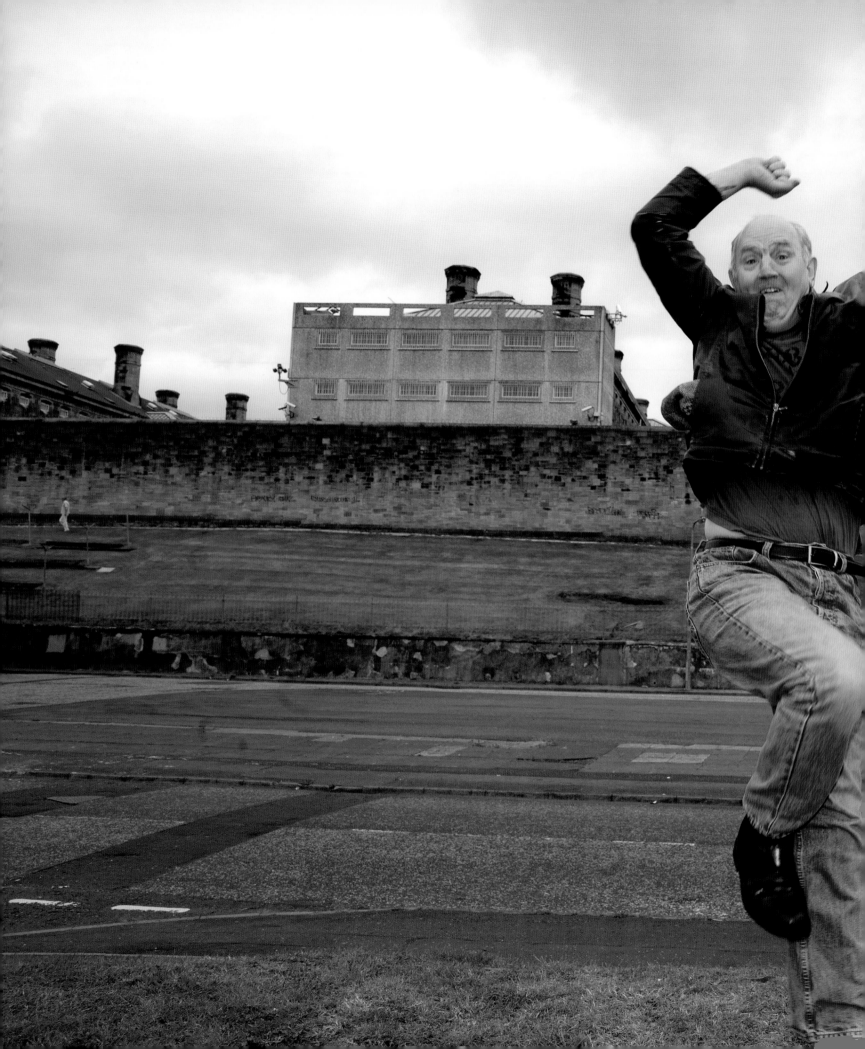

Tommy 'TC' Campbell, August 2006

Campbell jumped for joy outside Barlinnie Prison, happy to be free. He had been wrongly jailed for the ice-cream war murders and served almost twenty years. In 2004, his conviction was quashed and he was released from Barlinnie. It is hard to imagine what it must have been like knowing you are innocent and being imprisoned for a crime you didn't commit.

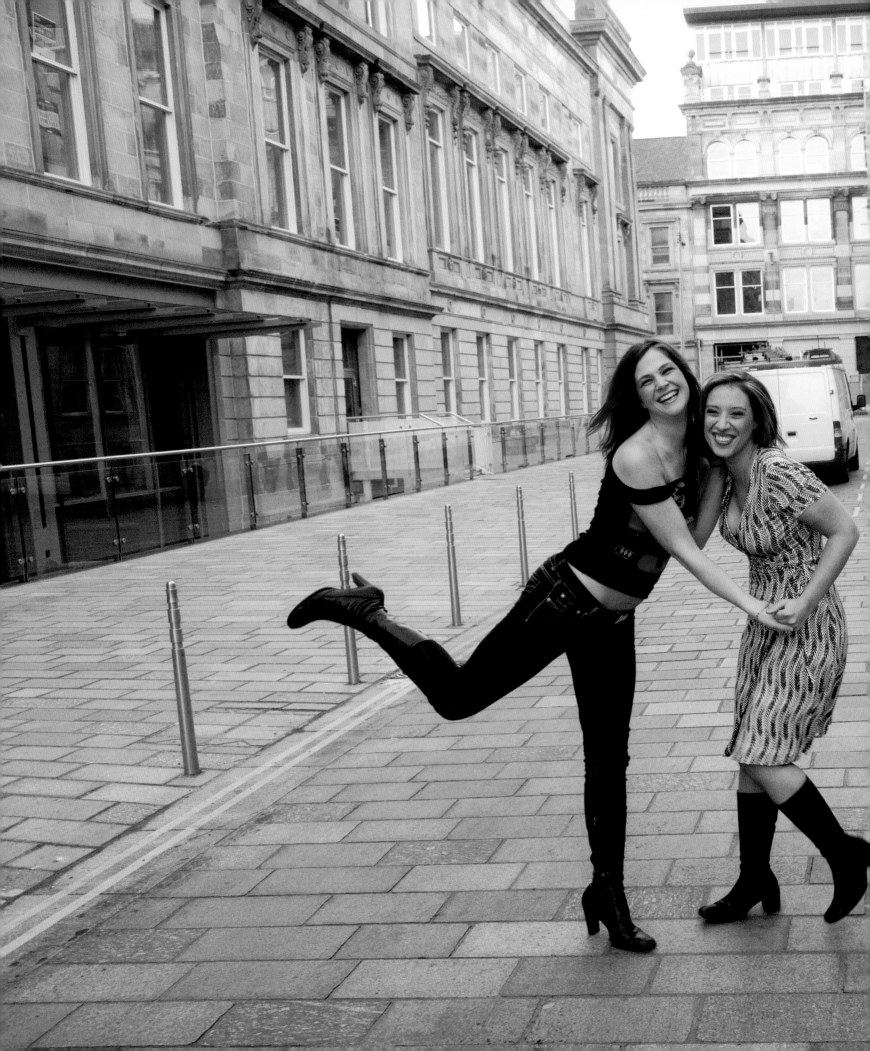

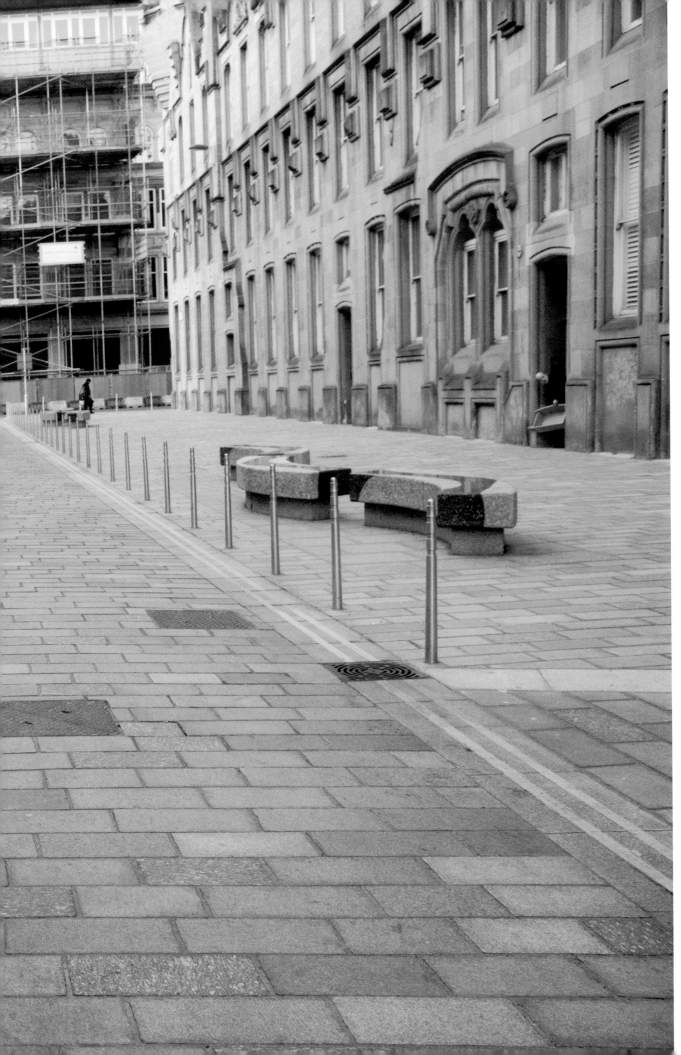

**Cath Bennett and
Beverley Lyons,
April 2006**

The fun-loving 'Razz Girls',
popular reporters for the
Daily Record, took me with
them one evening on their
nightly round of parties.

Charan Gill MBE, July 2007

The man known as 'Glasgow's Curry King' agreed to be photographed at his home in his native Indian dress. Charan first arrived in Glasgow in 1963 at the age of nine with little knowledge of English. He started working in the shipyards and, by 1984, was able to purchase his first restaurant. He went on to build his business into the largest chain of Indian restaurants in the UK. After selling the chain in 2005, he now focuses his attention on other business interests and charity work.

Steve Flannery, 1988

The up-and-coming young fashion designer posed with one of his designs.

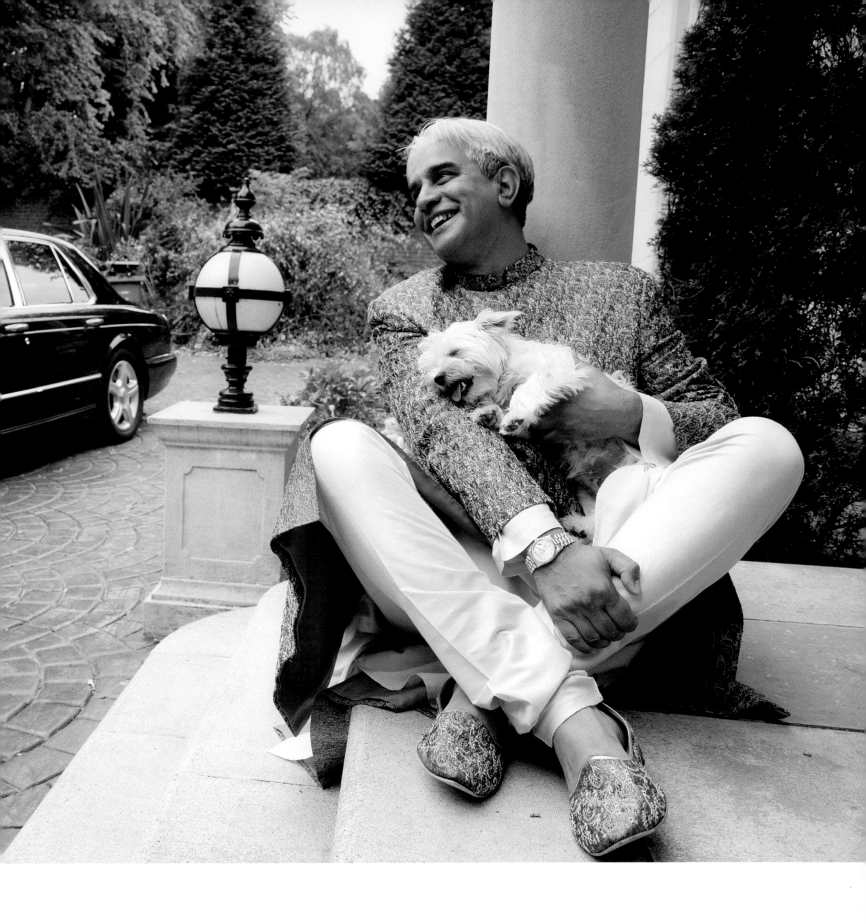

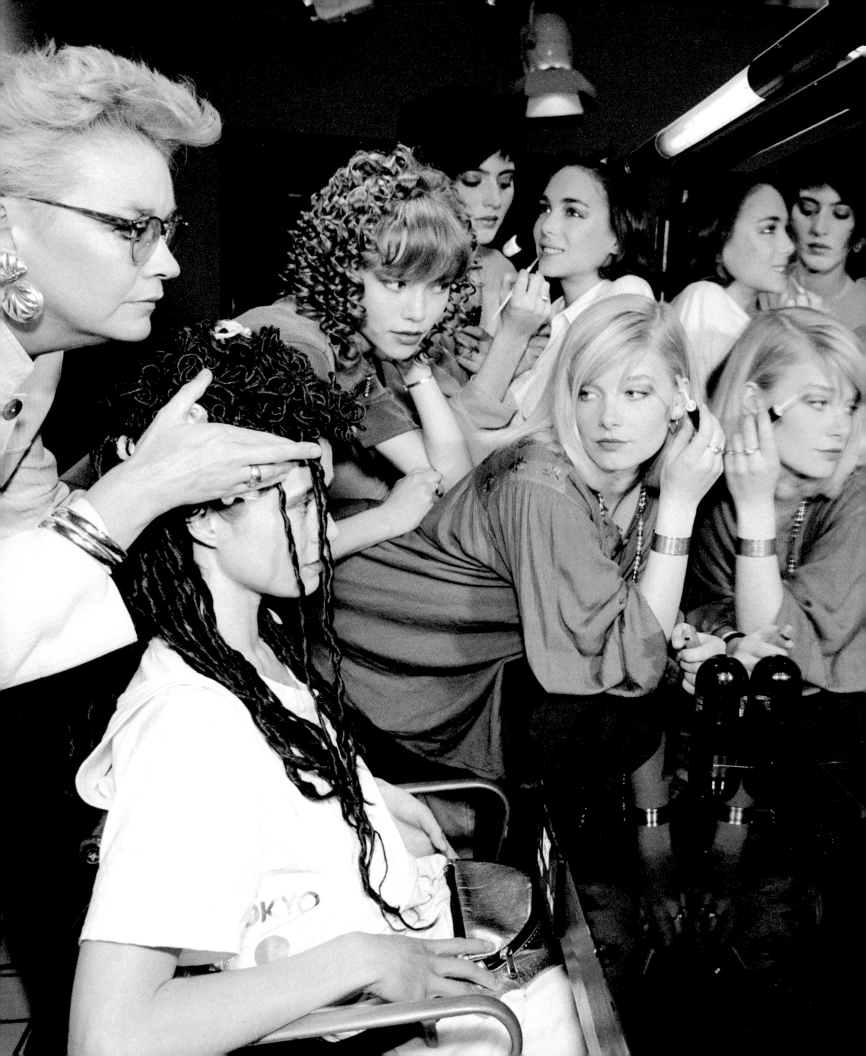

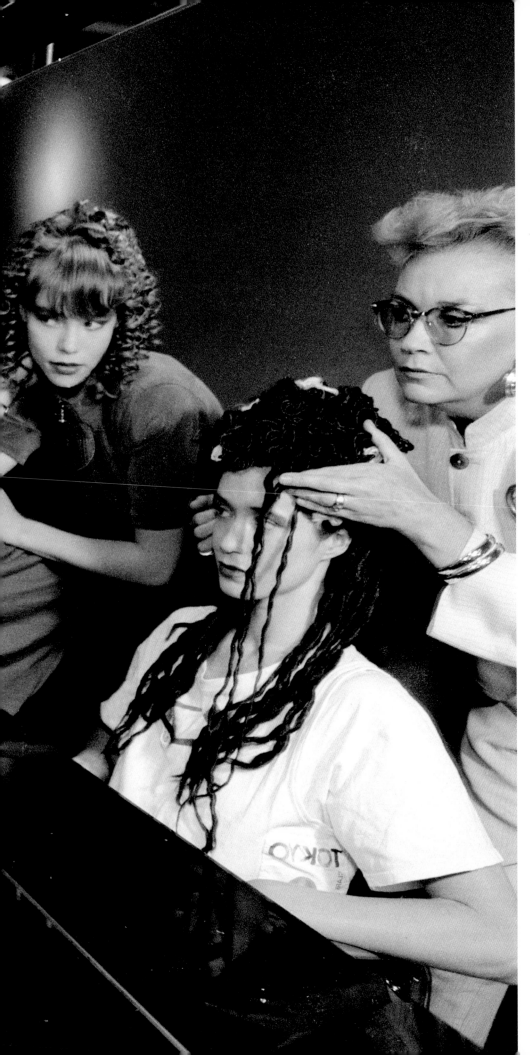

Rita Rusk, 1990
The well-known Glasgow hairdresser was readying these models for a photo shoot. She was the first woman to be awarded the prestigious British Hairdresser of the Year title and is still a major force in the beauty industry today.

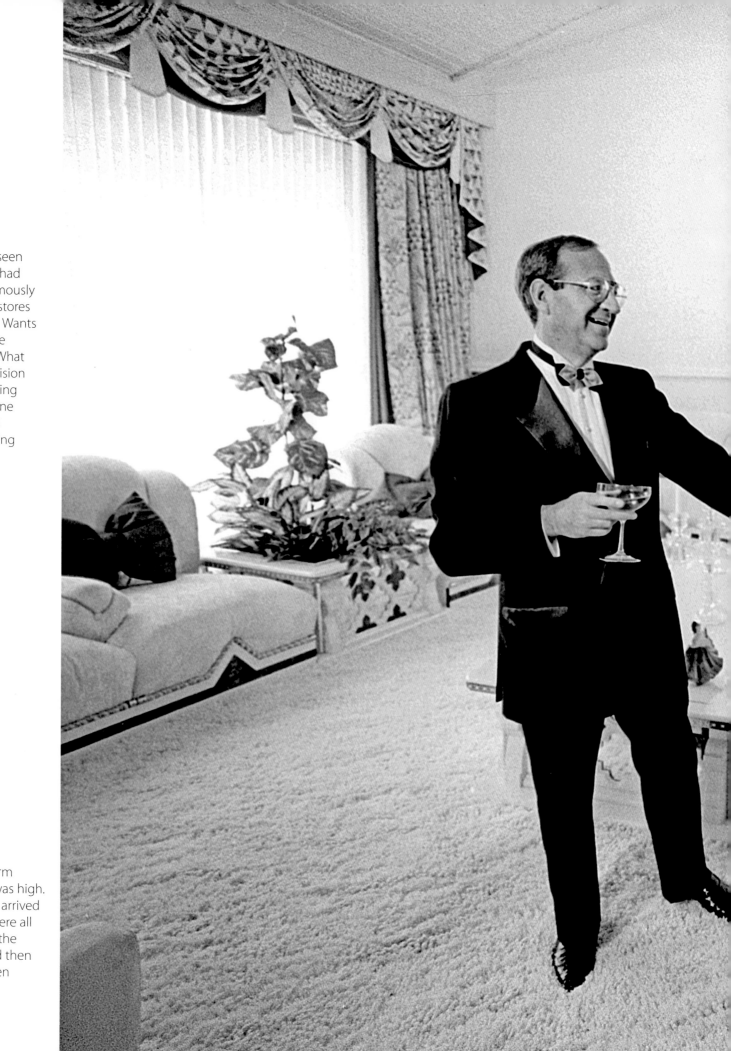

Gerald and Vera Weisfeld, 1990
The happy couple, seen here in their home, had just sold their enormously successful chain of stores What Every Woman Wants for £50 million at the time of this photo. What prompted their decision to sell was a harrowing experience on a plane that almost crashed as they were returning from a holiday.

Following pages:
Soccer Fans, 1971
Tension at an Old Firm game at Parkhead was high. Full seating had not arrived and these people were all standing, watching the game solemnly. And then cheers went up when Celtic scored.

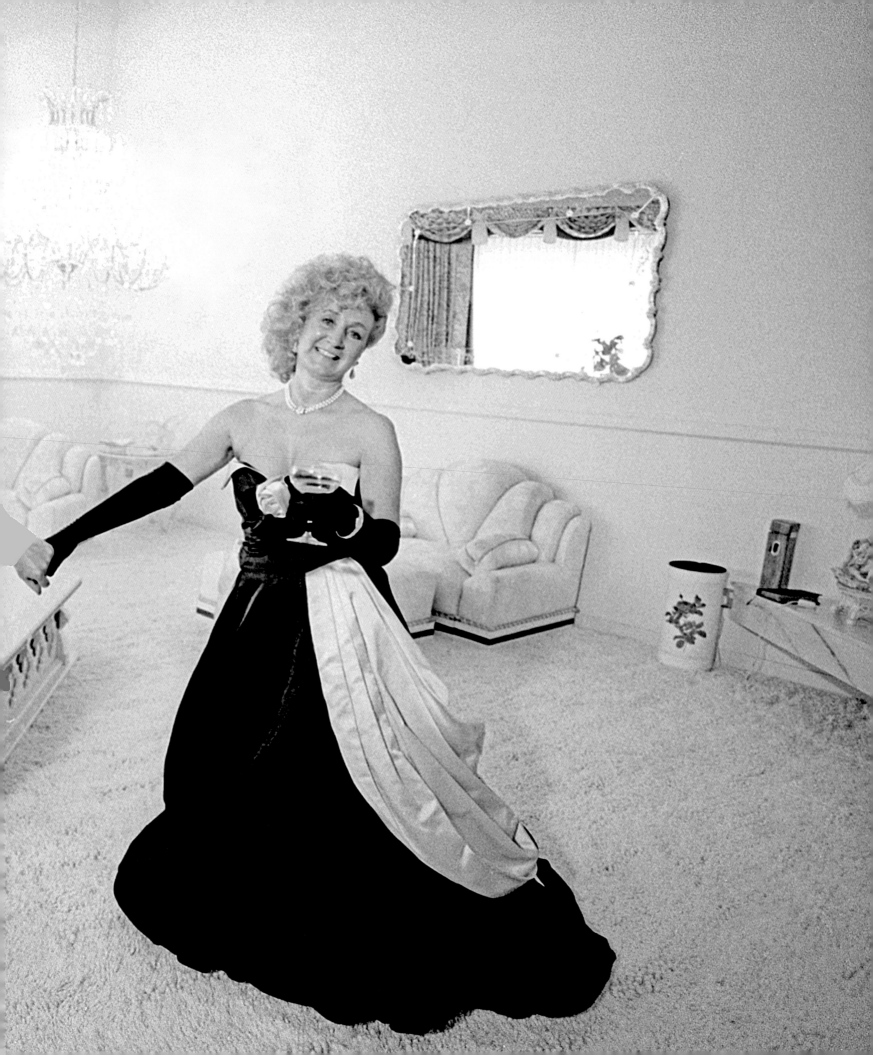

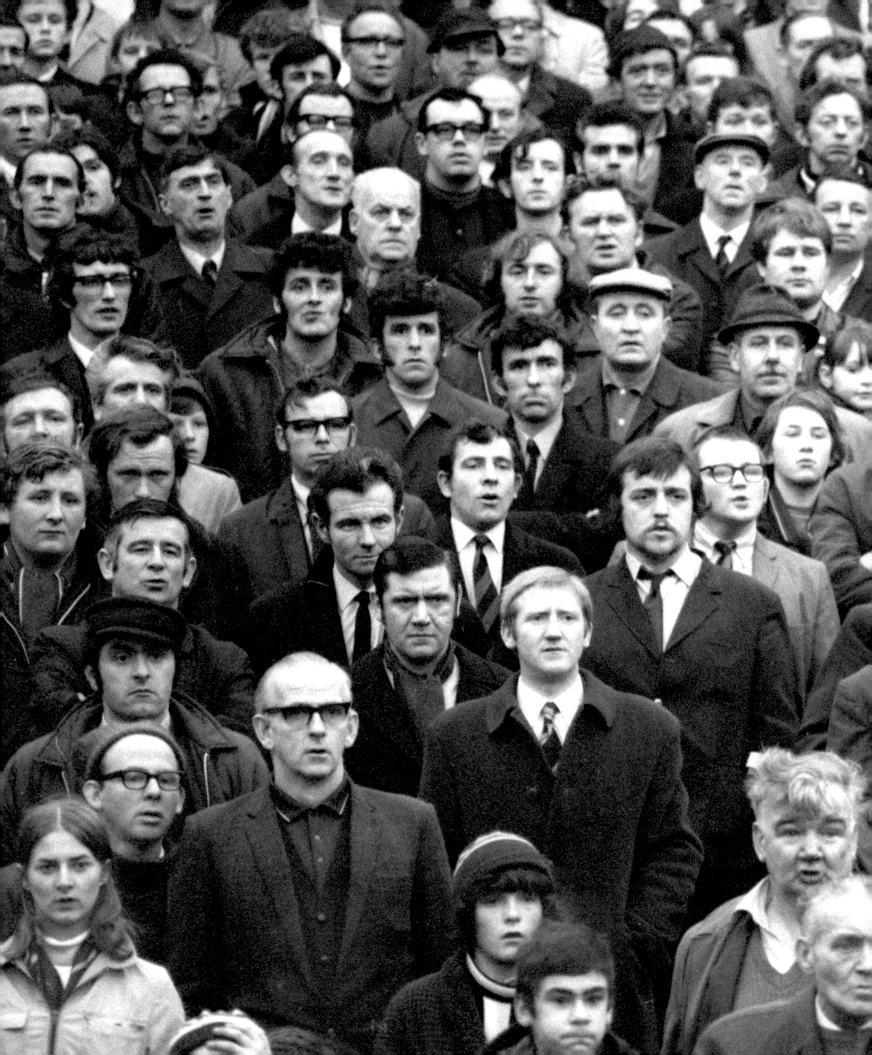

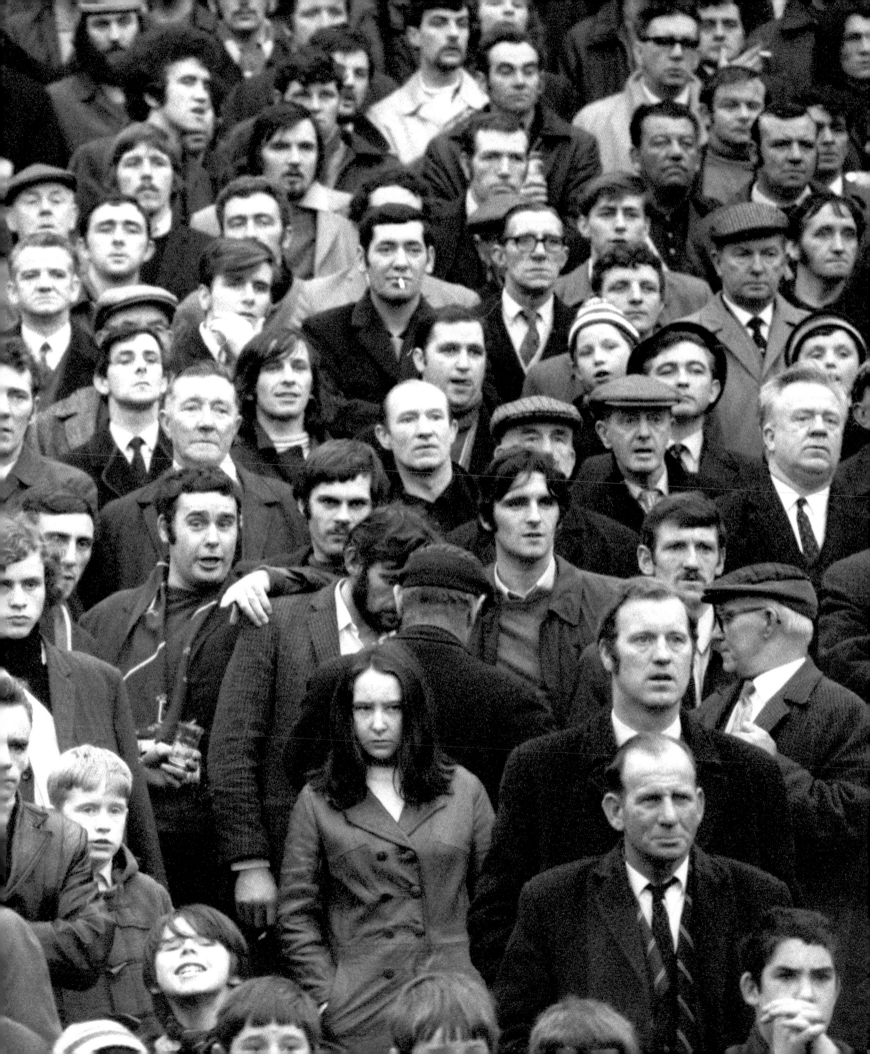

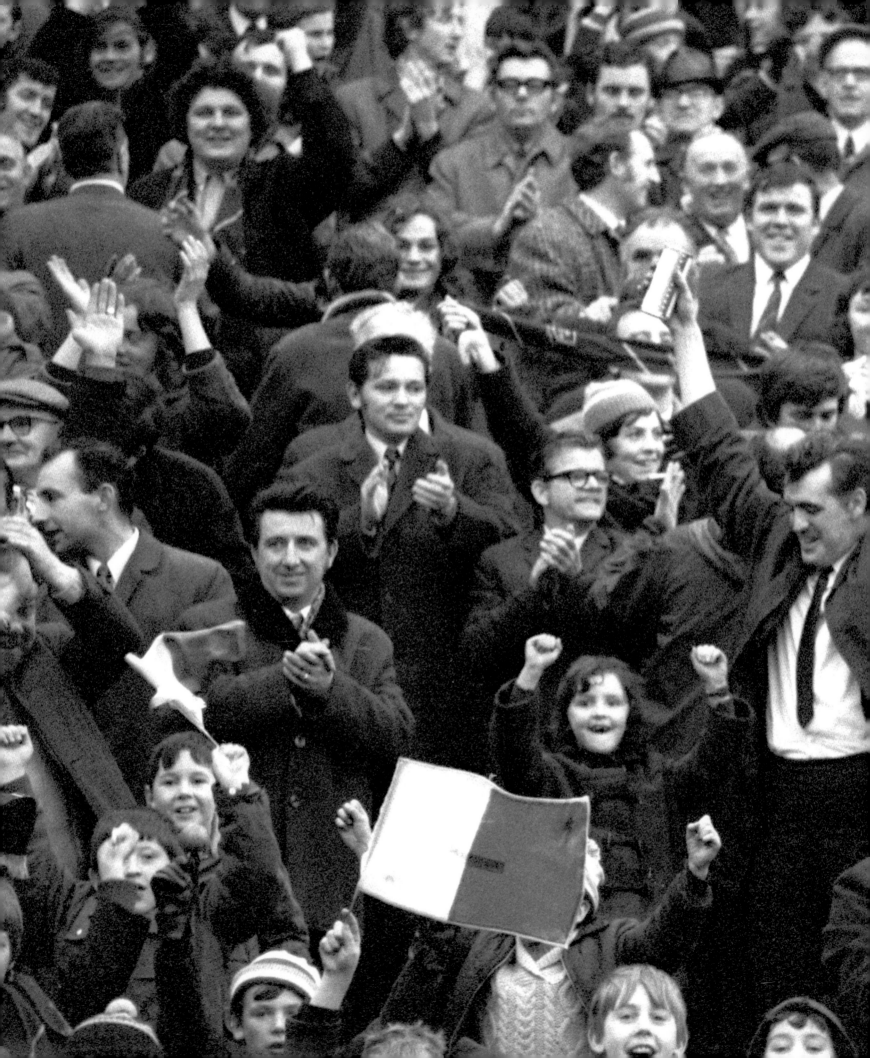

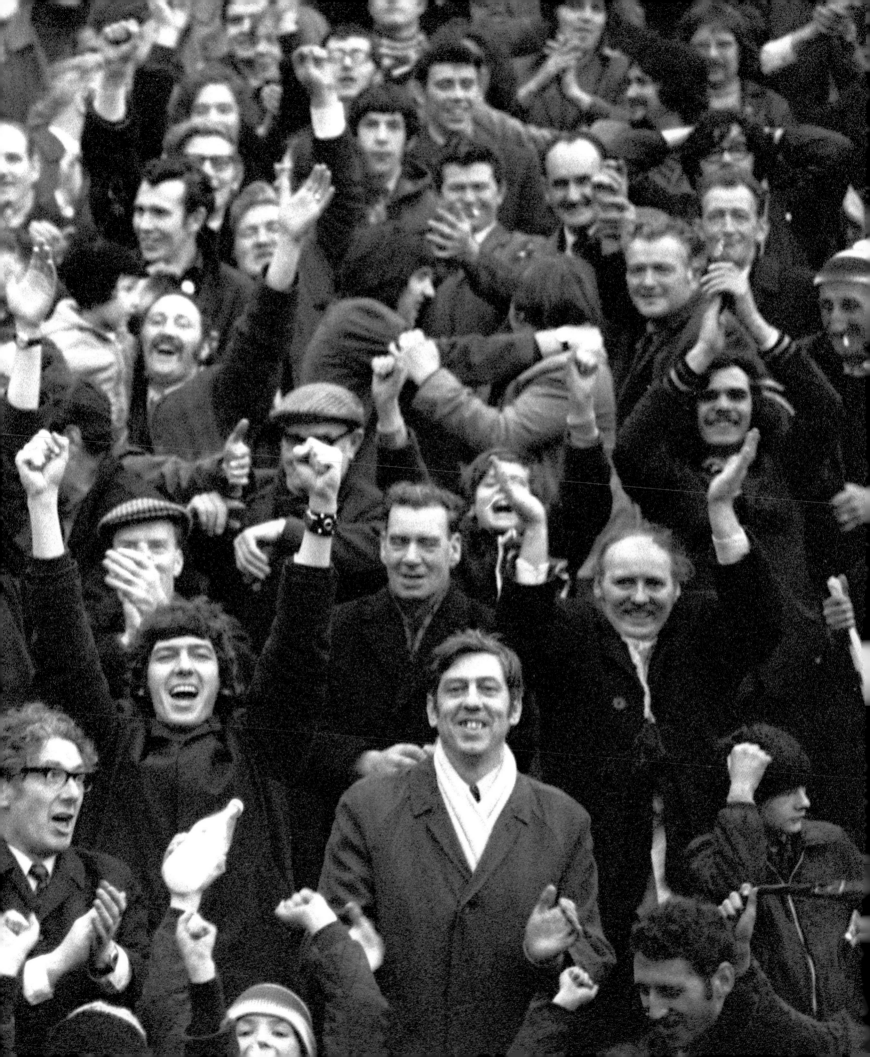

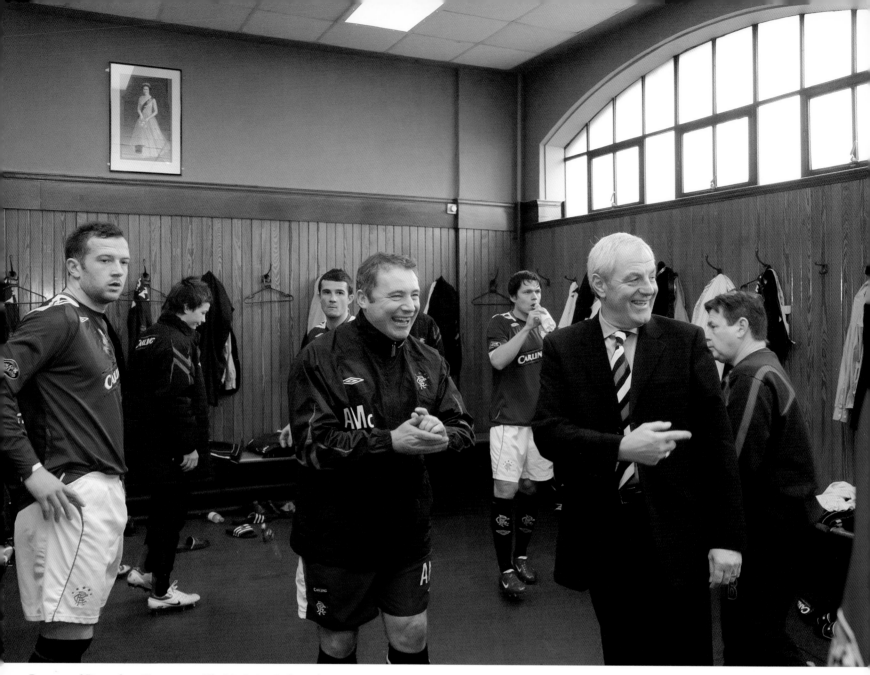

Rangers' Dressing Room, Ibrox Stadium, 27 January 2007

Earlier this month, the former Scotland manager Walter Smith had returned as manager of Rangers to be assisted by the ex-Rangers star forward, Ally McCoist. Before the game against Hearts, they share a joke with the team in the dressing room. Captain Barry Ferguson can be seen just behind McCoist.

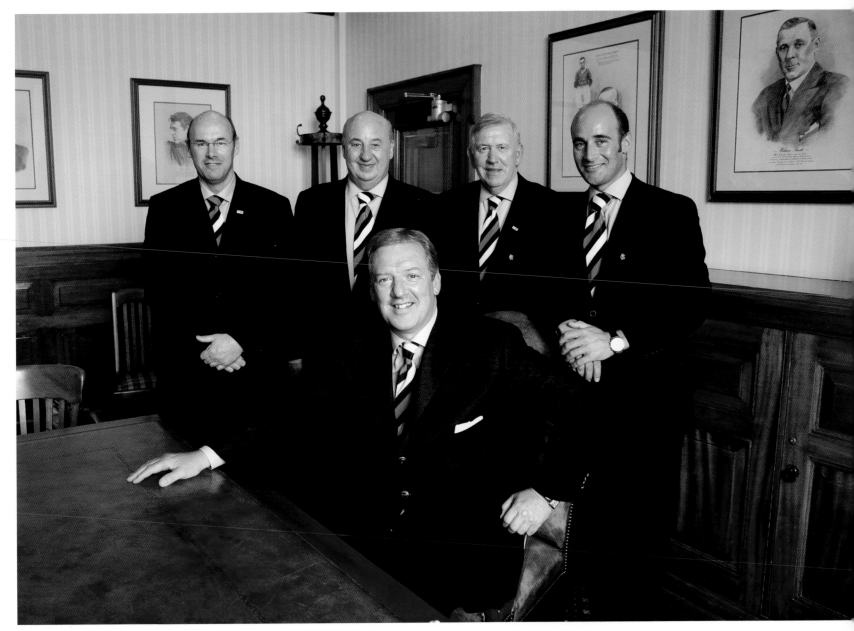

The Directors' Room, Ibrox Stadium, 5 August 2006

Before an afternoon game against Dundee United, I was very pleased to be allowed to photograph the distinguished Chairman of the Board of Directors, Sir David Murray, seated at the table, with Directors Donald McIntyre, John McLelland, John Greig and the Rangers Chief Executive Martin Bain.

Rangers' Dressing Room, 27 January 2007

Team manager Walter Smith had a quiet moment with star player and captain Barry Ferguson before the game against Hearts.

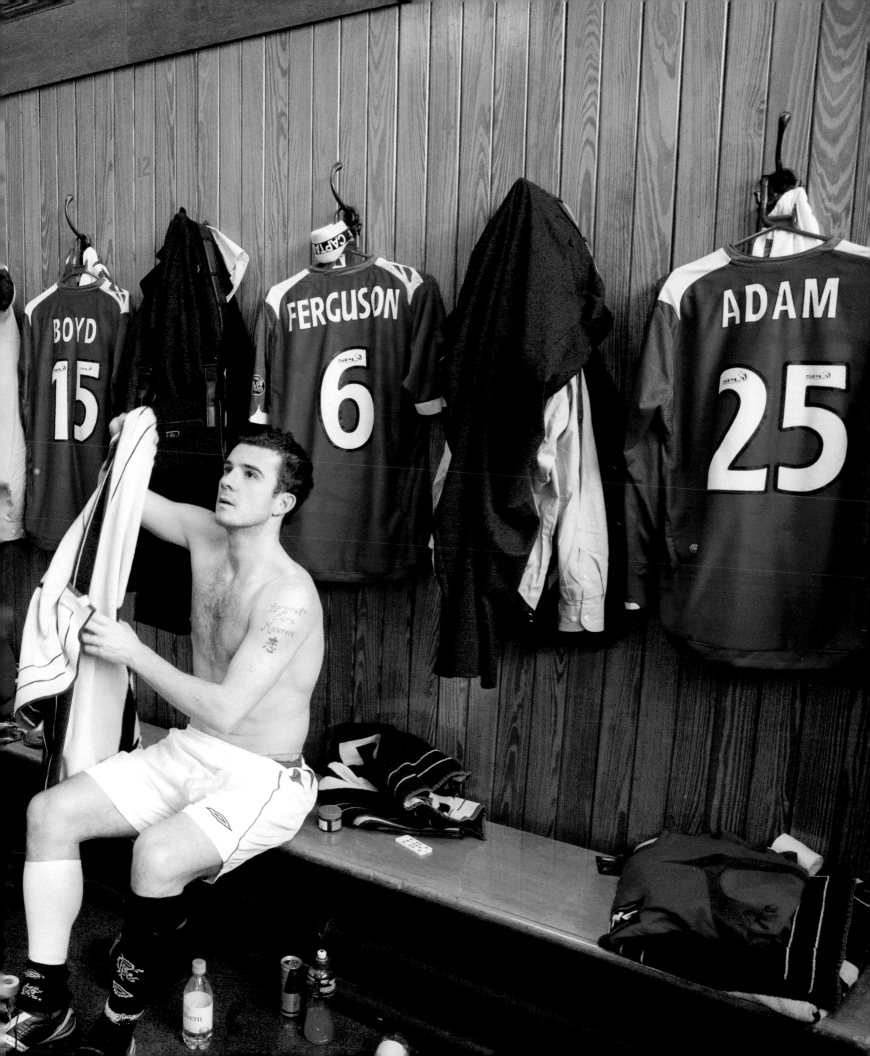

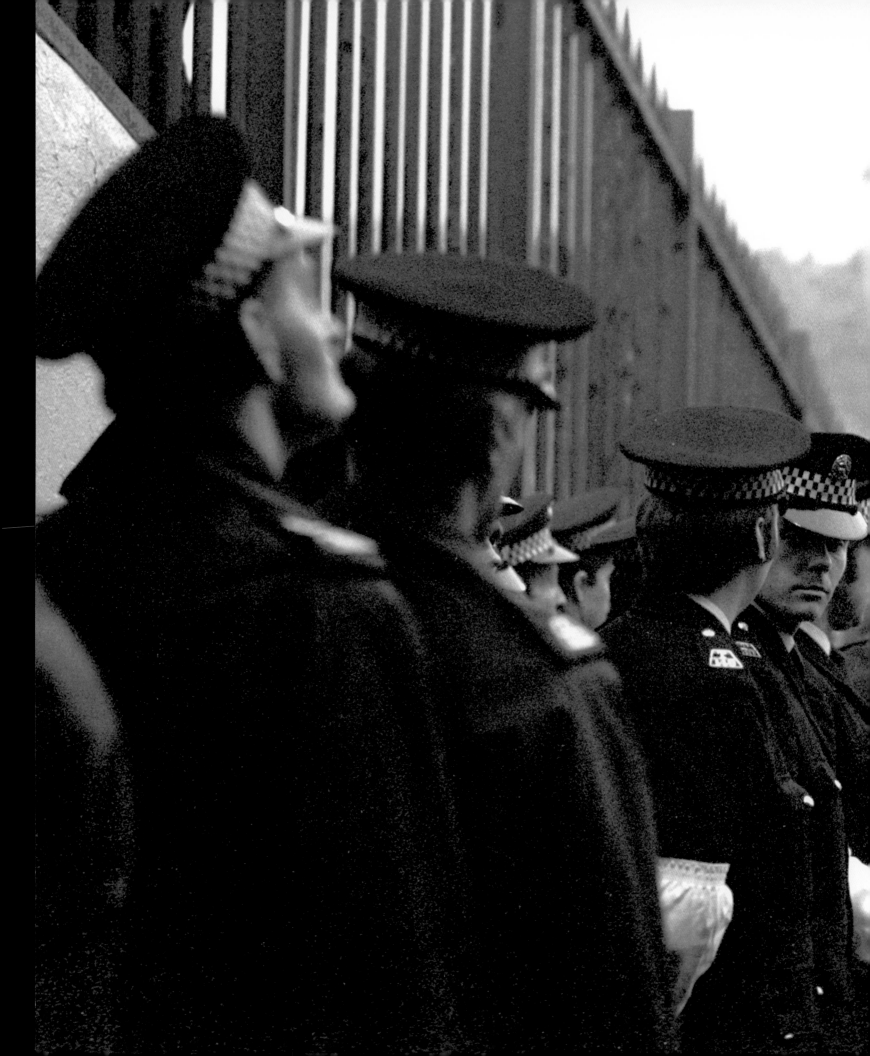

Ibrox Stadium, 1971
Standing between the terraces, a group of policemen intently watched a Rangers v Celtic game. There are always quite a few policemen at these games in case the fans get rowdy and cause a bit of trouble.

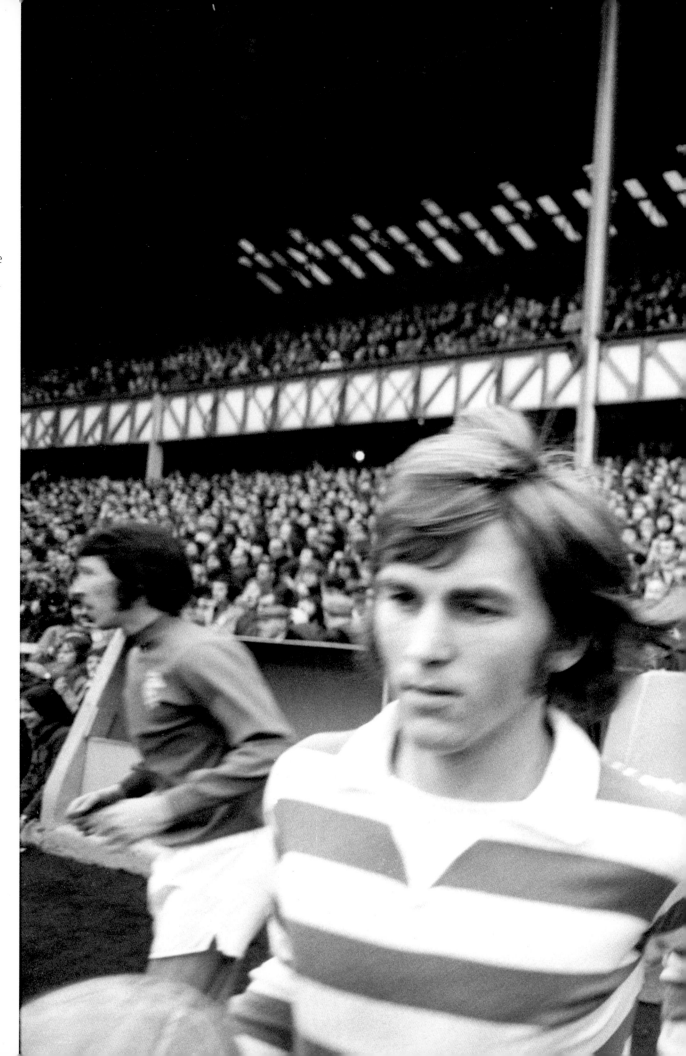

Kenny Dalglish, 1972
With a determined demeanour, Celtic favourite Dalglish runs out on to the park at Ibrox for the start of the game against Rangers.

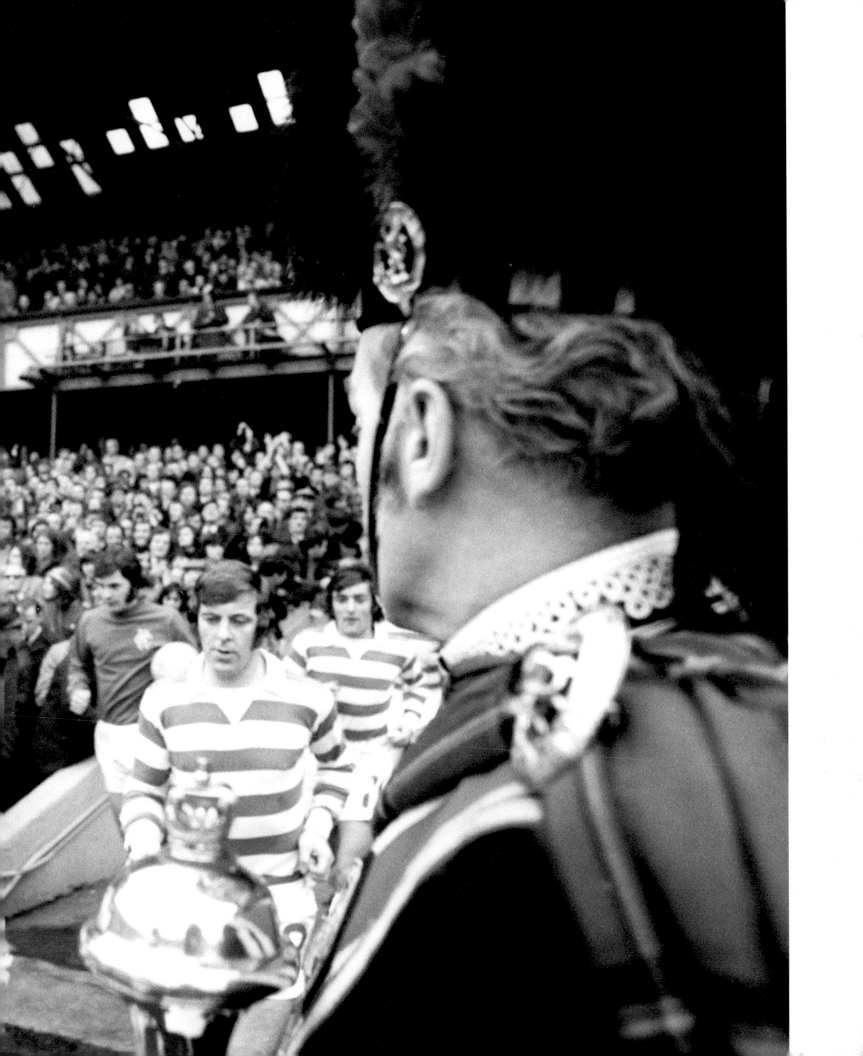

**Billy McNeill,
February 2006**

I photographed the Celtic legend on a wind-swept field in Cathkin Braes on the outskirts of Glasgow. He had lost none of the spirit he exhibited as the Celtic captain in the 60s and 70s.

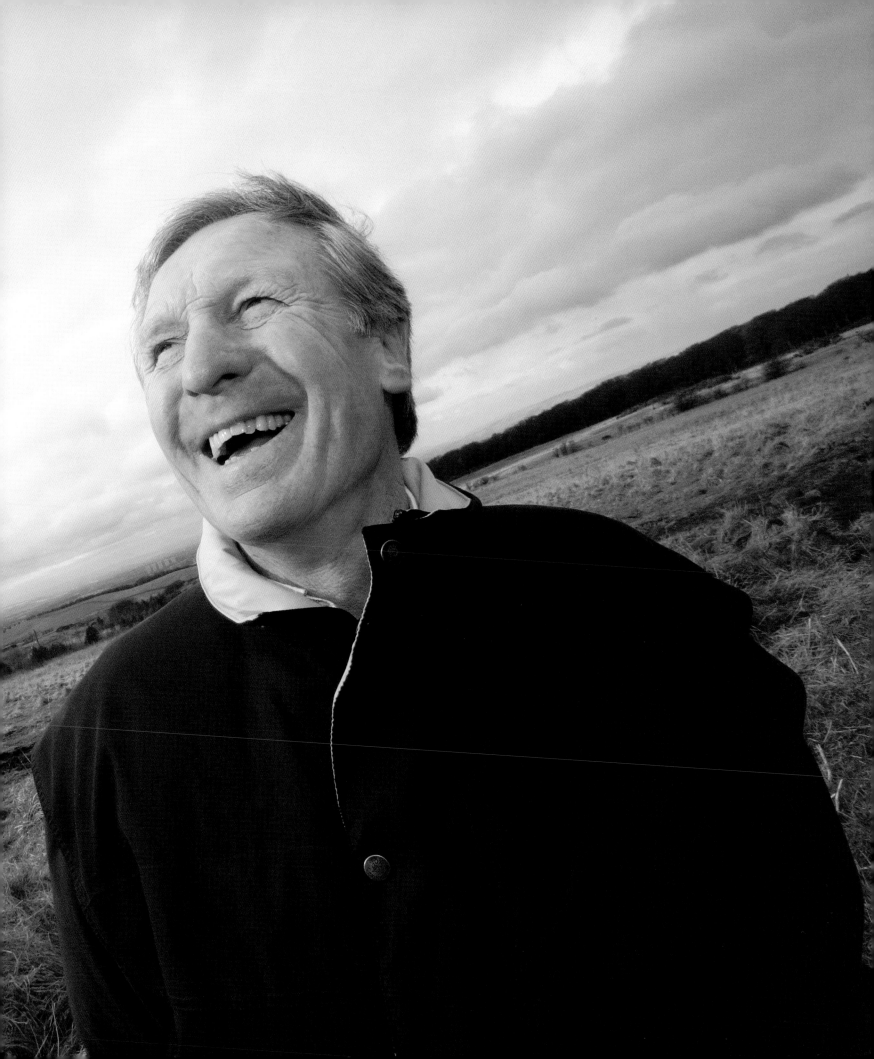

John Greig and Billy McNeill, 1972

Rangers' captain Greig taps Celtic captain McNeill as they enter the field together for a game between the great rival teams.

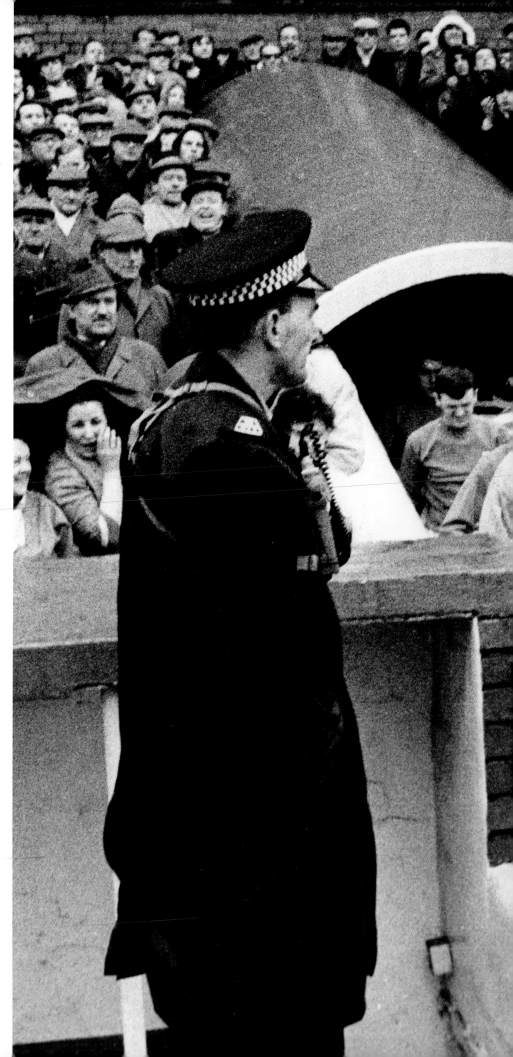

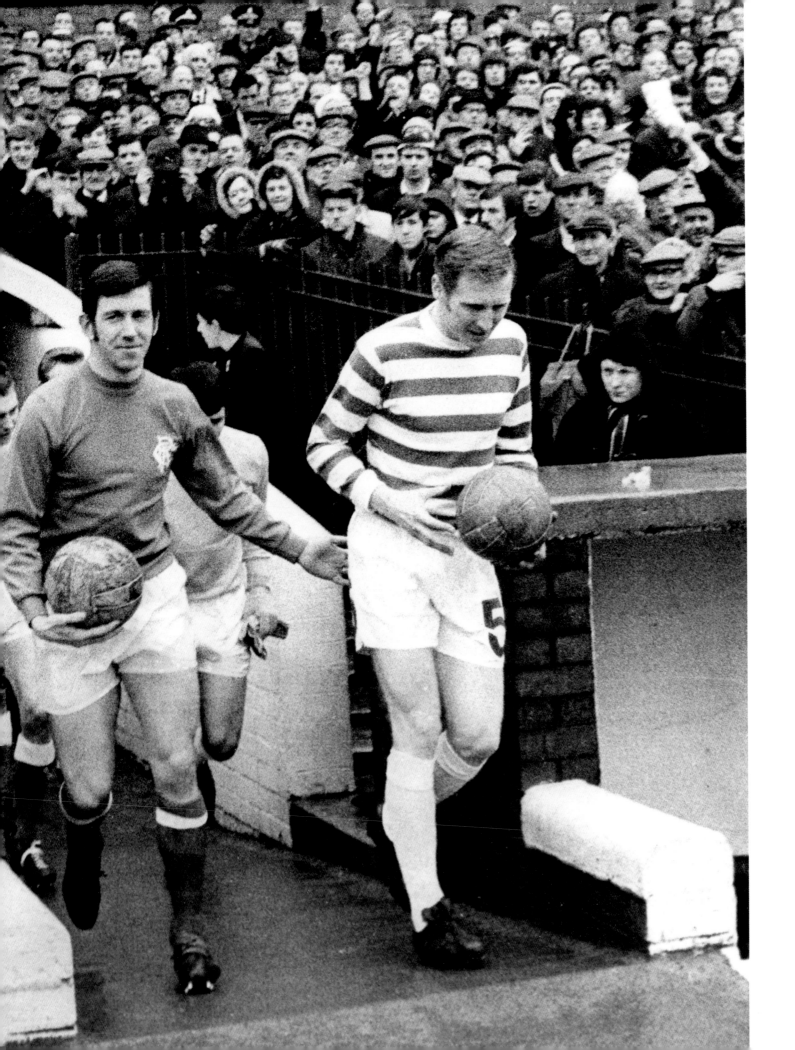

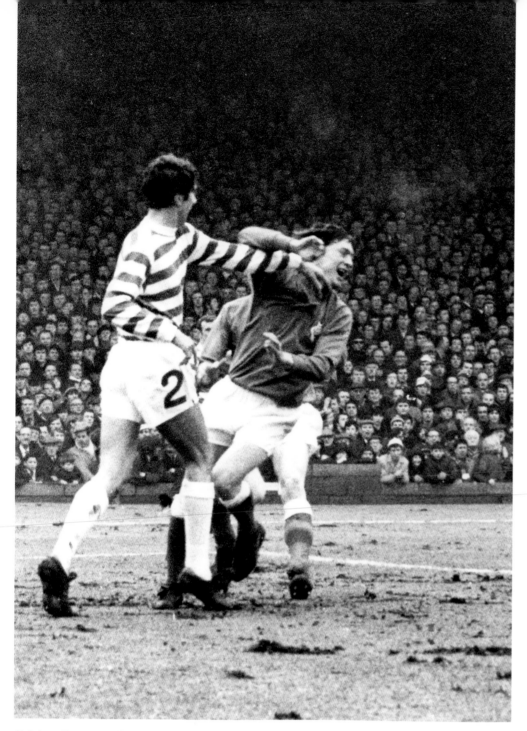

Celtic v Rangers Game, 1971

Celtic captain Jim Craig had just put the ball into his own goal and was congratulated unkindly by Rangers' forward Willie Johnston. Craig slapped Johnston and caused a bit of a commotion in the crowd.

Scottish Cup, Hampden Park, 1957

The game was Hibs v Rangers. While the Rangers team and the referee discuss what has happened and who is to blame, the injured Hibs goalkeeper, clearly in pain, is ignored.

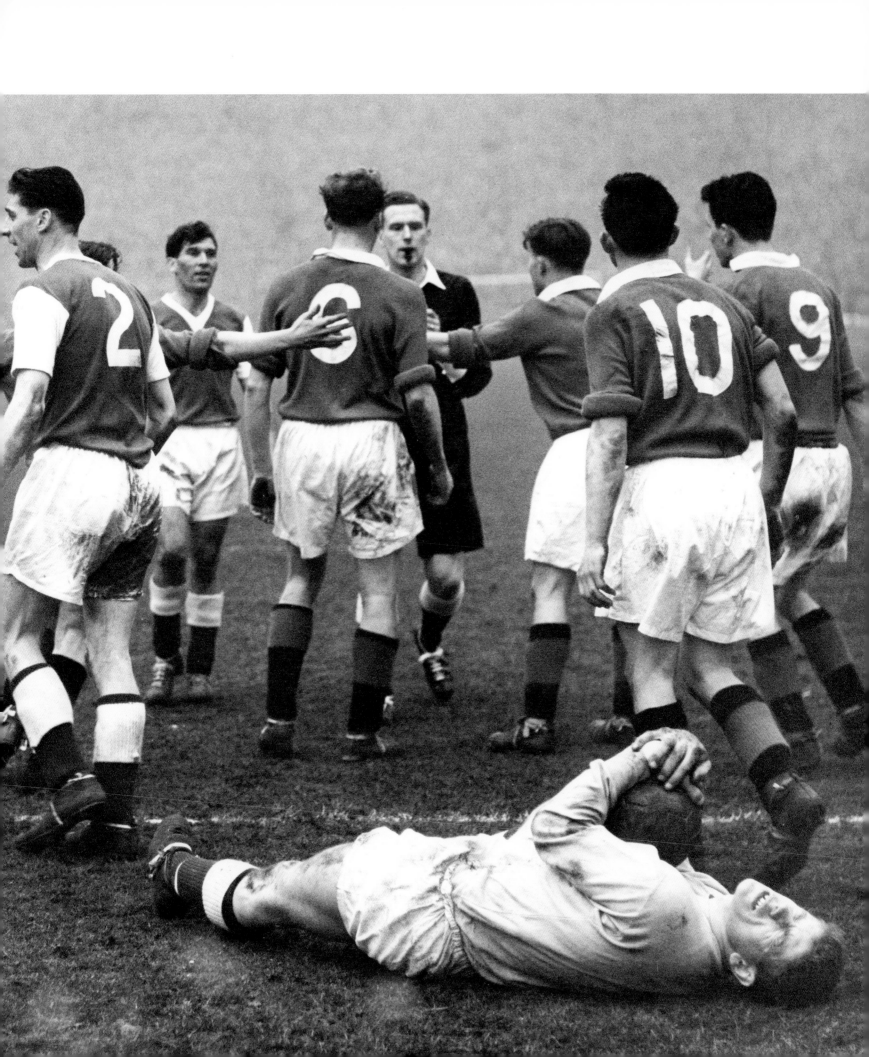

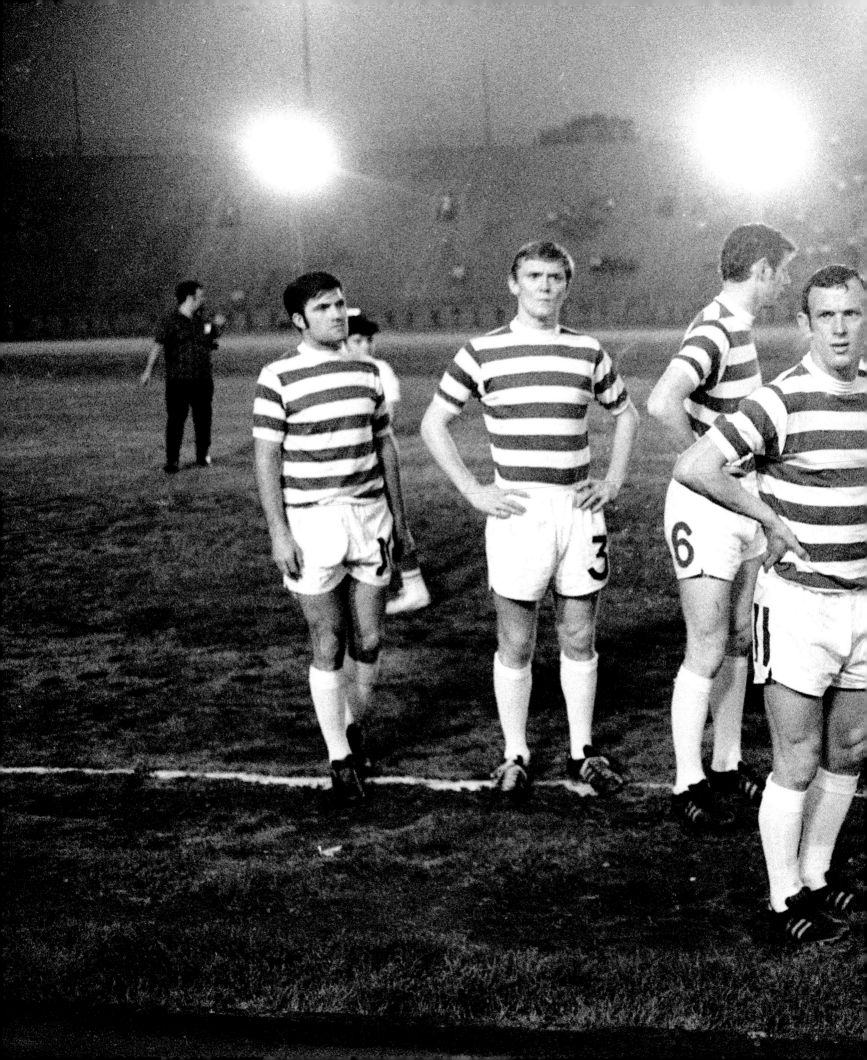

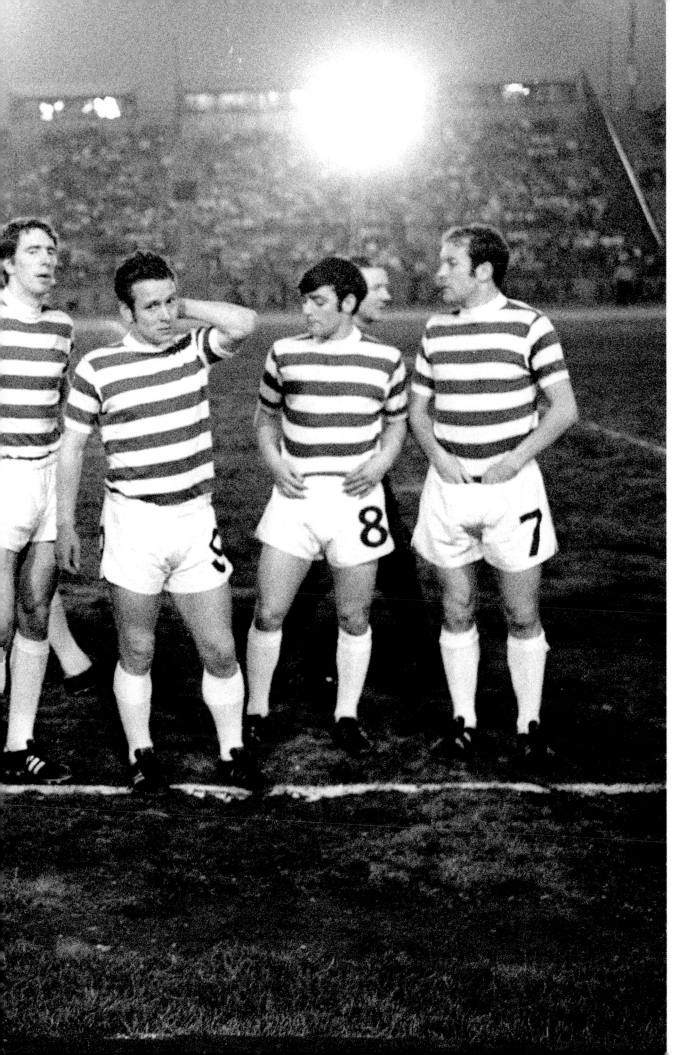

Celtic Team, 1970

The team had come to New York to play several exhibition games. Football, which the Americans call soccer, was just beginning to catch on in the US. This game against Fiorentina of Italy was played at New York's Randall's Island Stadium.

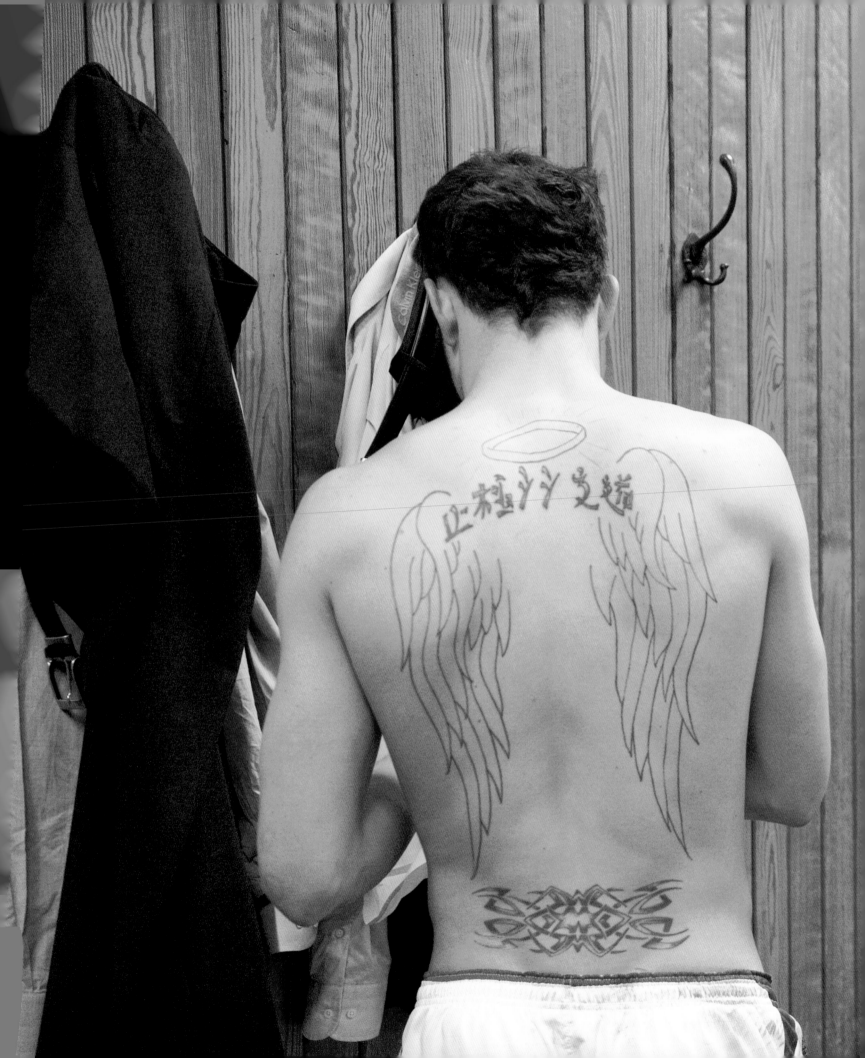

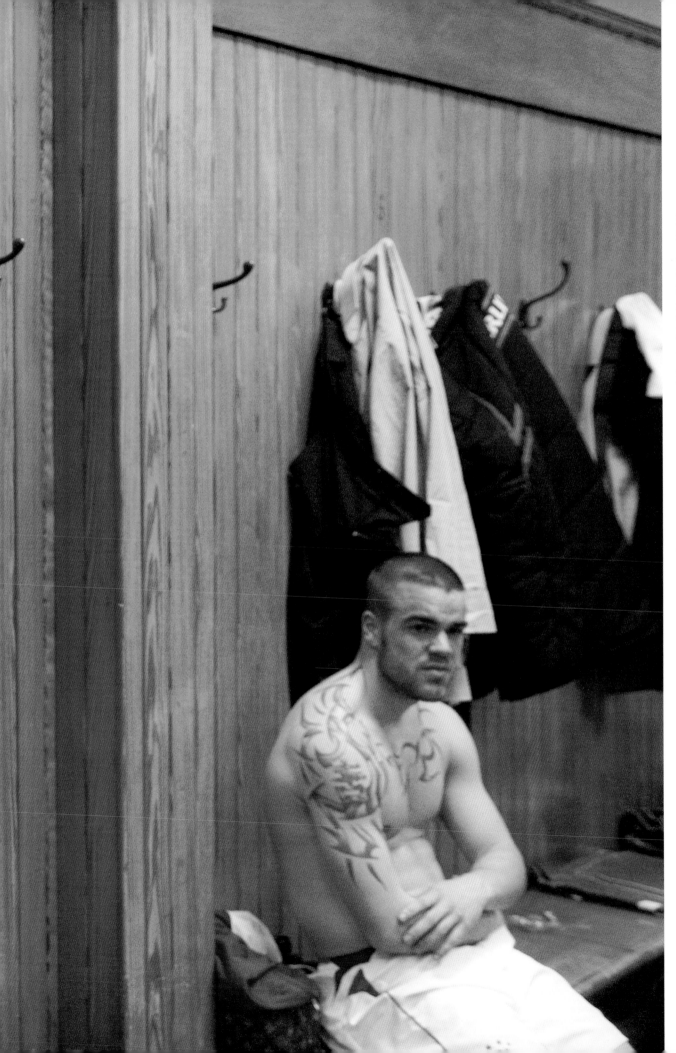

Rangers' Dressing Room, 27 January 2007
After a goalless draw against Hearts, the Rangers players are getting changed. Alan Hutton has his name tattooed in Chinese on his back. His seated team-mate, who clearly also favours tattoos, is Filip Sebo.

Celtic Park, June 1968

Parkhead on a match day.

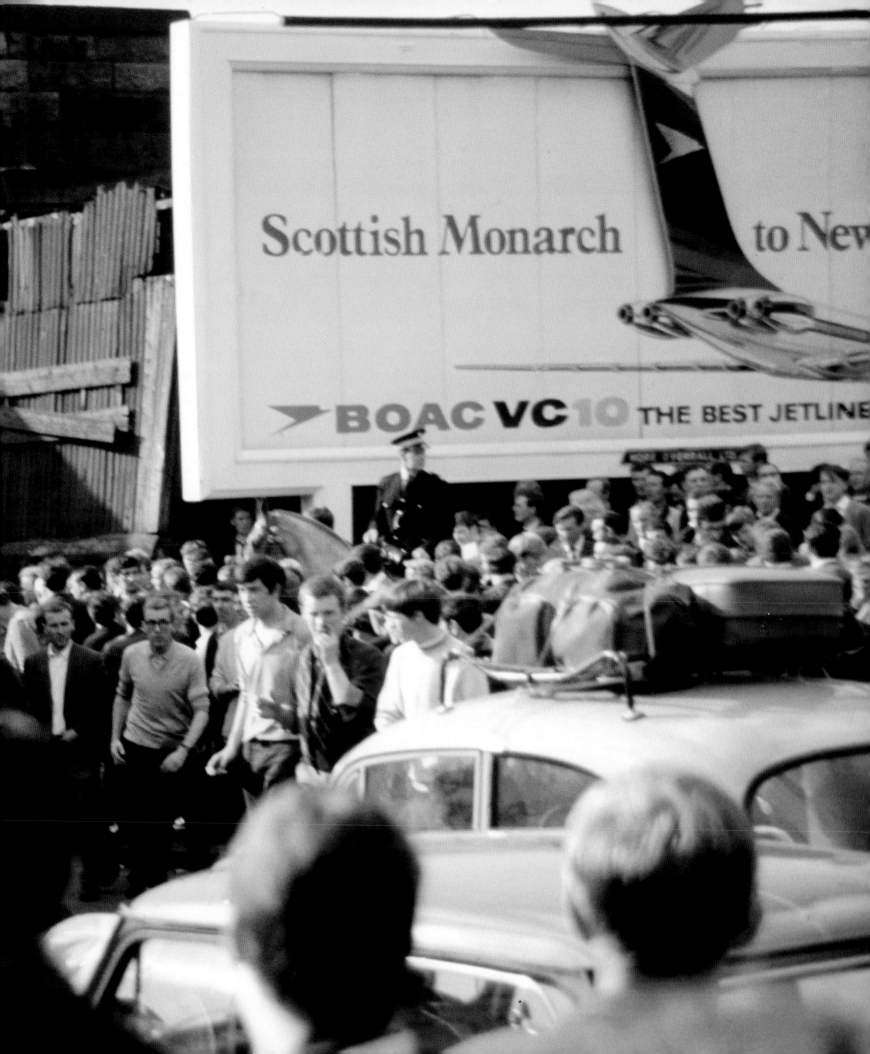

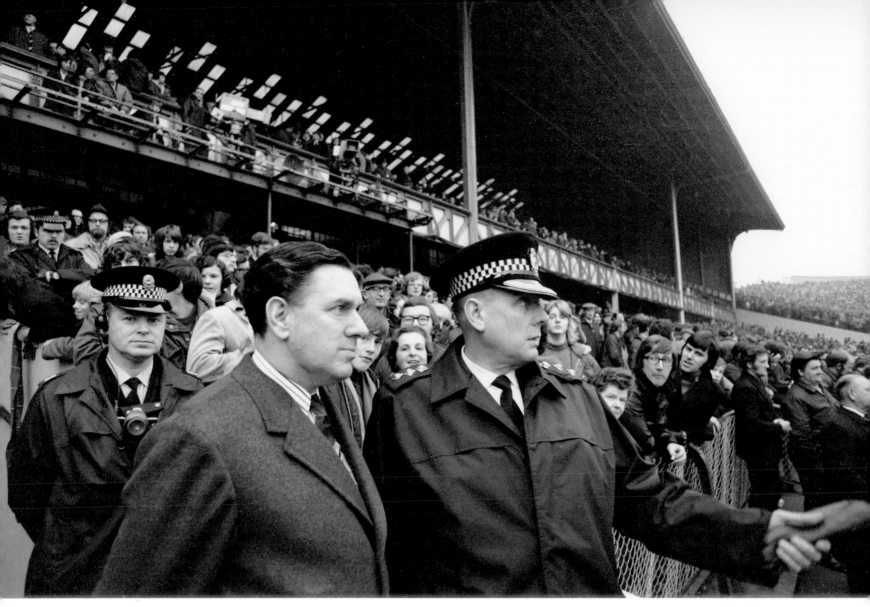

Sir David McNee, 1971

Sir David (out of uniform) was Chief Constable of the City of Glasgow Police (later the Strathclyde Police when this photograph was taken. To me he is the double of my football hero Willie Waddell.

Jock Stein, New York, 1970

The famous Celtic manager who won the European Cup was talking with journalists Hugh Taylor and John Blair in Randall's Island as the Celtic team prepared to play against Fiorentina of Italy.

Right:
Celtic v Rangers game, Ibrox Stadium, 1971

On the far right is Celtic sta Jimmy Johnstone, a great player who sadly died in March 2006. I had hoped to photograph him again but it wasn't to be.

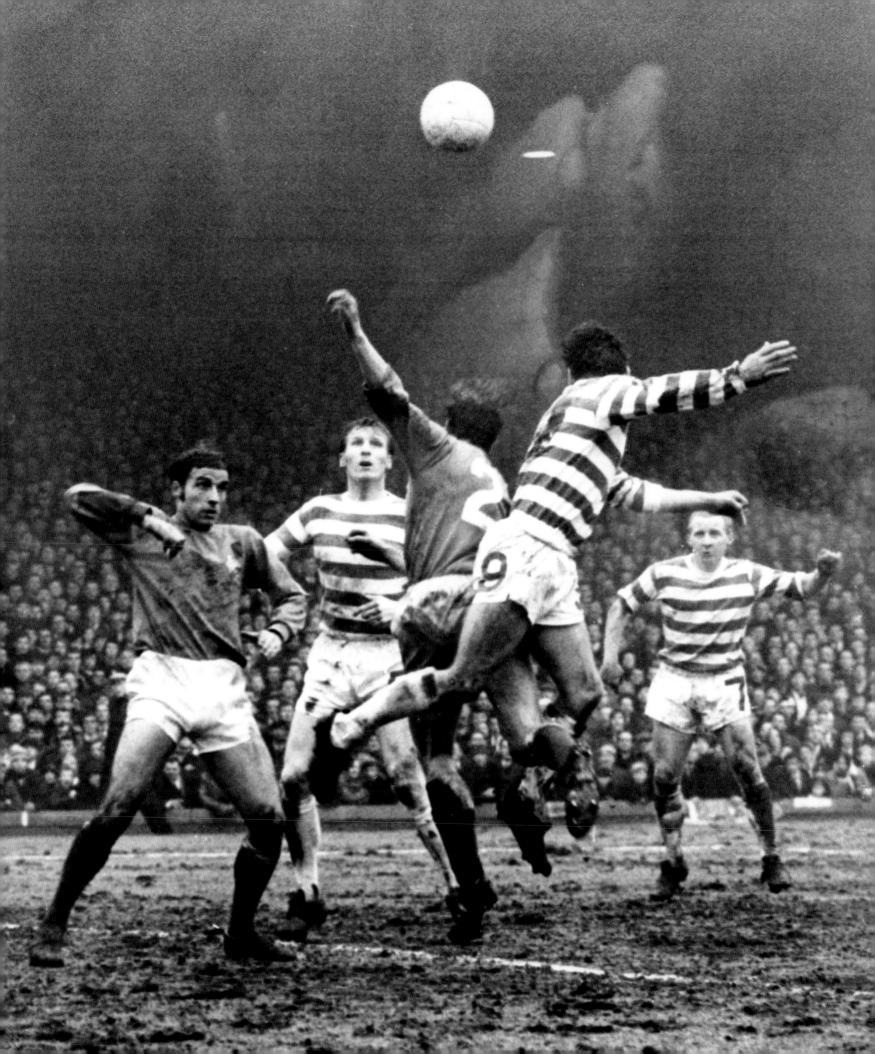

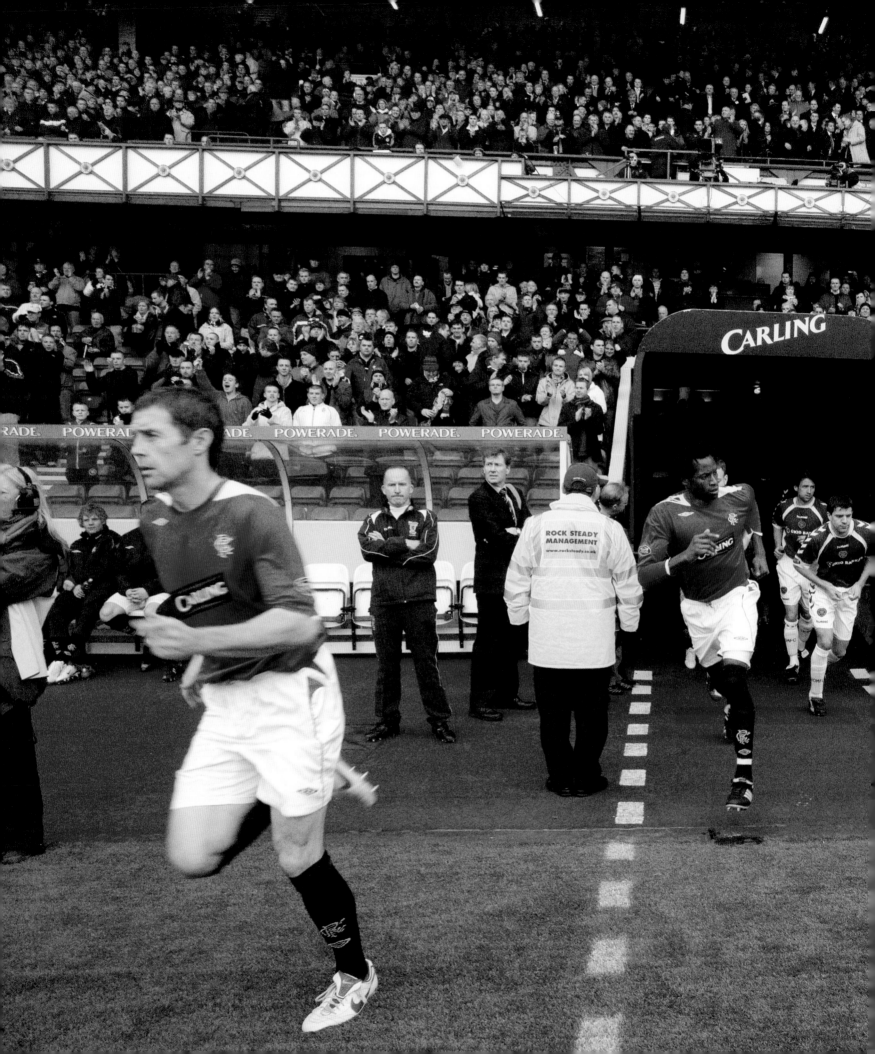

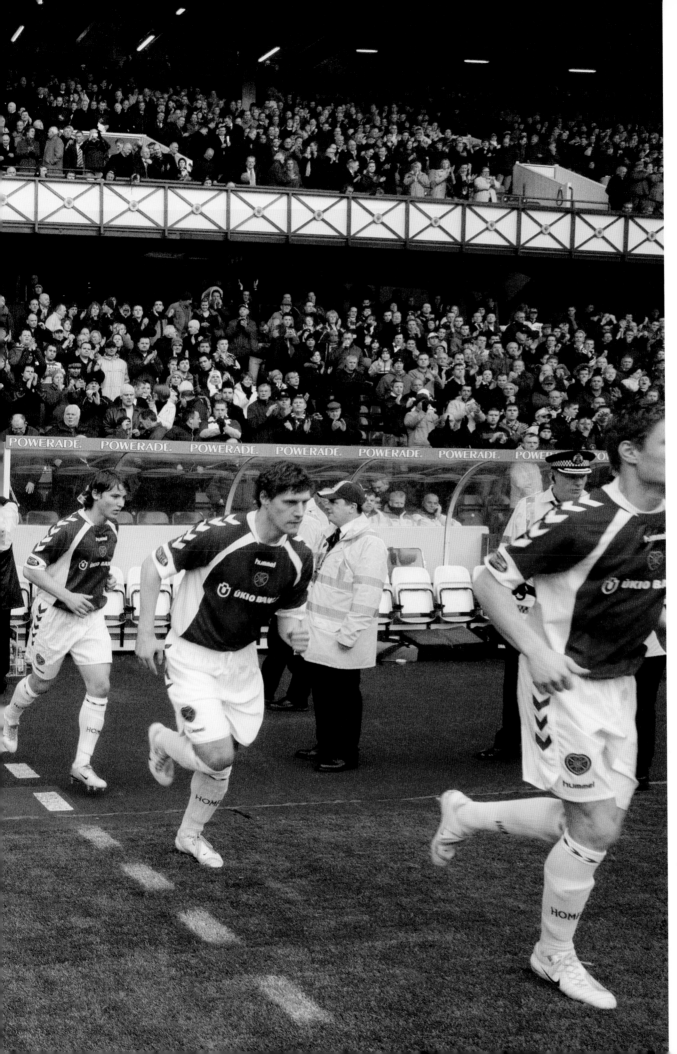

**Ibrox Stadium,
27 January 2007**
The Rangers and Hearts teams run on to the field at the start of the game.

**The Rangers' Dressing
Room, Ibrox Stadium,
27 January 2007**
Kris Boyd sits in the dressing
room after a goalless draw
with Hearts.

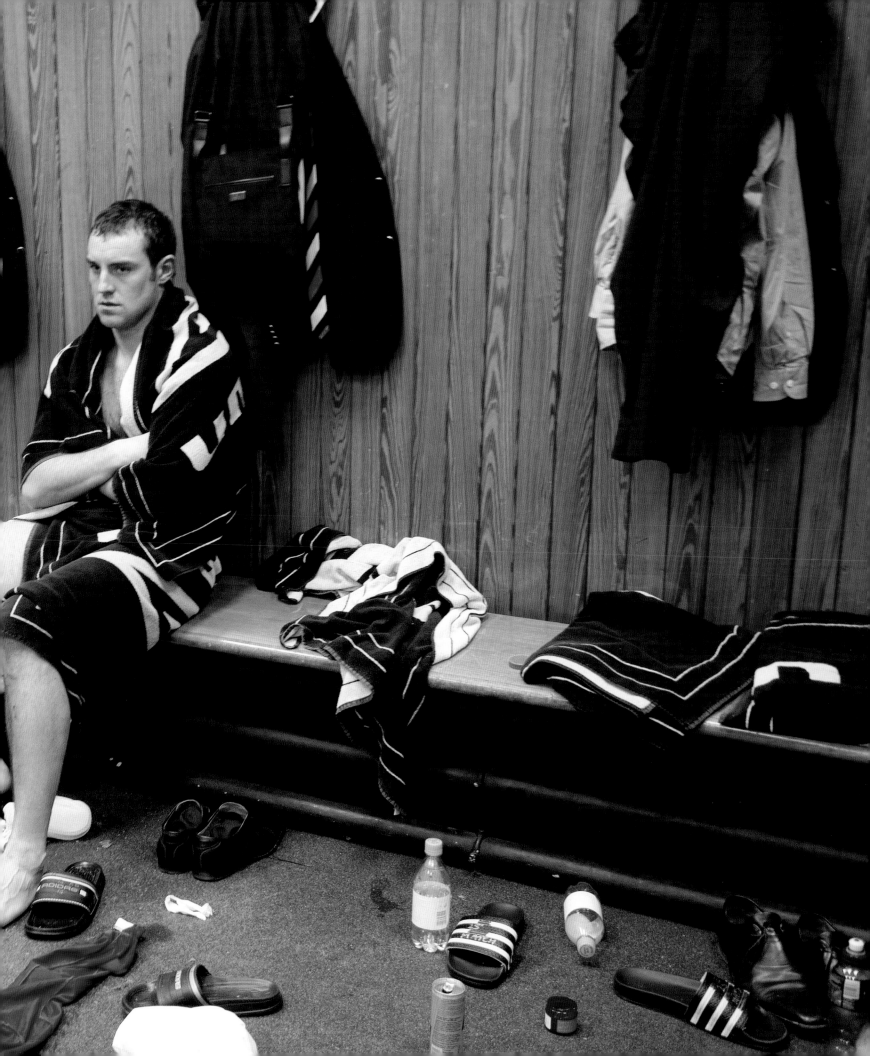

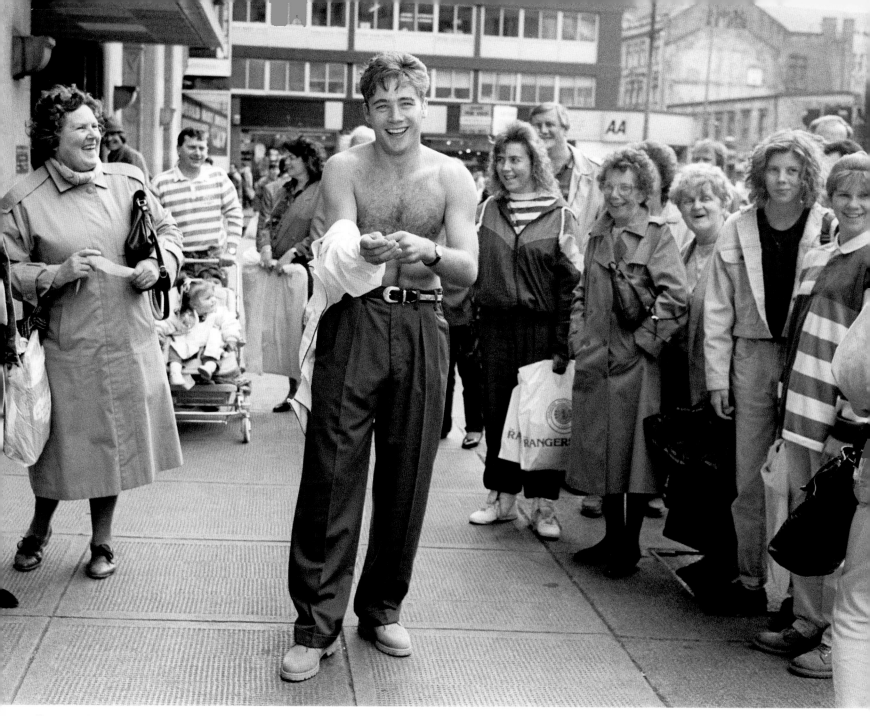

Ally McCoist, 1990

On the corner of Argyle Street and Hope Street, the Rangers star forward, who also played for Scotland, turned the ladies' heads when he stripped off his shirt to the delight of passers-by. I counted off the names of all the Rangers teams from 1945. He said that was amazing because he couldn't name the team from last week. What a good sport he was.

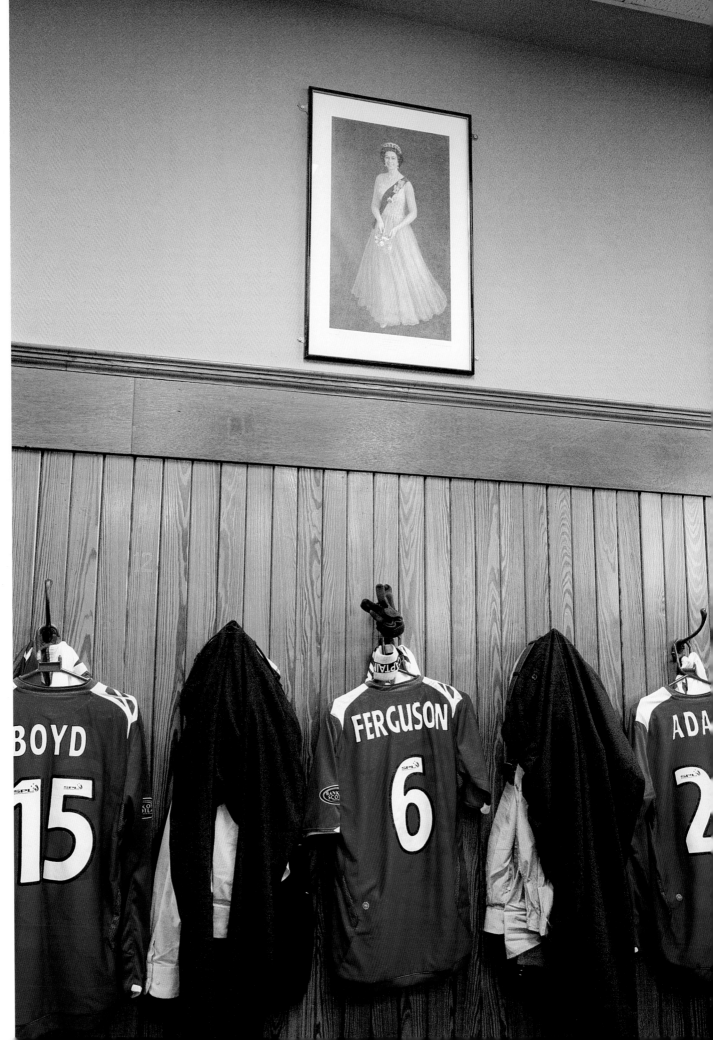

The Rangers' Dressing Room, 4 August 2006
Barry Ferguson's number six jersey hangs in the dressing room under a portrait of HRH Queen Elizabeth II.

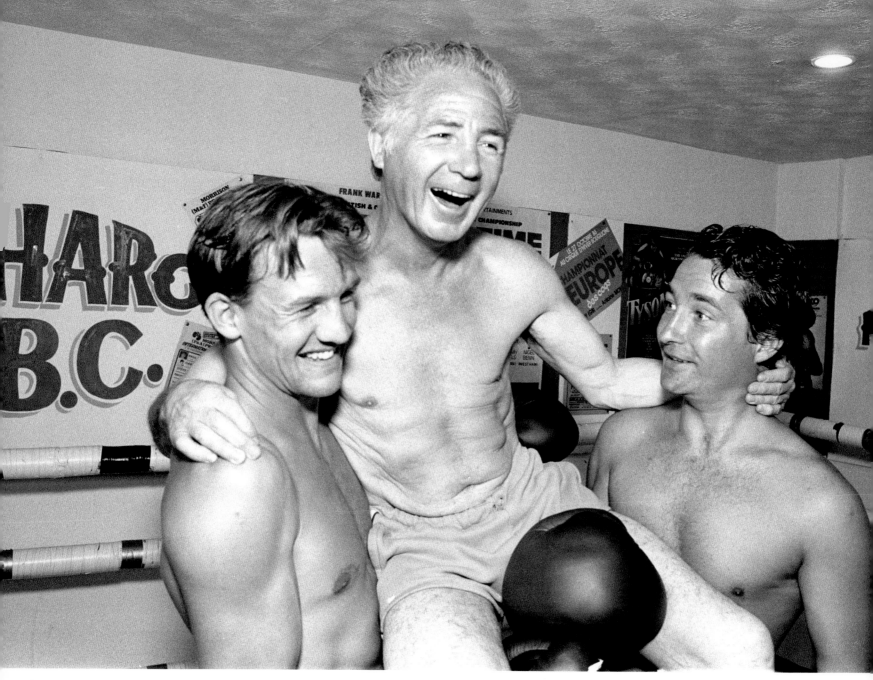

Peter Keenan, 1990

In a gym in the East End of Glasgow, two young boxers held aloft the boxing legend. I used to take Keenan's photograph and give him copies to autograph for his fans. He was the only one who ever paid me for the favour and I'll never forget it. When I had a book signing in Glasgow in the 90s, he came by to say hello. It was so good to see him again. I introduced him to my mother who was duly impressed.

**Charles McBain and
Davie Cooper, 1990**

Fellow *Hamilton Advertiser*
photographer Charlie
McBain was in the dressing
room at Fir Park with Davie
Cooper who played for
Rangers and Motherwell.
My long-time friend Charlie
and I used to photograph
the games together when
we were at the *Advertiser*.

**Alex Morrison,
February 2006**

The well-known boxing
promoter posed in Morrison's
gym in Dalmarnock. Many of
the fights he promotes
are held in the Thistle Hotel
in Glasgow.

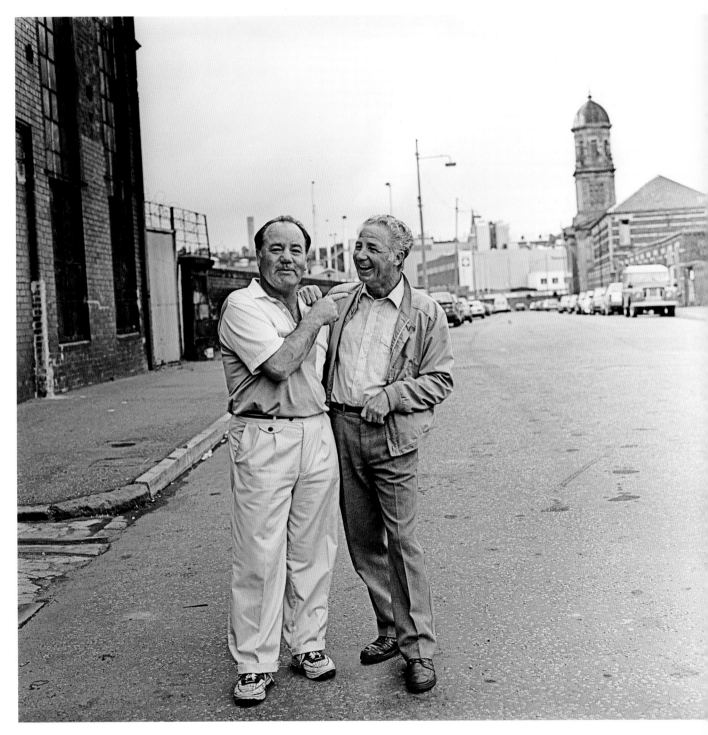

**Walter McGowan and
Peter Keenan, 1990**

McGowan (left) was
bantamweight world
champion but, to my mind,
he would not have beaten
Keenan. As they boxed
at different times, we'll
never know.

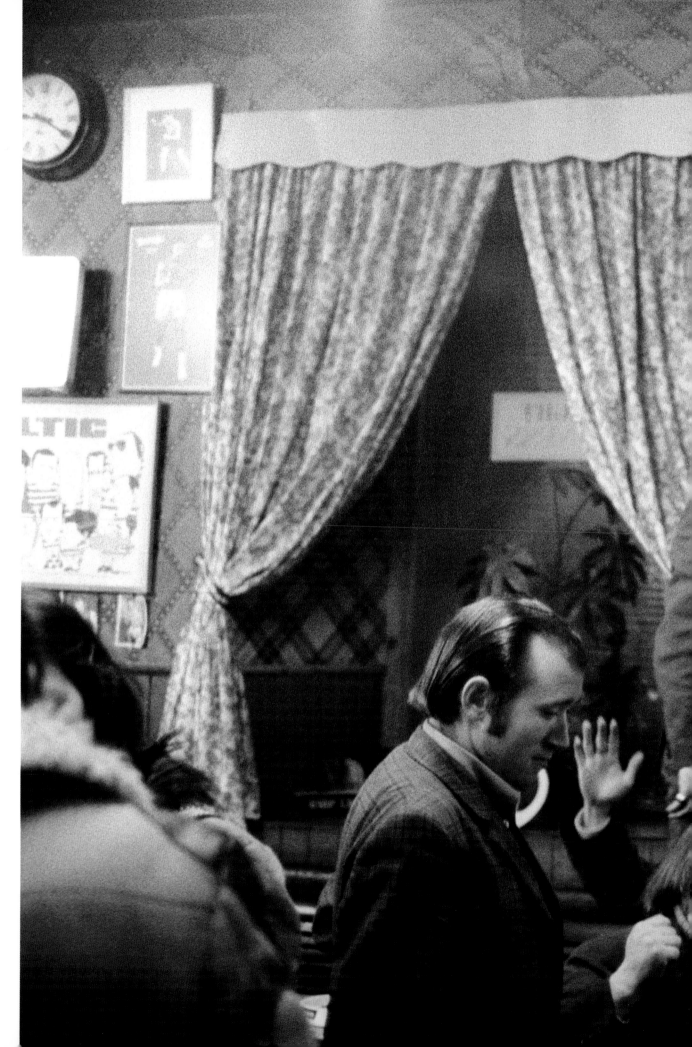

The Norfolk Arms, Gorbals, 1972

The pub's owner, Dick Gilmour (centre), and patrons were keen to pose beside a portrait of the world famous Scottish boxing champion Benny Lynch.

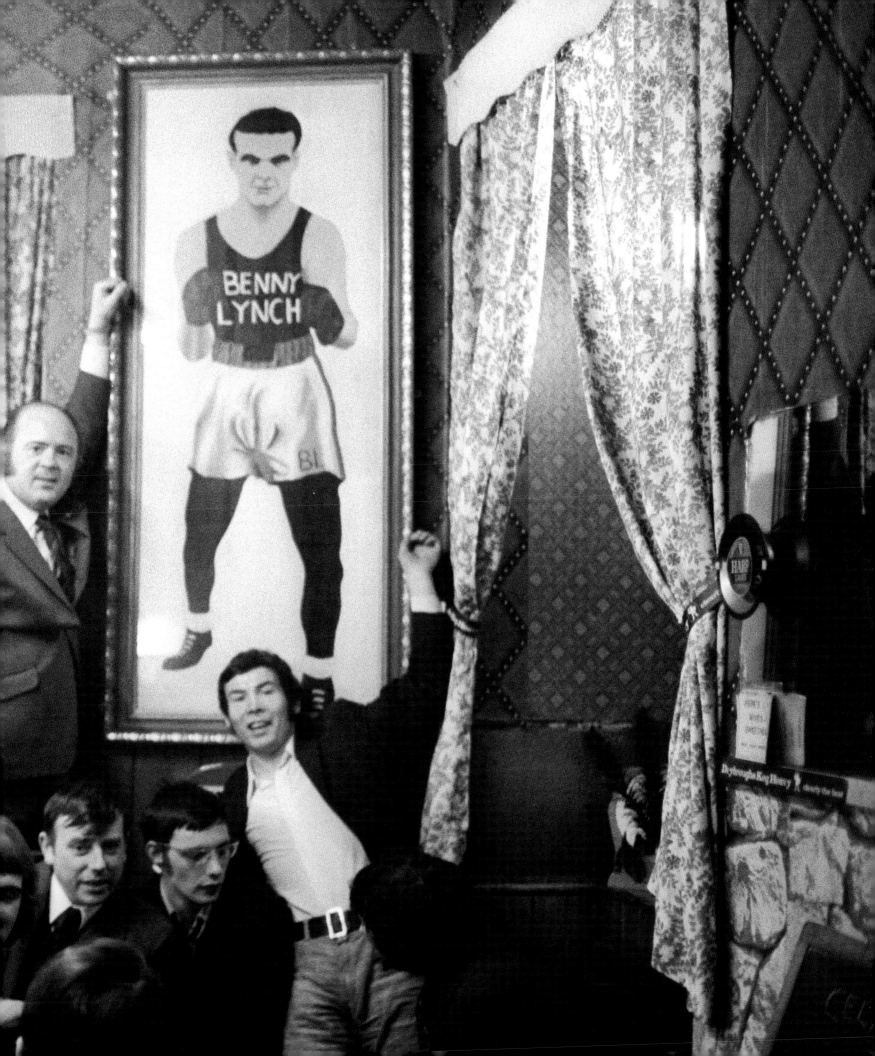

St Andrew's Sporting Club, 1990

Boxing night in Glasgow – it has become popular to stage a match in the middle of the hotel dining room.

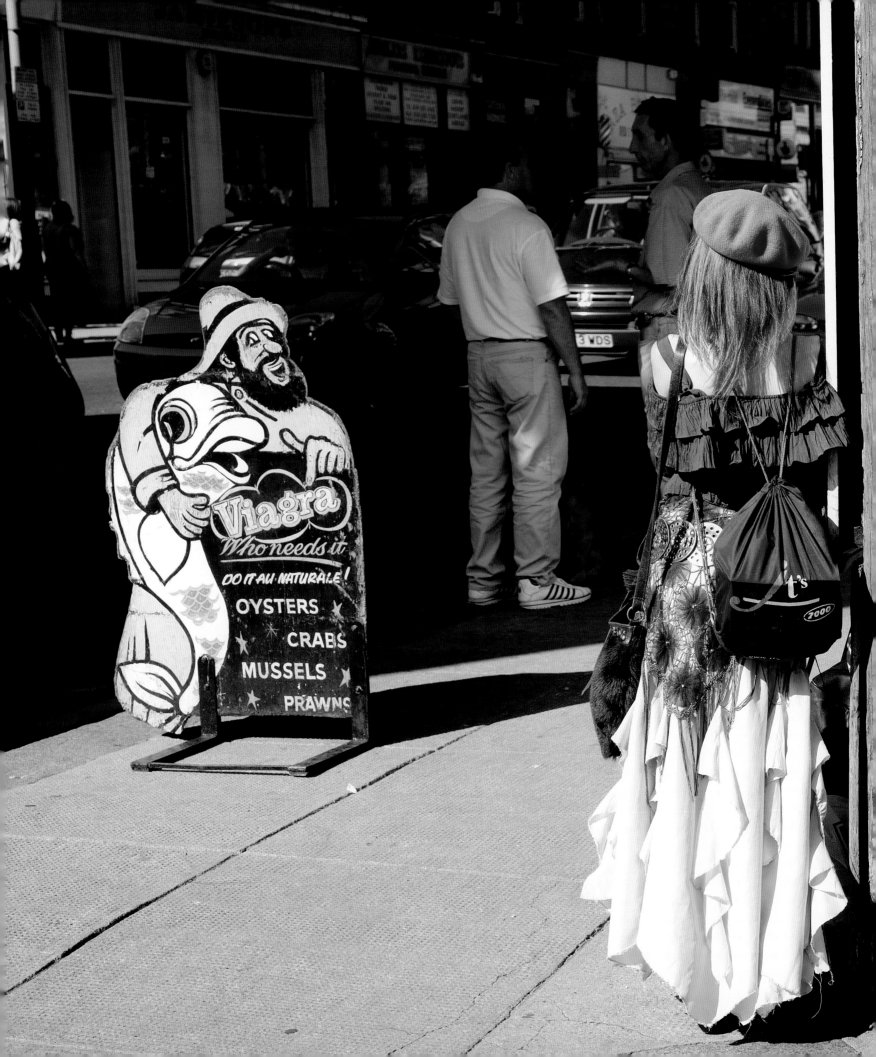

**Saltmarket,
August 2006**

I just happened upon this woman near the corner of Saltmarket and London Road leaning on the wall. Immediately, I was reminded of the hippy scene of the 60s.

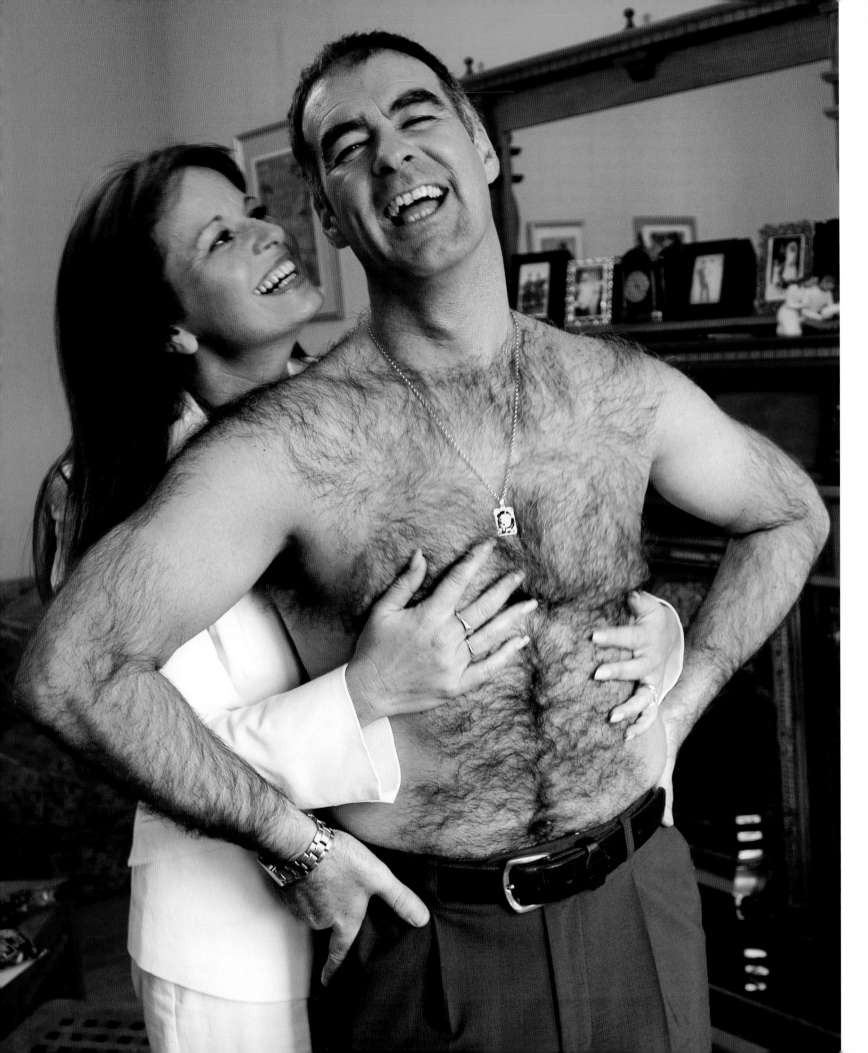

Tommy Sheridan and his wife Gail, August 2006

While I was in Glasgow working on this book, I read in all the papers about the defamation suit being brought against the *News of the World* by ex-MSP Sheridan. I read that Mrs Sheridan had taken the stand and had mentioned her husband's unusually hairy chest. It occurred to me that this would make a good photograph. It took the jury only three hours to find in Sheridan's favour.

Sauchiehall Street, August 2006

A young couple oblivious to their surroundings caught my eye.

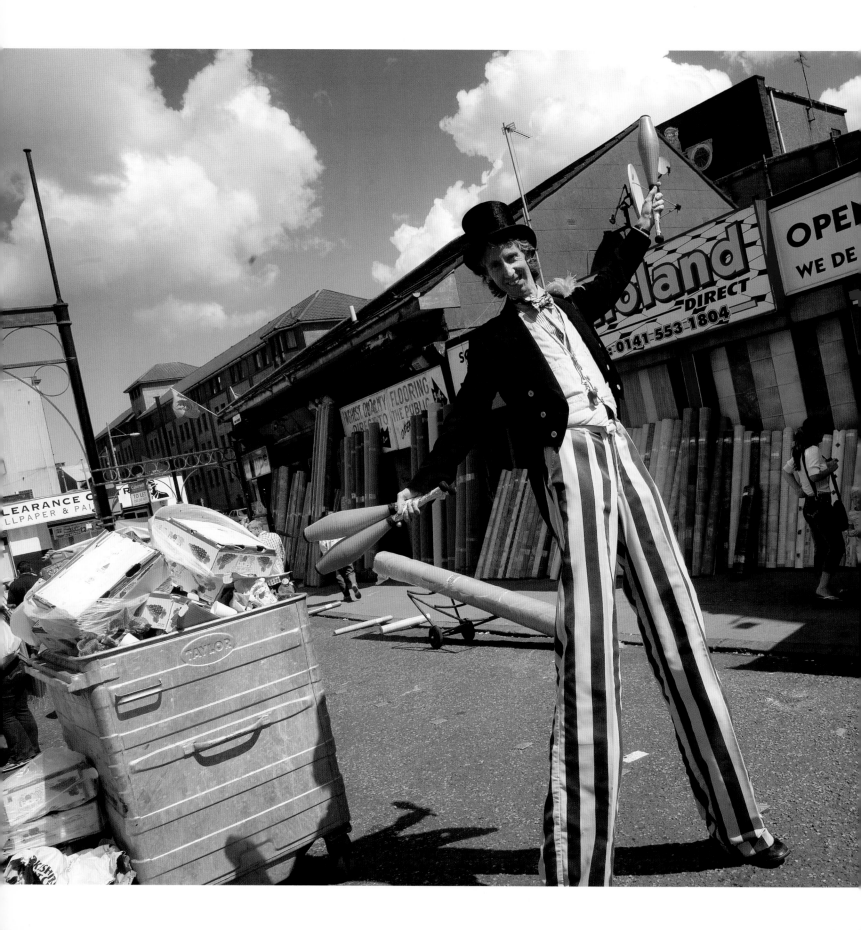

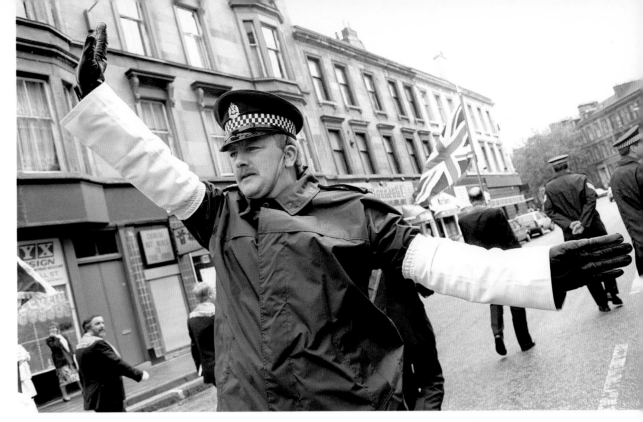

Policeman, 1990

This policeman was stopping traffic for the annual Orange Walk to pass by.

The Barras, August 2006

You never know what you will find in the Barrowland market, to give it its proper name. The ultimate flea market, I have visited the Glasgow landmark many times but I'd never seen the man on stilts before.

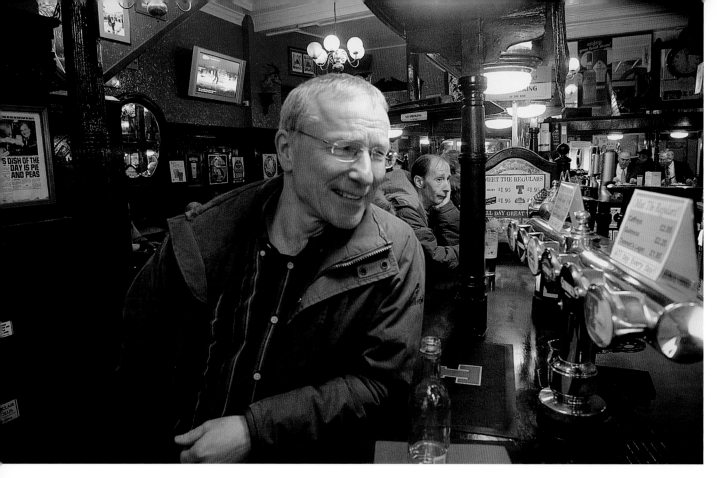

**Ian Pattison,
February 2006**

The Horseshoe Bar, right in the middle of town, is one of the most famous, if not *the* most famous, bars in Glasgow and that's where I met the congenial writer and creator of the television series *Rab C Nesbitt* for a drink. Upstairs is the Karaoke Capital of Glasgow but we left that for another time.

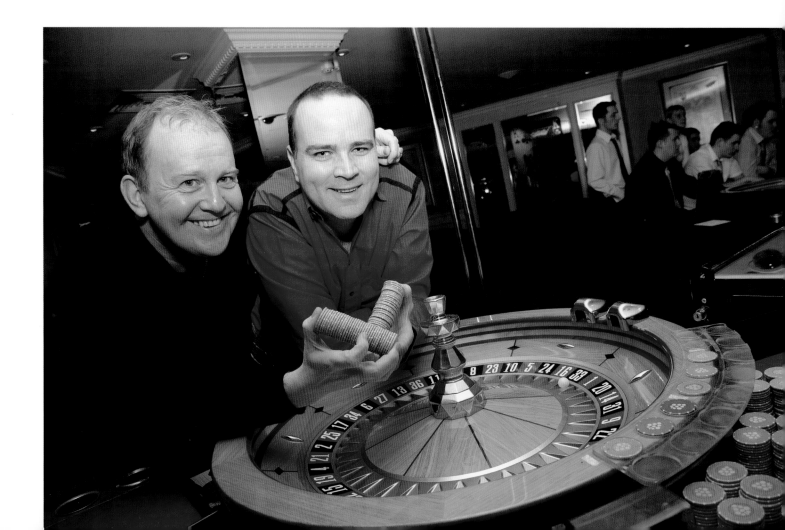

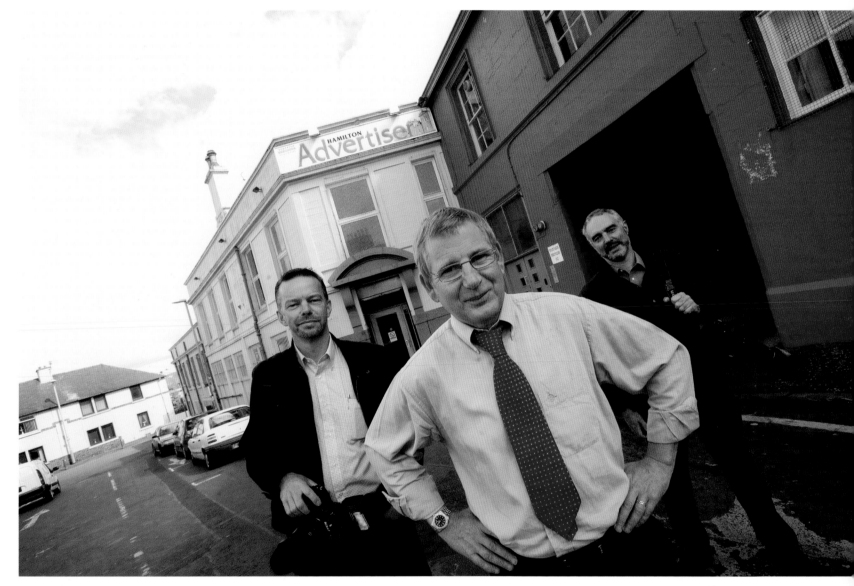

**Joe Kelly,
August 2006**

The editor of the *Hamilton Advertiser*, my first newspaper, posed in front of photographers Douglas McKendrick (left) and Norman Inglis outside the same office where I worked in the 50s.

ord Kiernan and Greg Hemphill, February 2006

he stars of *Still Game*, the hilarious Scottish BAFTA award-winning comedy eries, met me at the Rotunda casino for their hotograph.

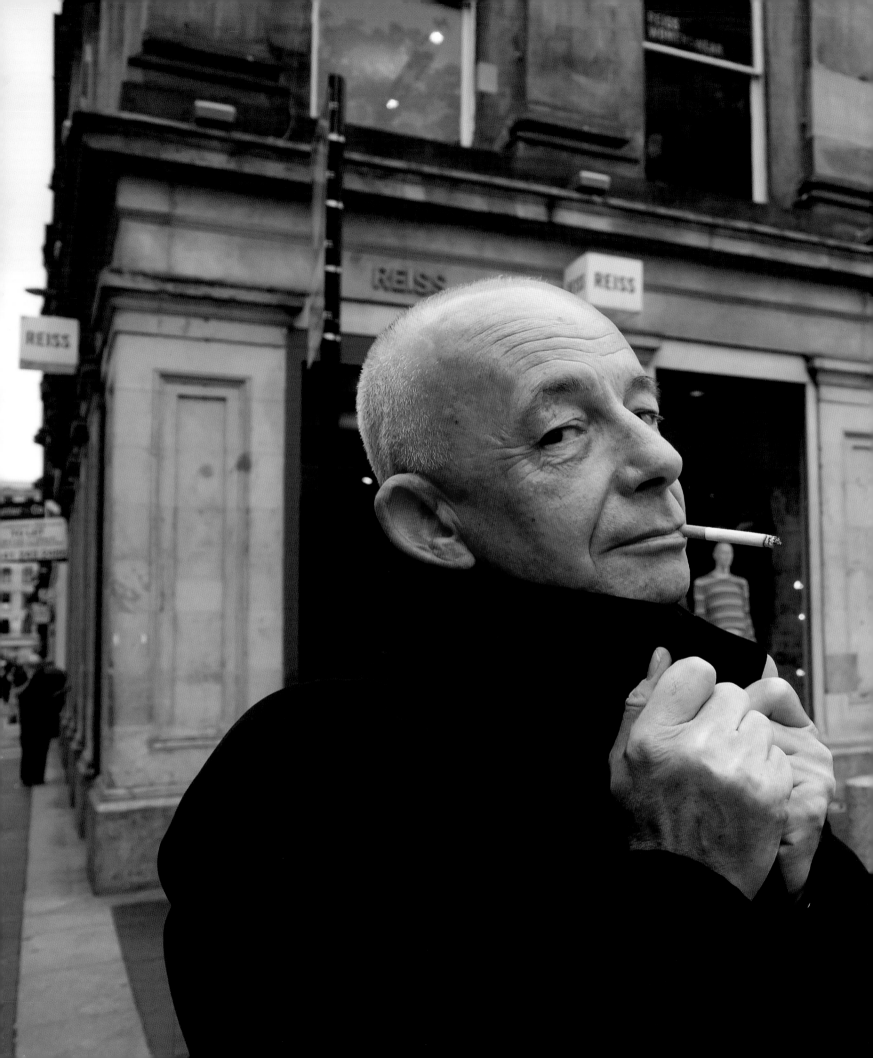

**Reg McKay,
February 2006**

When we met at the Rogano restaurant in Exchange Square, I wasn't disappointed. In his trench coat and with a cigarette between his teeth, Reg looked like the investigative reporter/crime writer he is. His quick eyes took in everything around us. He didn't miss a thing. And he was very helpful in getting Paul Ferris to pose for me. We had lots to talk about, including the infamous Kray Twins who I had once photographed and whom he had written about in his book *The Last Godfather – The Life and Crimes of Arthur Thompson*.

Gregor Fisher and his son, 1990

The Scottish actor is best known for his portrayal of Rab C Nesbitt in the popular sitcom but he also gave a brilliant performance when he played the manager of fading singer Bill Nighy in the 2003 film *Love Actually* which starred Hugh Grant.

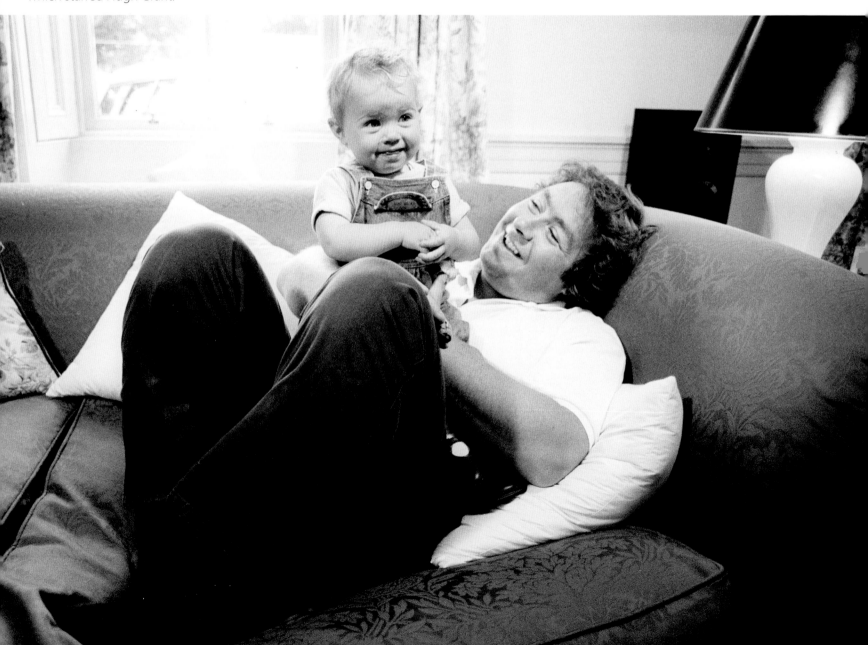

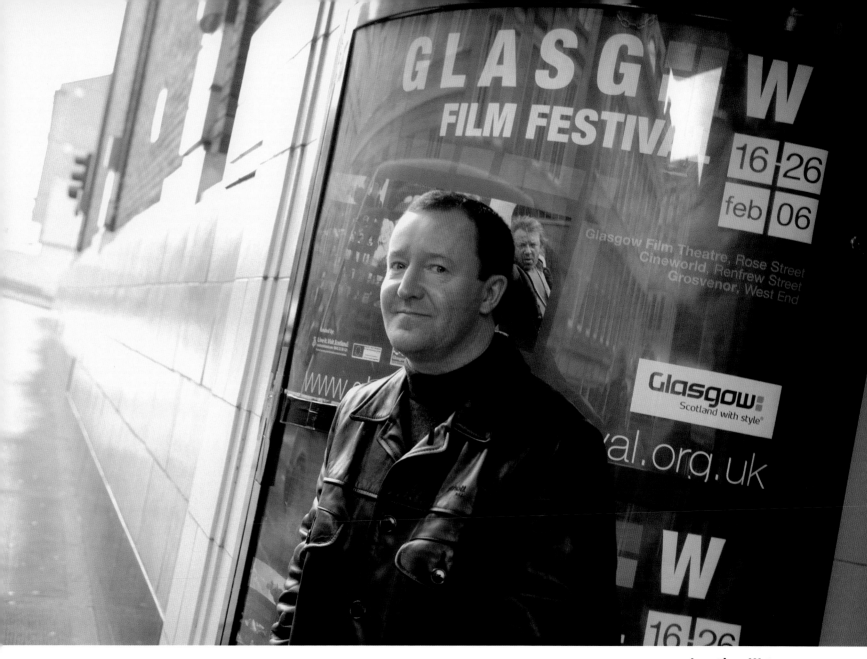

**Jonathan Watson,
February 2006**
Comedian and
impersonator extraordinaire
Jonathan Watson's TV show
Only an Excuse? takes a
satirical swipe at the world
of football and has gained
cult status. He has also
starred in the TV comedies
Naked Video and *City Lights*.
We met at the Glasgow Film
Festival Theatre on Rose
Street, where he records his
radio programme *Watson's
Wind-up*.

**John Hannah,
May 2006**

Nominated for a BAFTA for his superb performance in *Four Weddings and a Funeral*, the Scottish actor studied at the Royal Scottish Academy of Music and Drama in Glasgow. With a slew of credits to his name including *Sliding Doors* opposite Gwyneth Paltrow and the *Mummy* franchise of films, Hannah has not lost his down-to-earth Glasgow charm.

Following page:
**The Press Bar,
August 2006**

Here gathered together with only one drink for the entire group are the editors of the Glasgow papers. The encounter was certainly not like in the old days when everyone would be drinking and laughing in the bar. The editors and deputy editors who joined me for the photograph are: Charles McGhee, *The Herald*, Richard Walker, *Sunday Herald*, Les Snowdon, *Sunday Times*, David Dinsmore, *The Sun*, Bruce Waddell, *Daily Record*, Allan Rennie, *Sunday Mail* and Donald Martin, *Evening Times*.

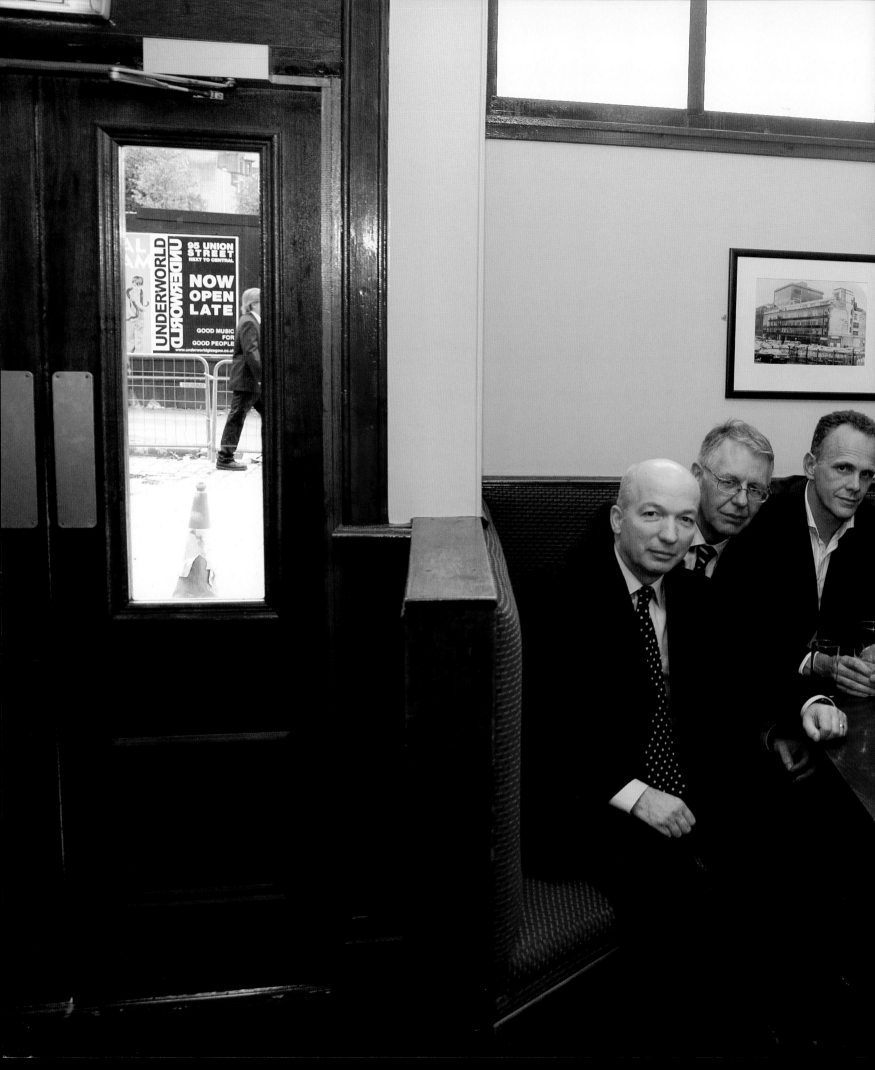

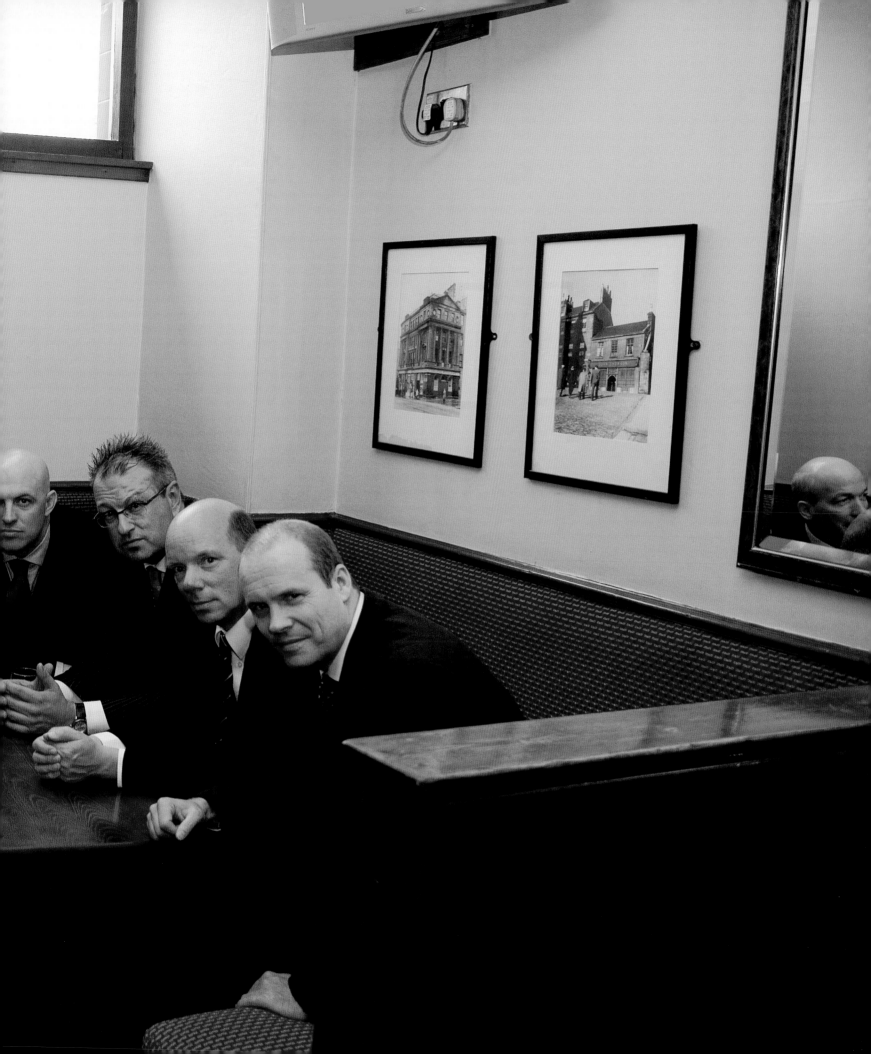

Kenny MacAskill MSP, 2006

We became friends when the charismatic MSP included me in the book he co-authored with former First Minister Henry McLeish entitled *Global Scots – Voices from Afar*. Kenny has found time to write several books while keeping up a formidable schedule as the MSP for Edinburgh East and Musselburgh. He generously helped to arrange it for me to photograph the Rangers' Board of Directors for this book. Kenny was appointed Justice Minister in May 2007.

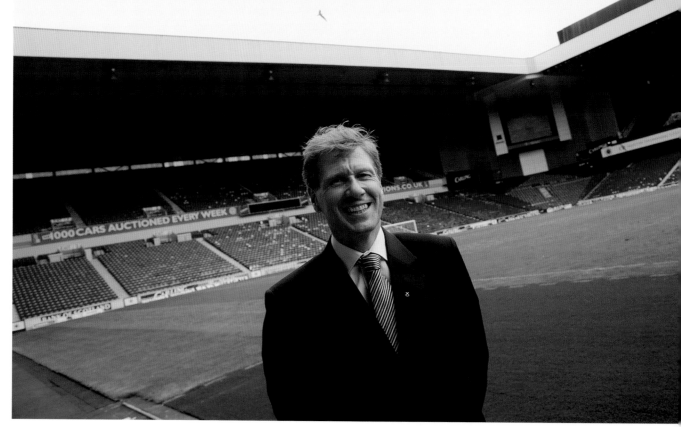

Philip Rodney, September 2006

The amenable Chairman of Burness LLP, one of Scotland's premier law firms, posed in their Glasgow office. The firm employs over 220 people in Glasgow and Edinburgh and its diverse clients are based all over the world. Burness steps up to sponsor many exhibitions for Scottish museums including *Being There*, the exhibition of my photographs at the Scottish National Portrait Gallery in 2006.

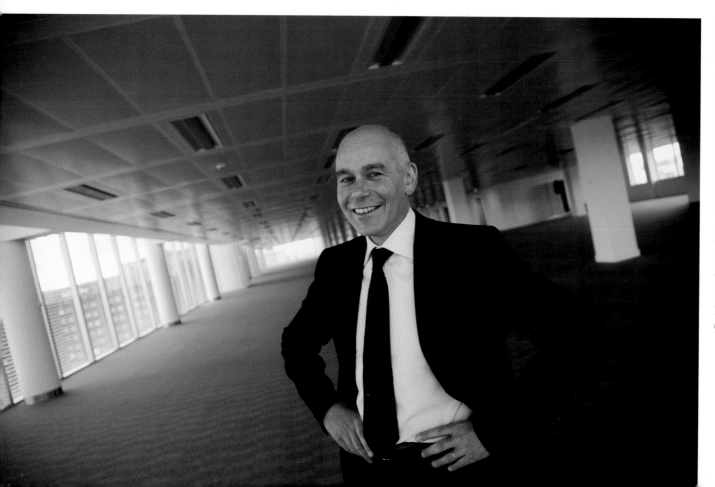

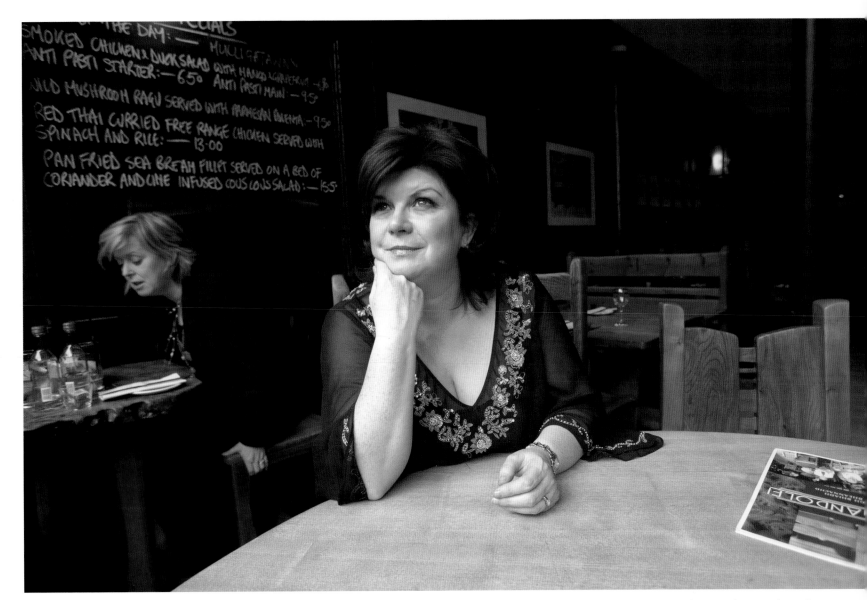

The blackboard in the background reads:

OF THE DAY :— MULLIGATAWNY
SMOKED CHICKEN & DUCK SALAD WITH MANGO VINEGRETTE +8⁰
ANTI PASTI STARTER :— 6⁵⁰ ANTI PASTI MAIN — 9⁵⁰
WILD MUSHROOM RAGU SERVED WITH PARMESAN POLENTA — 9⁵⁰
RED THAI CURRIED FREE RANGE CHICKEN SERVED WITH
SPINACH AND RICE :— 13·00
PAN FRIED SEA BREAM FILLET SERVED ON A BED OF
CORIANDER AND LIME INFUSED COUS COUS SALAD :— 15⁵⁰

**Elaine C. Smith,
February 2006**

Elaine is one of Scotland's
best-known actresses
and I met her at the Café
Gandolfi for a cup of
tea. Her television series

Elaine with Attitude and
Hormonally Driven were not
only fun but also successful
and, for the last seven years,
she has played the panto
dame at the King's Theatre.

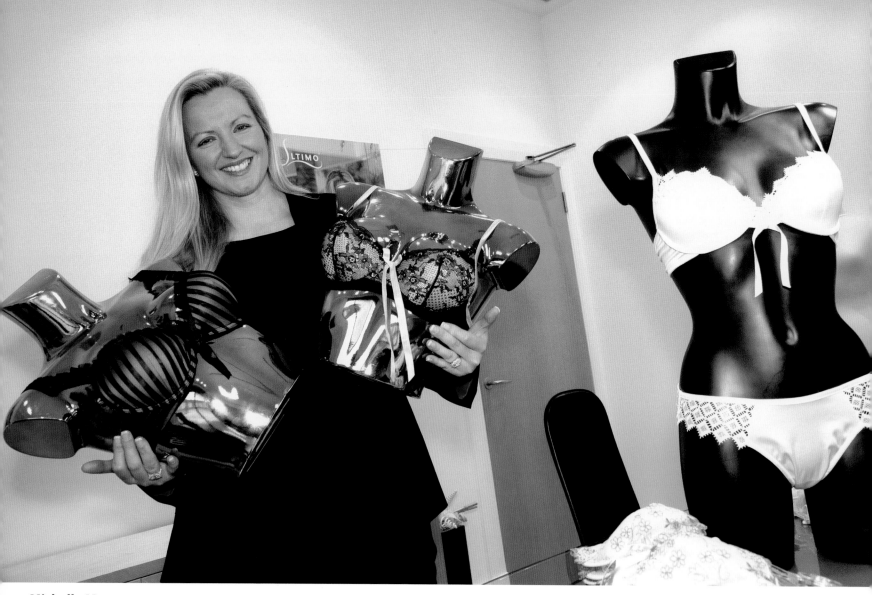

**Michelle Mone,
February 2006**

When I asked the attractive
entrepreneur to grab two
mannequins, she was a
good sport and obliged.
Shown here in her Ultimo
design room, she turns out
the lingerie and swimwear
women want.

Mary Lee,
February 2006

Ms Lee was married to
the late Jack Milroy and
she agreed to wear her
husband's signature
red satin jacket for the
photograph. Milroy was one
half of the comedy team
Francie and Josie.
His partner in the much-
loved 60s television series
of the same name was
Rikki Fulton.

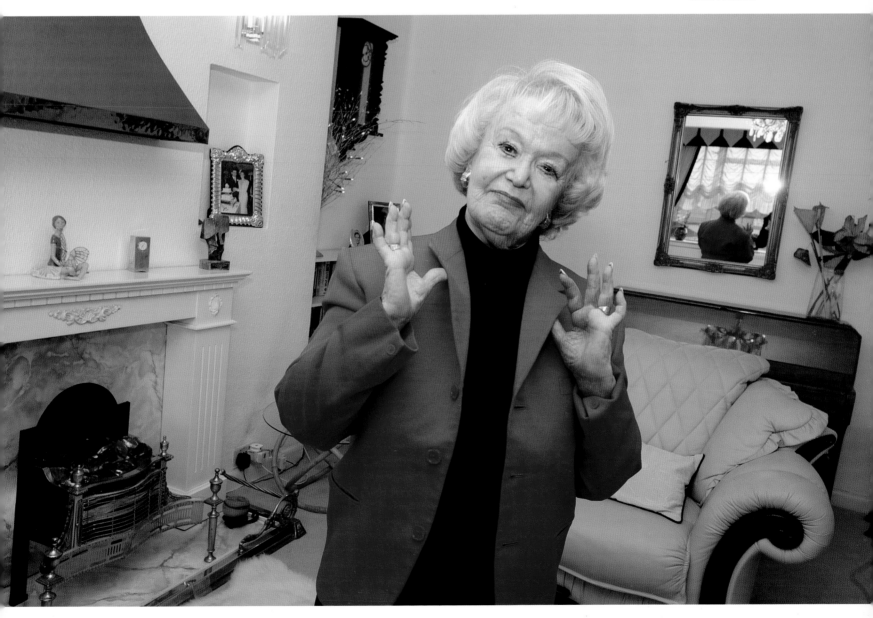

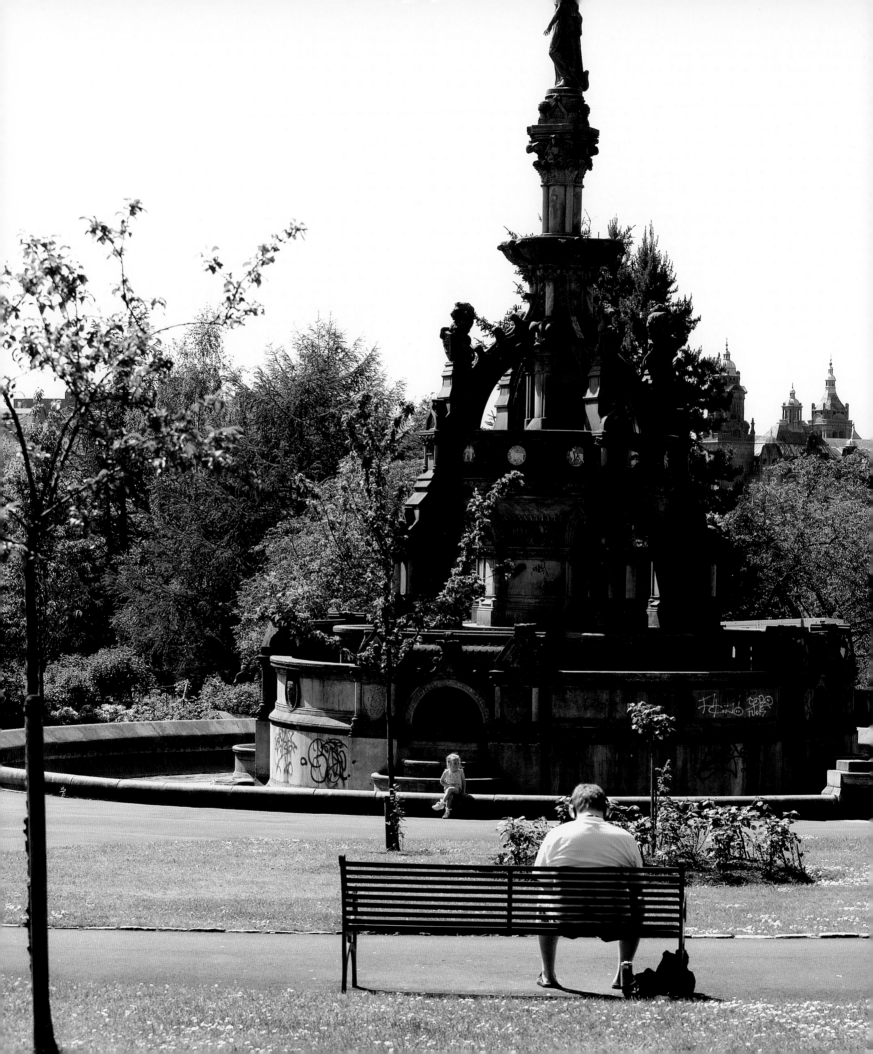

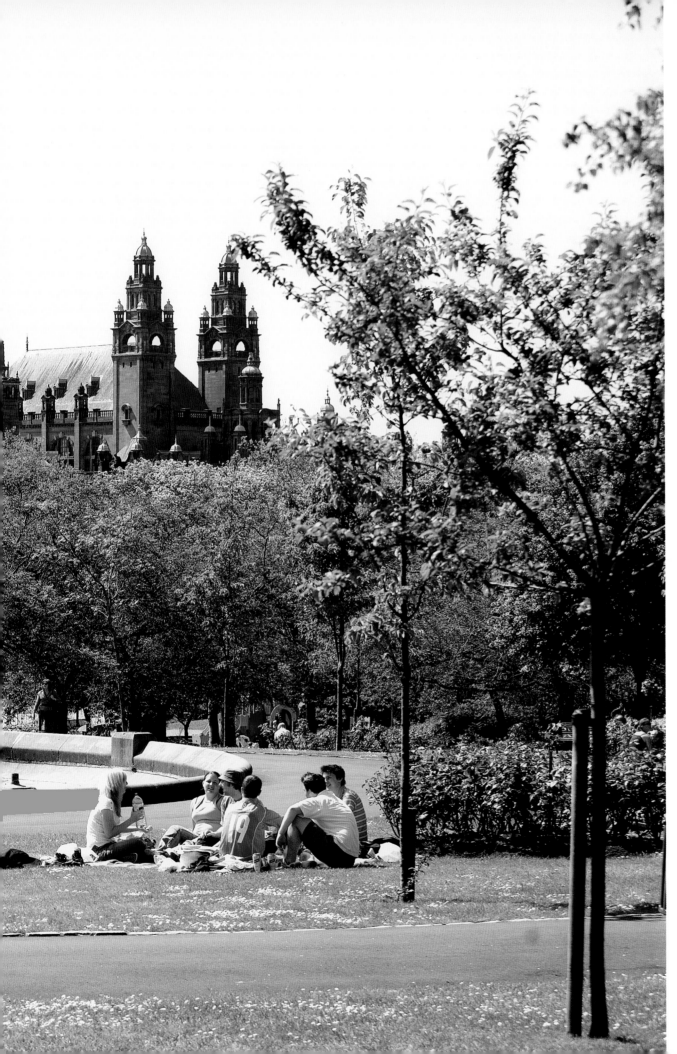

**Kelvingrove Park,
May 2006**
Kelvingrove Park, with the
Stewart Memorial Fountain
in the foreground and
Kelvingrove Art Gallery and
Museum in the background,
is one of the most beautiful
parks in the world.

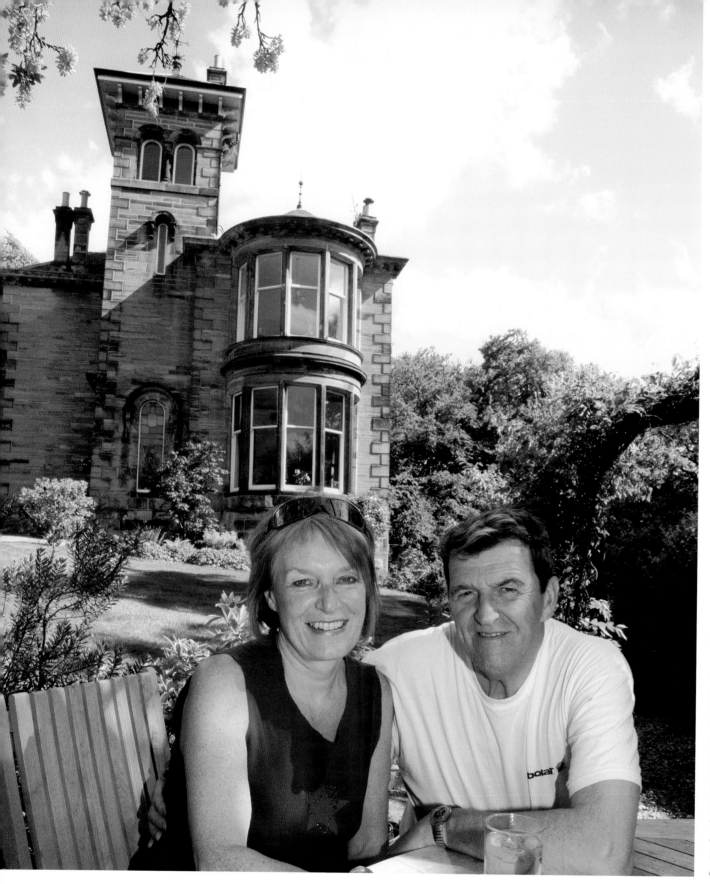

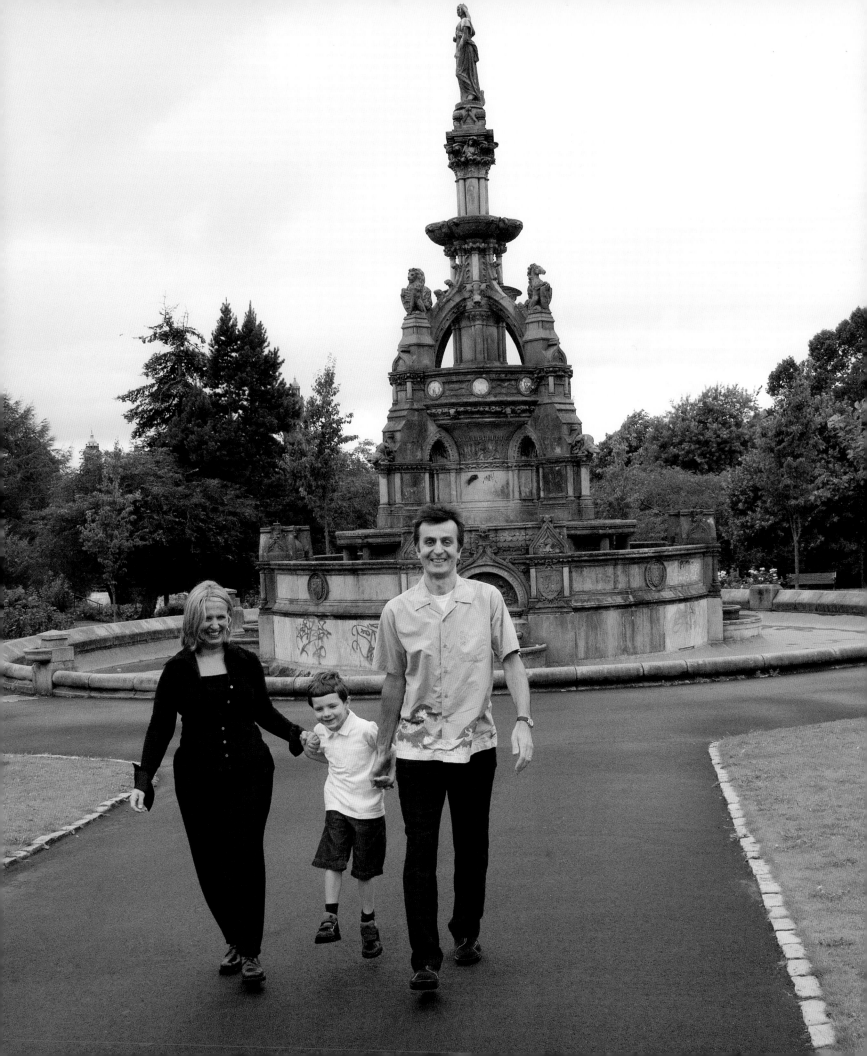

A Single End, 1972

A man and his wife lived
in this one very tidy room.
Their bedroom, kitchen
and living room were all
combined in one room or,
to put it another way, they
had a studio apartment.

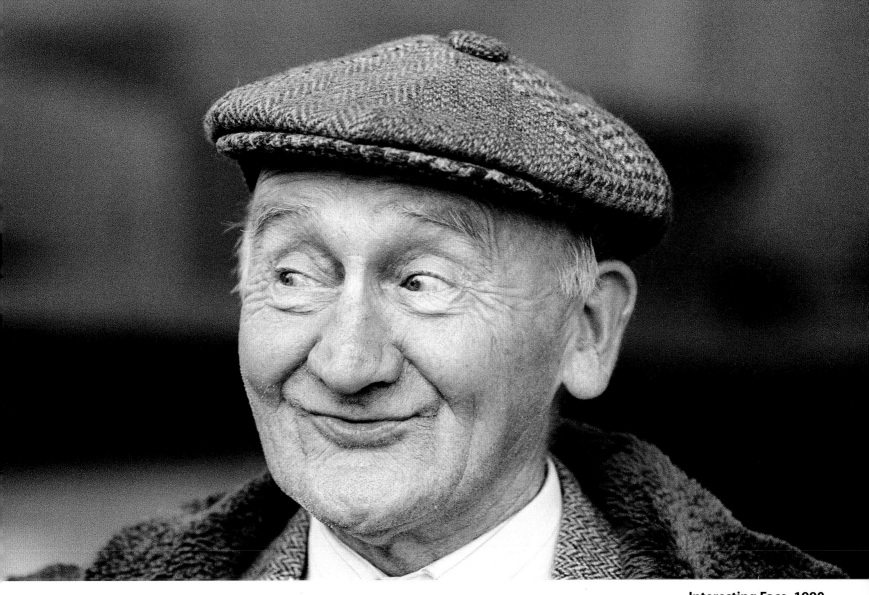

Interesting Face, 1990
While photographing in the fish market, I came across this gentleman who caught my eye immediately. With such a happy grin on his face, he made everyone around him smile.

Doulton Fountain on Glasgow Green, August 2006

The largest terracotta fountain in the world, it was built in Kelvingrove Park in 1888, relocated to Glasgow Green in 1890 and then moved to the front of the People's Palace in 2005. Queen Victoria sits atop the magnificent structure with four of Britain's colonies – Australia, India, South Africa and Canada – carved below.

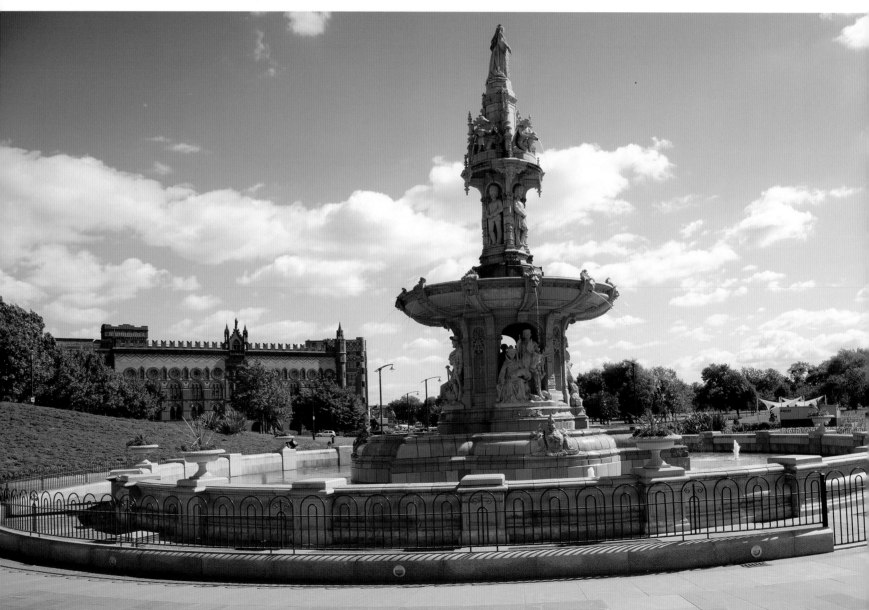

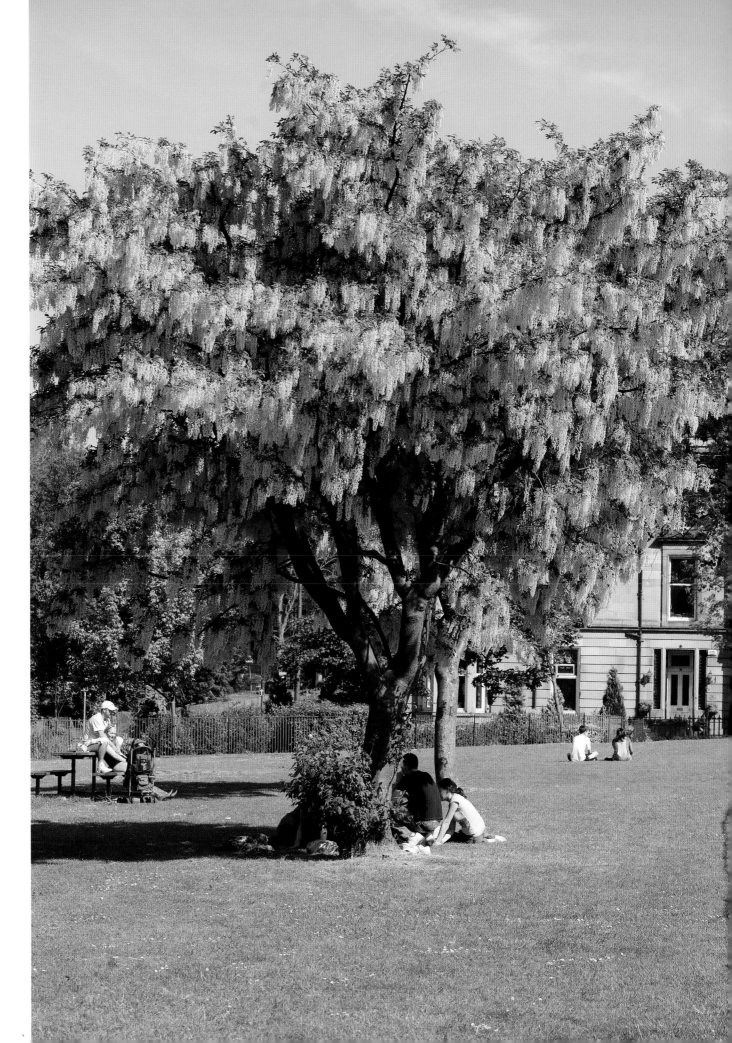

Kelvingrove Park, June 2006

This stately laburnum tree caught my eye as I wandered round the park one sunny day.

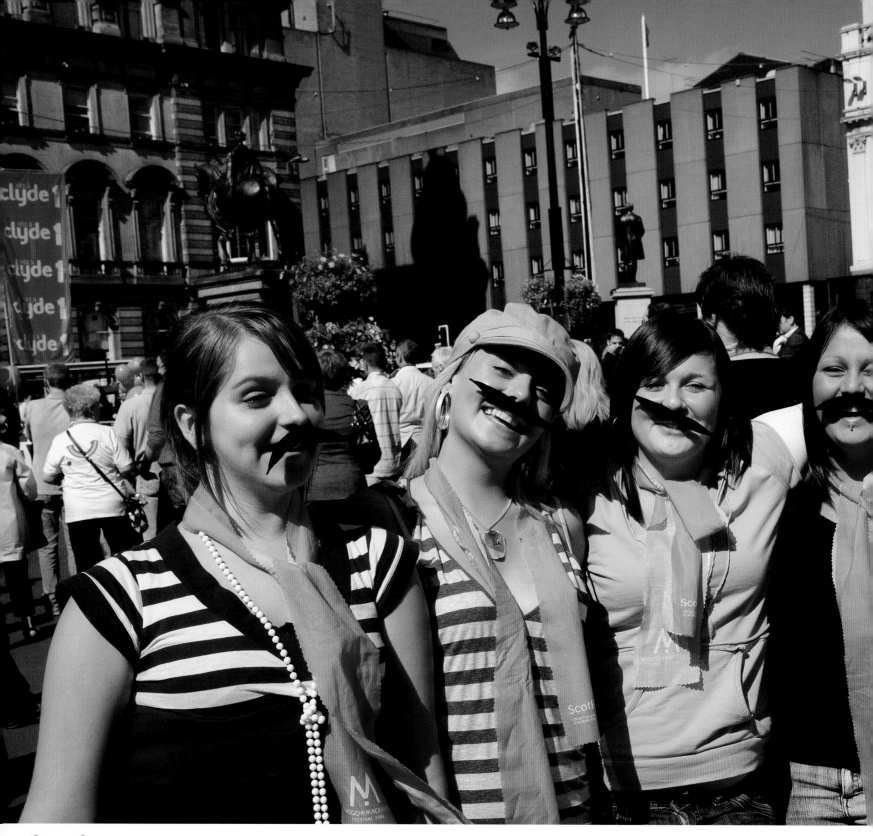

**George Square,
Rennie Mackintosh Day,
June 2006**

Everyone joined in the fun
by donning fake moustaches
and pink Mackintosh Festival
scarves in honour of the
anniversary of the famed
architect's birthday.

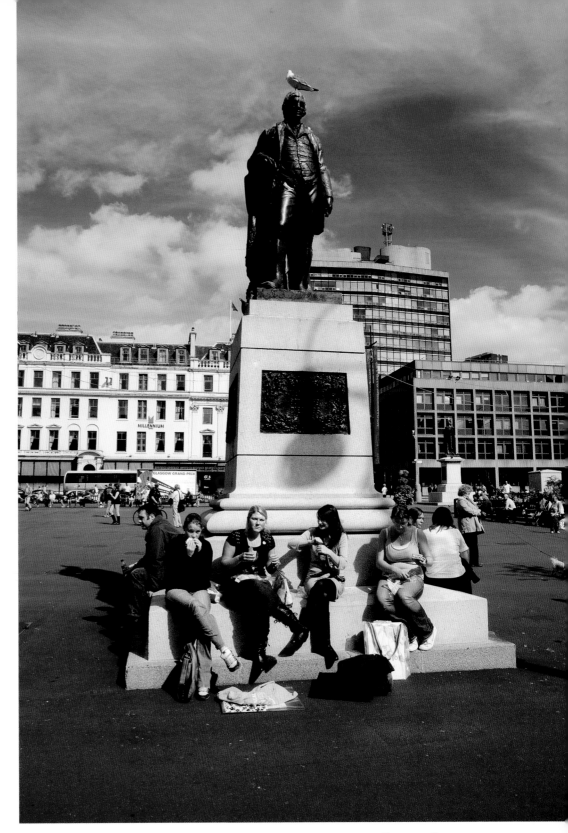

George Square, June 2006

Several young people were enjoying their lunch while sitting under the statue of Robert Burns. They were unfazed by a visitor perched on top of Burns' head.

Ashton Lane off Byres Road, June 2006

The charming outdoor cafes were full as everyone was enjoying the good weather. There were no cafes like these when I lived in Glasgow.

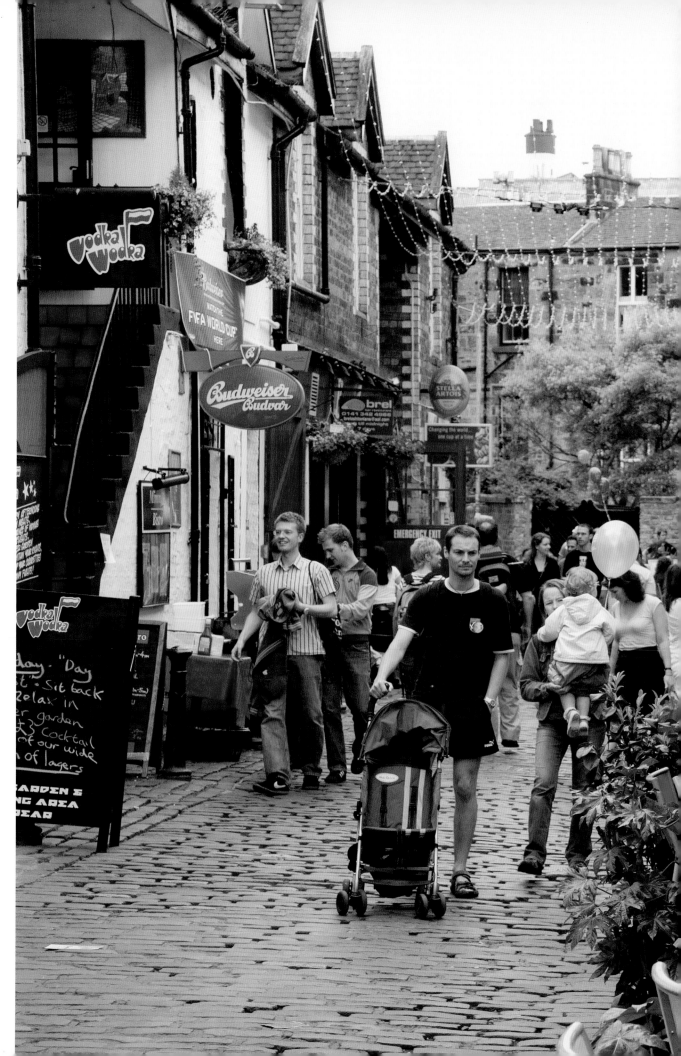

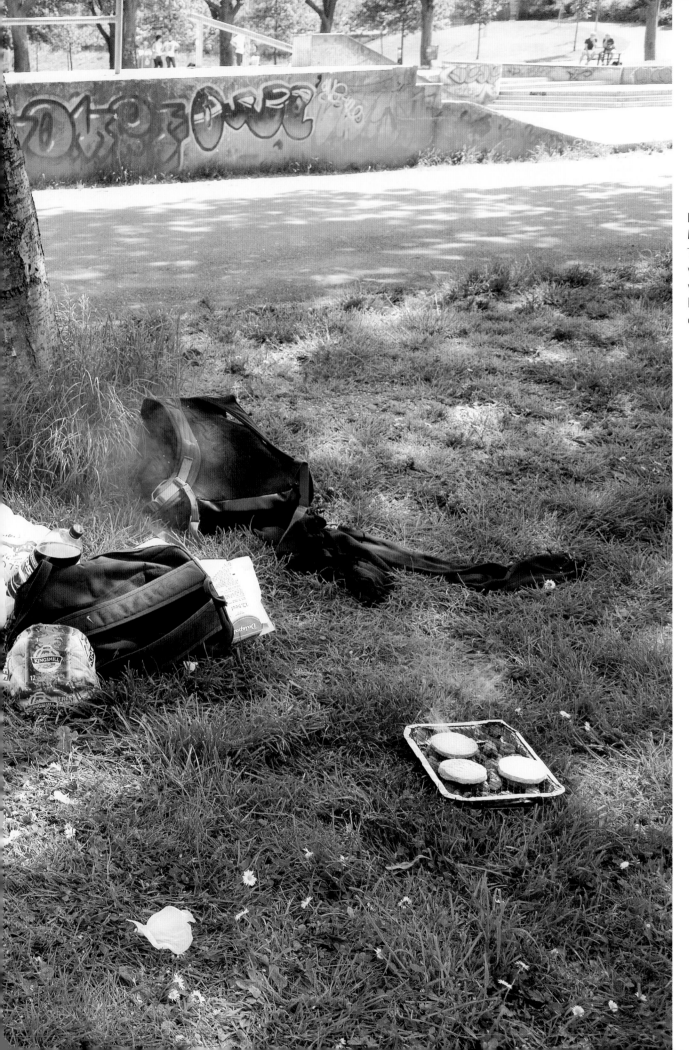

Kelvingrove Park, May 2006

These young people were relaxing in the park while they cooked hamburgers on a tiny disposable barbecue.

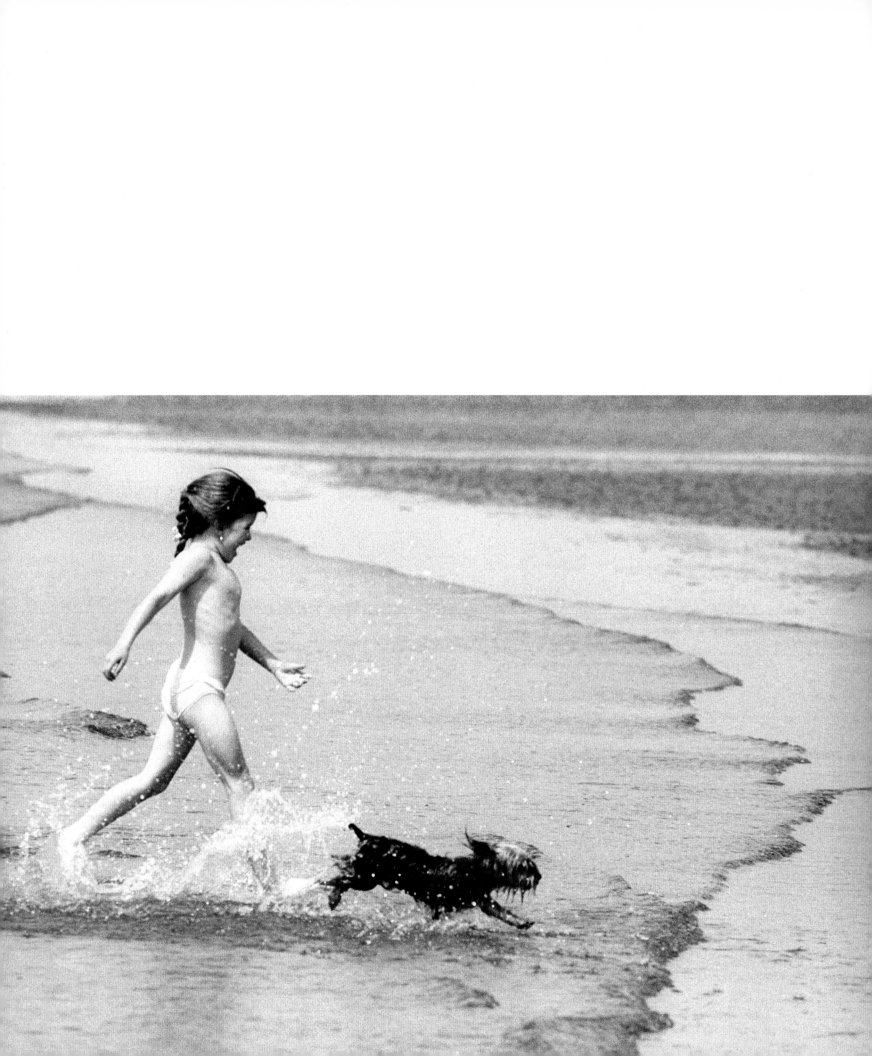

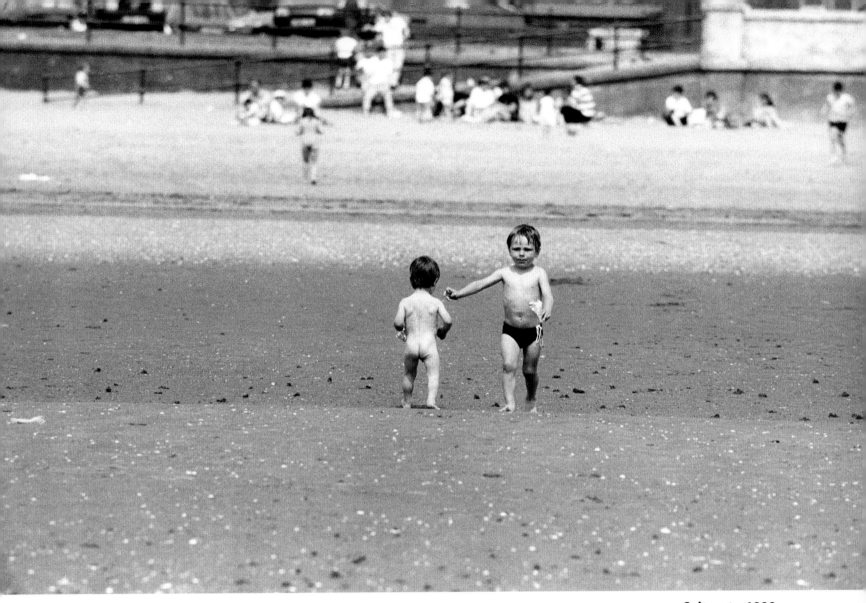

Saltcoats, 1990
With the BBC's Val Atkinson and camera crew in tow, we went to the beach at Saltcoats to see what we could find. She wanted to document me at work and I found several interesting situations like these – a little girl and her dog playing in the water and two children playing in the sand, each one oblivious of the other.

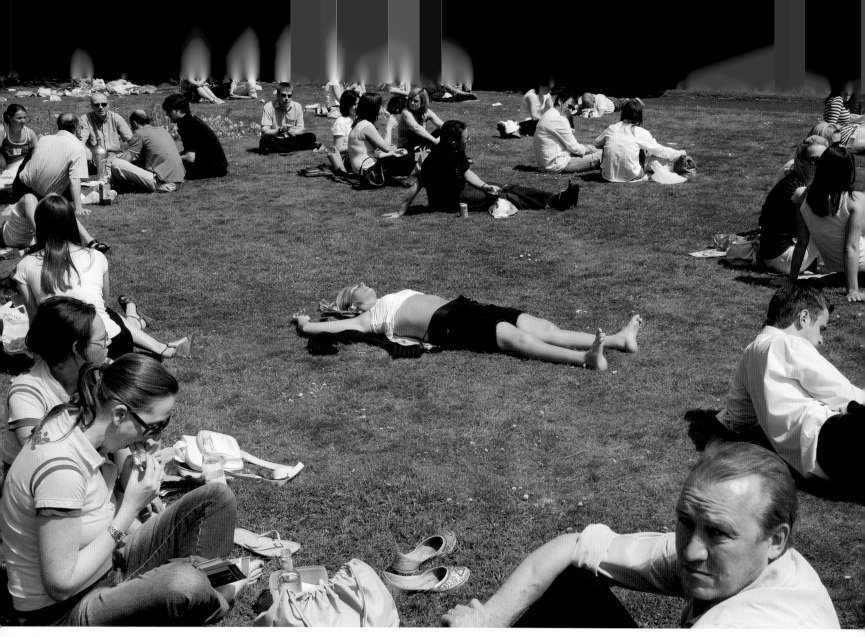

**Blythswood Square,
August 2006**

A sunny summer's day
had people going into the
square for their lunch break.
One woman at rest was
completely encircled by
fellow park visitors.

Saltcoats, 1990
I liked the graphic design
made by a woman sleeping
on the beach completely
surrounded by sand.

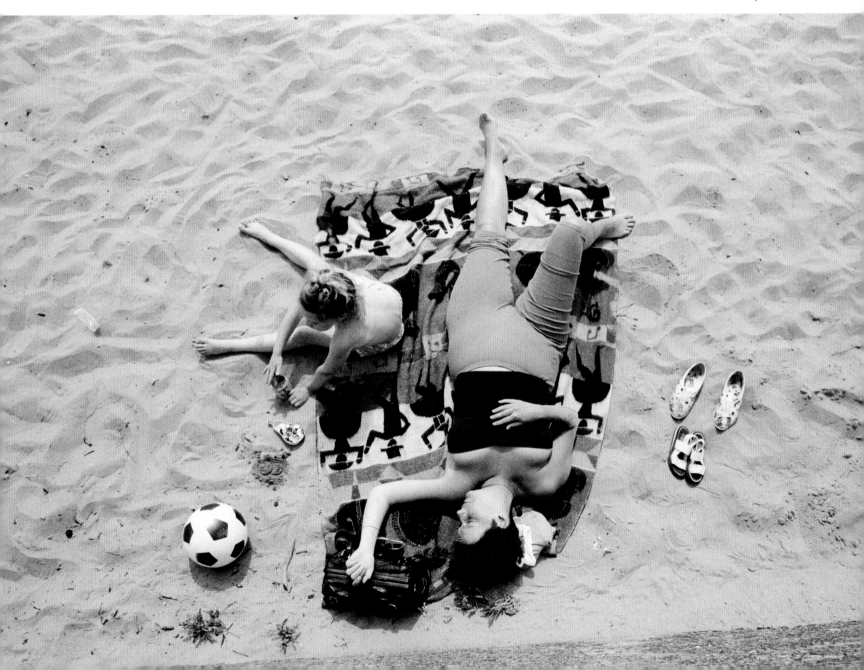

**Kelvingrove Park,
June 2006**
The barefoot frisbee player
was engrossed in her game
played during a spectacular
summer's day in the park.

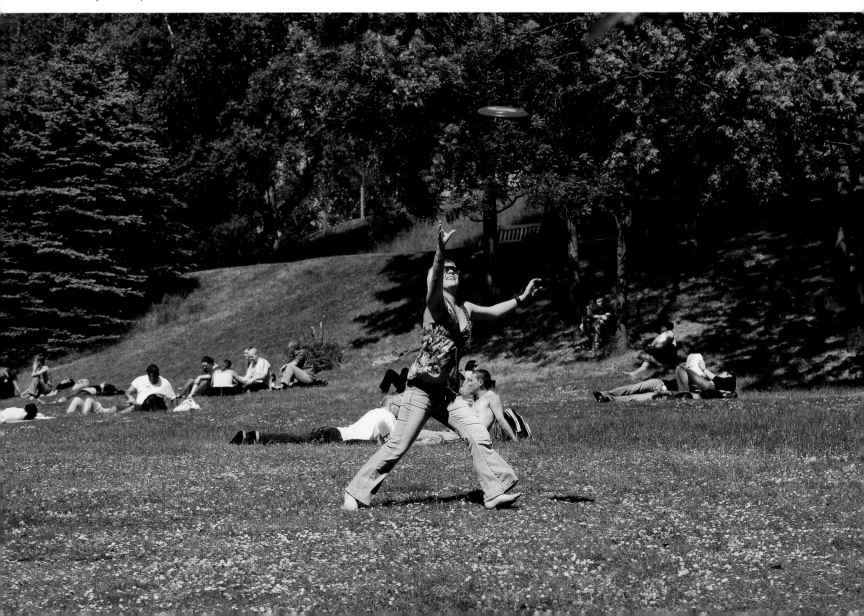

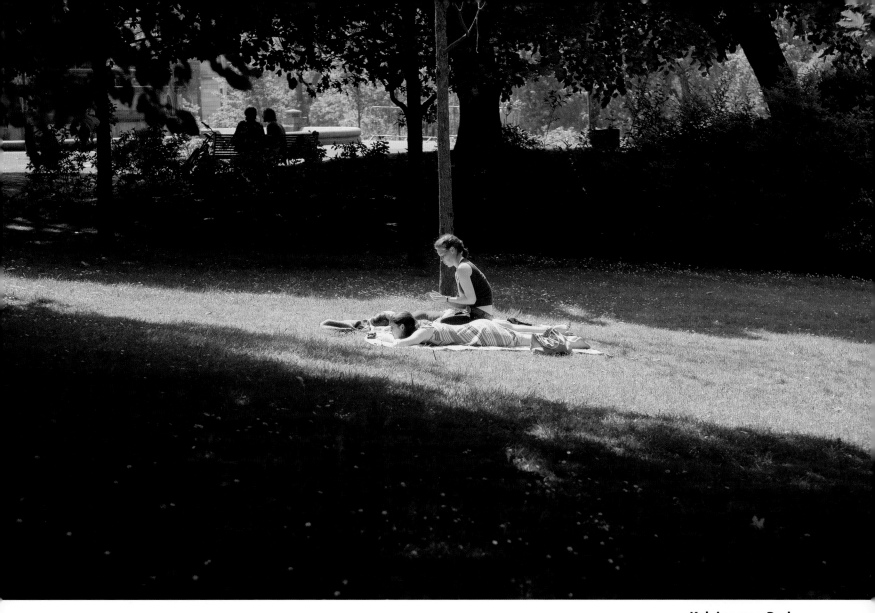

**Kelvingrove Park,
June 2006**

These young women look
as though they've found
one of the few sunny spots
in this part of the park.

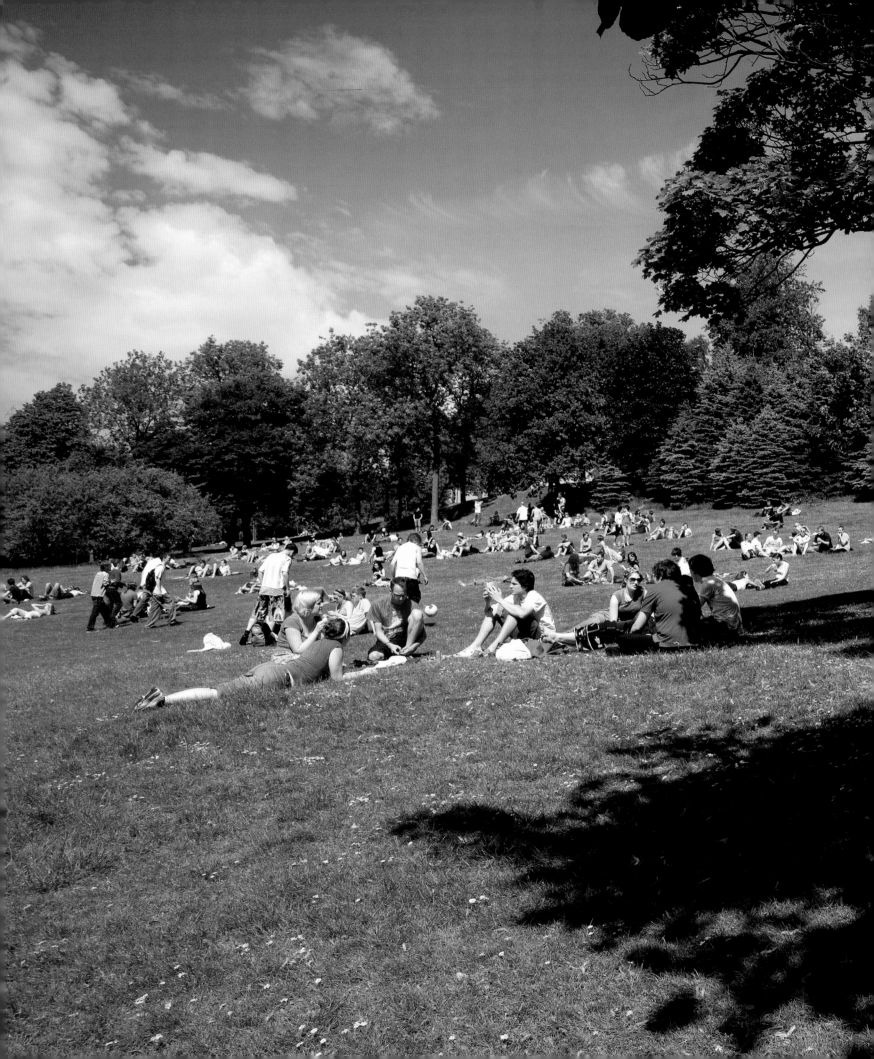

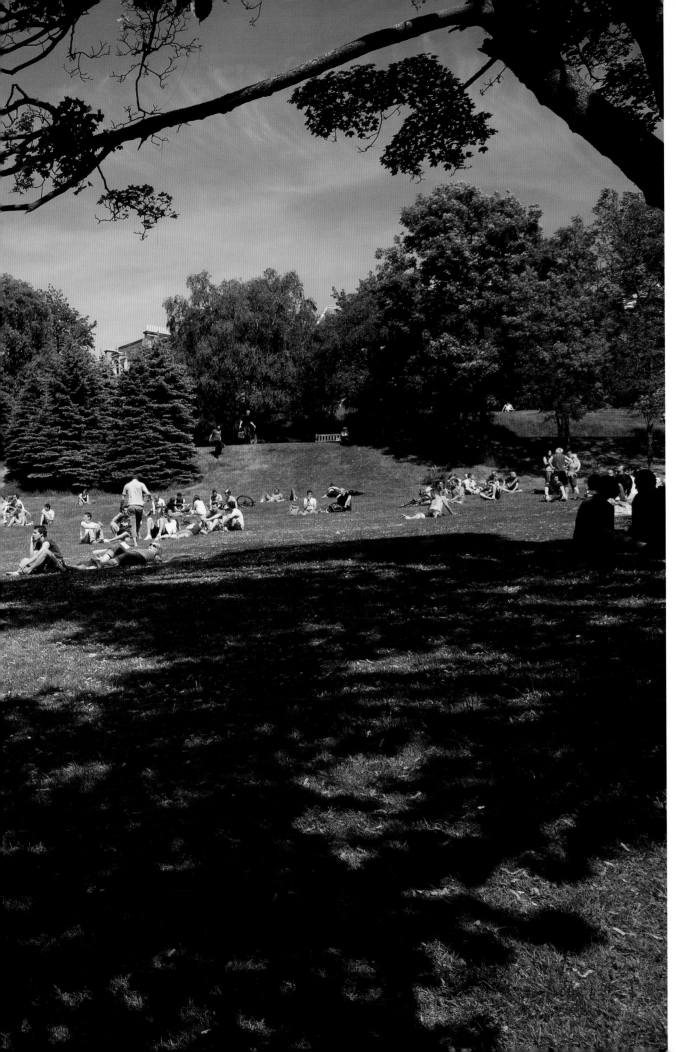

Kelvingrove Park, June 2006

Another bright summer's day found people relaxing in the sunshine and again carefully avoiding the shade of the trees.

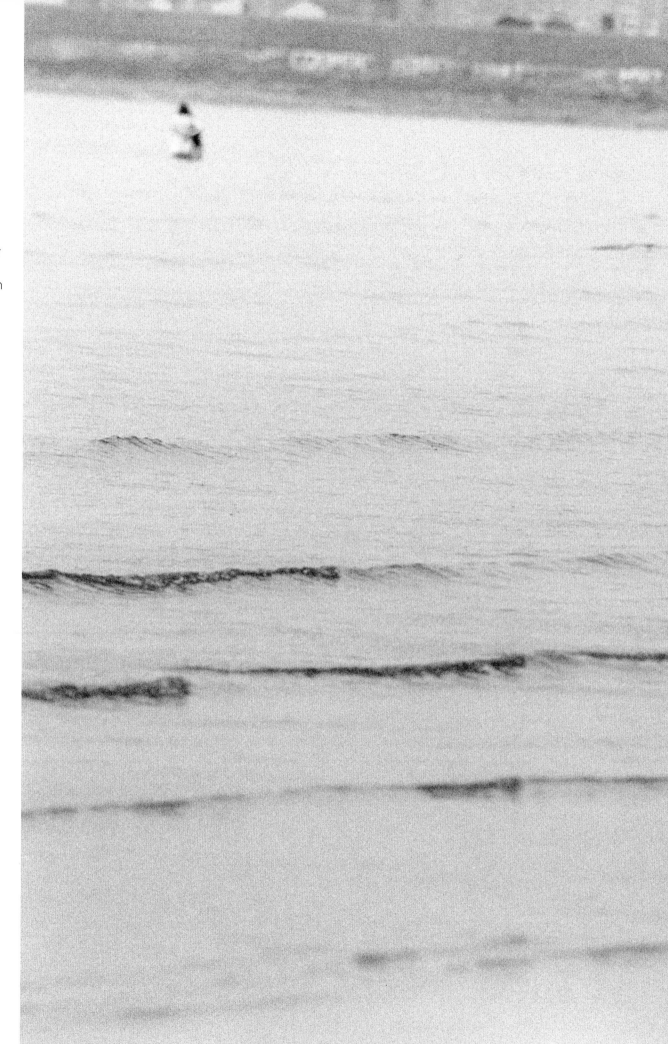

Saltcoats, 1990
When I came across a
baby in a pram completely
surrounded by water,
I thought it would make an
interesting photograph.

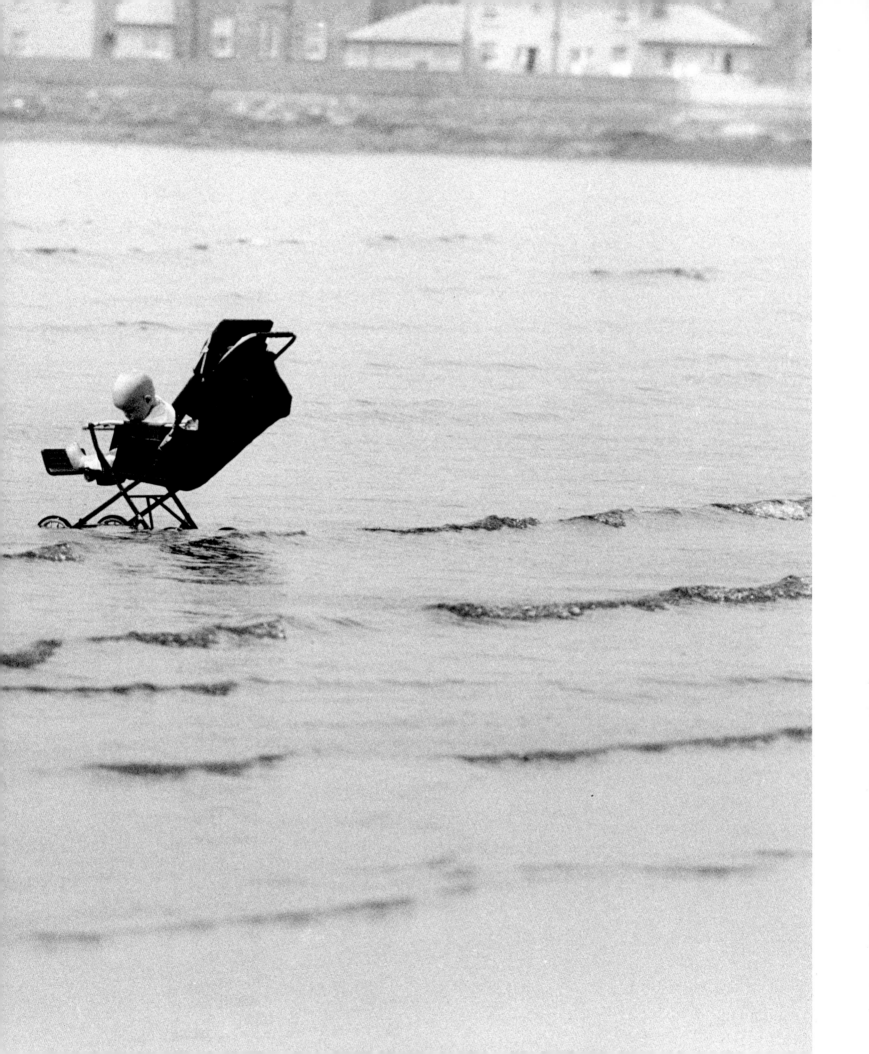

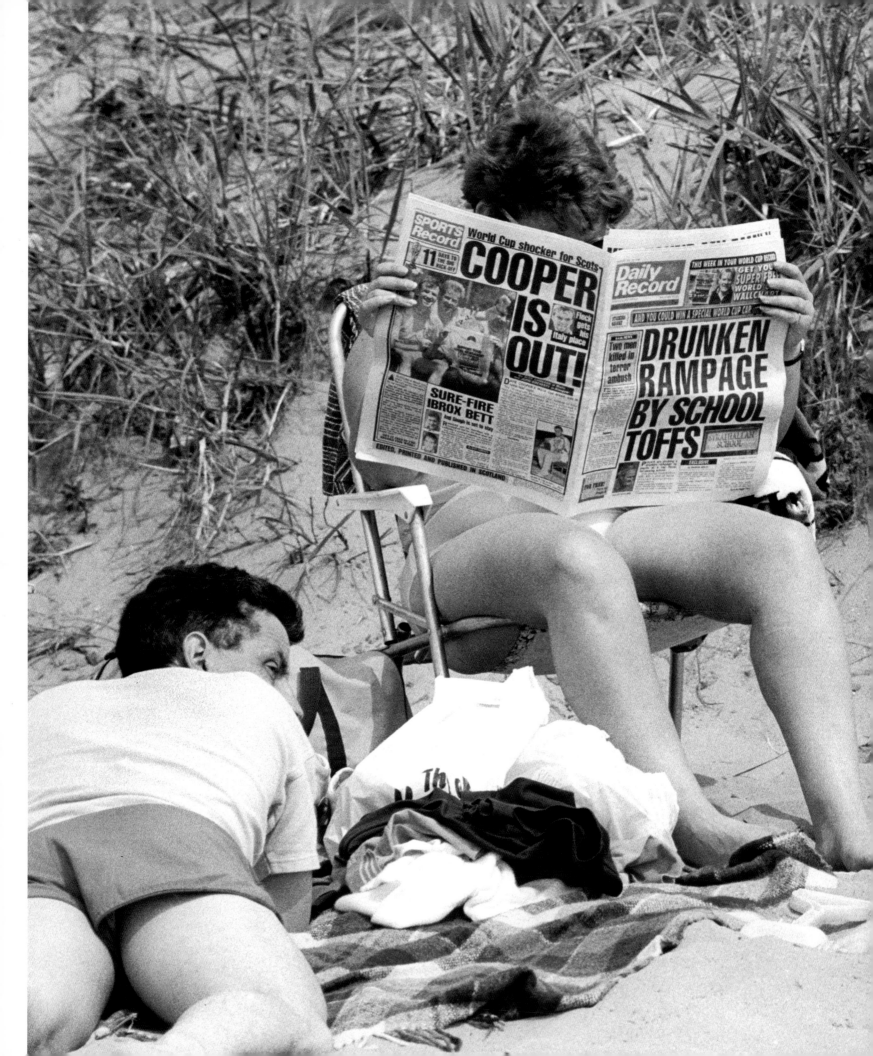

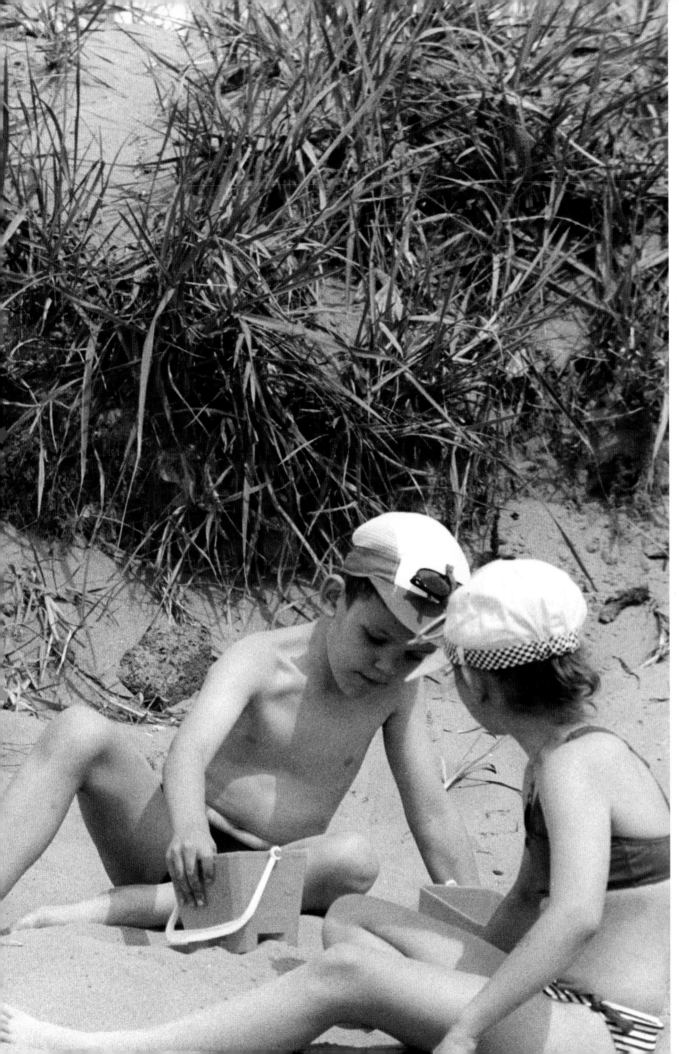

Saltcoats, 1990
This family, with each member in his or her own world, was relaxing on a hot summer's day at the beach.

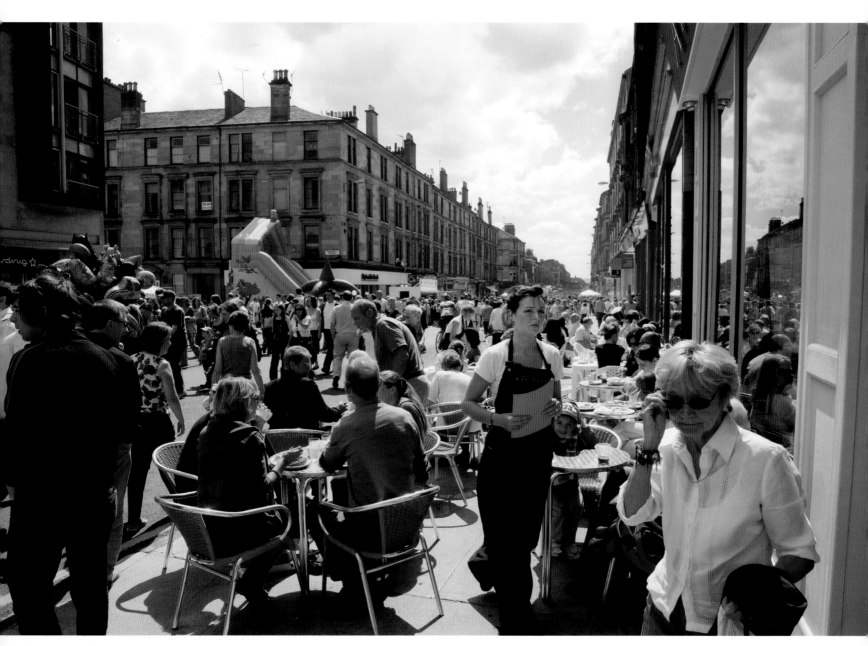

**Byres Road,
June 2006**

The outdoor restaurants
were filled with tourists and
locals during the height of
the summer season.

**Street Painter,
June 2006**
The street painter was just
finishing a large, detailed
chalk portrait on a sidewalk
on Buchanan Street when I
took this photograph.

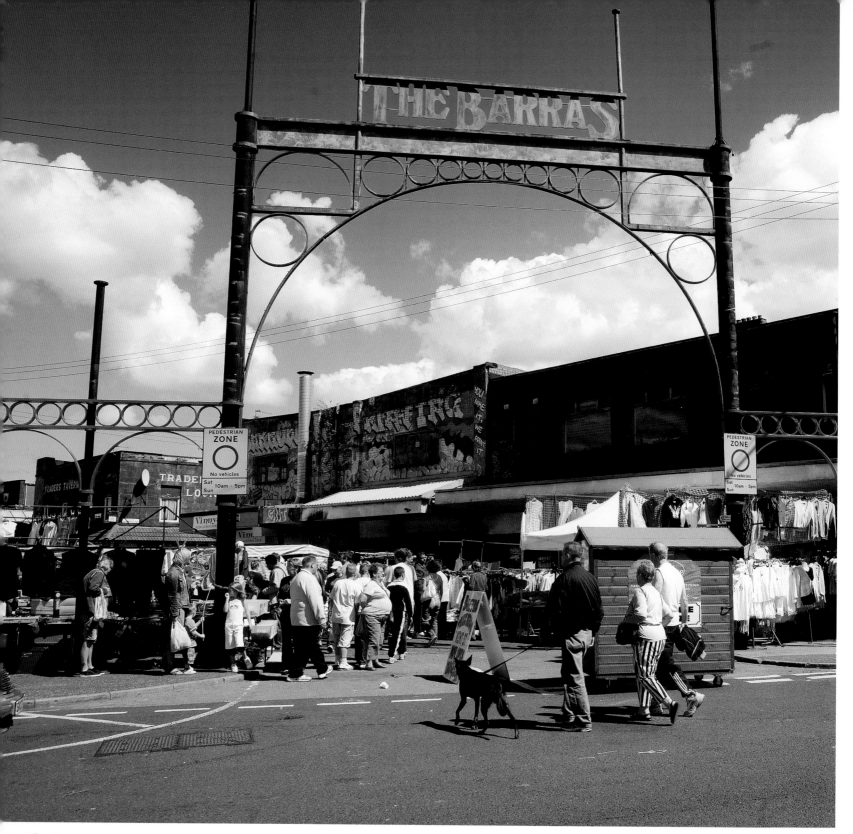

The Barras, June 2006

The Barras always seems to
be filled with people hoping
to find that one great treasure
discarded by someone else.

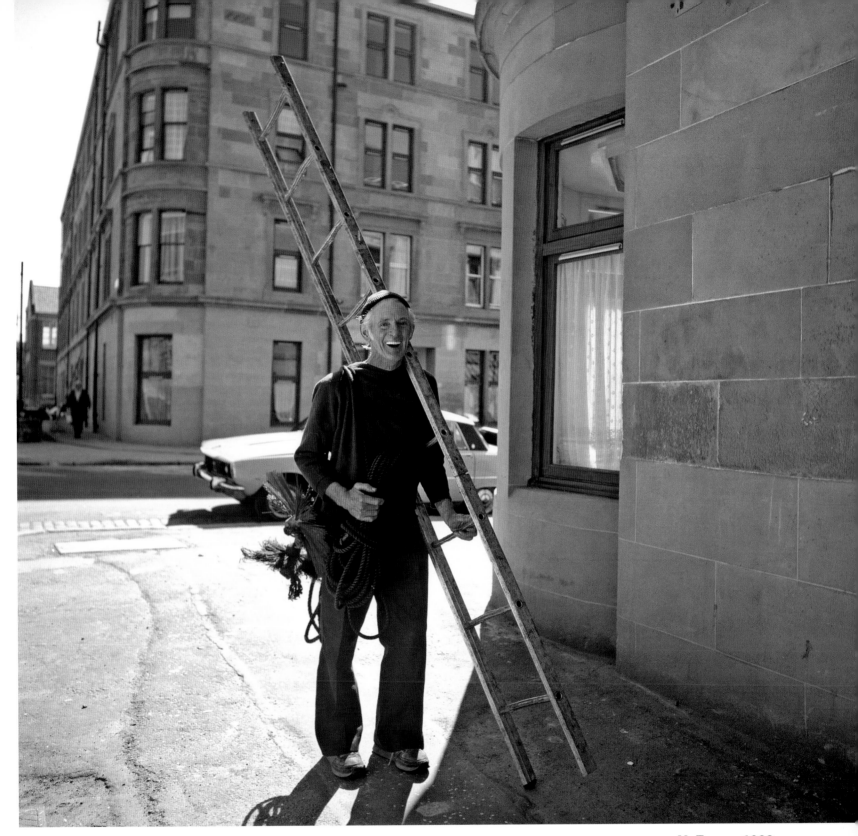

Mr Turner, 1988

The chimney sweep was on
his rounds when our paths
crossed off Argyle Street
in the west end. I think
it is safe to say there are
very few chimney sweeps
in Glasgow today.

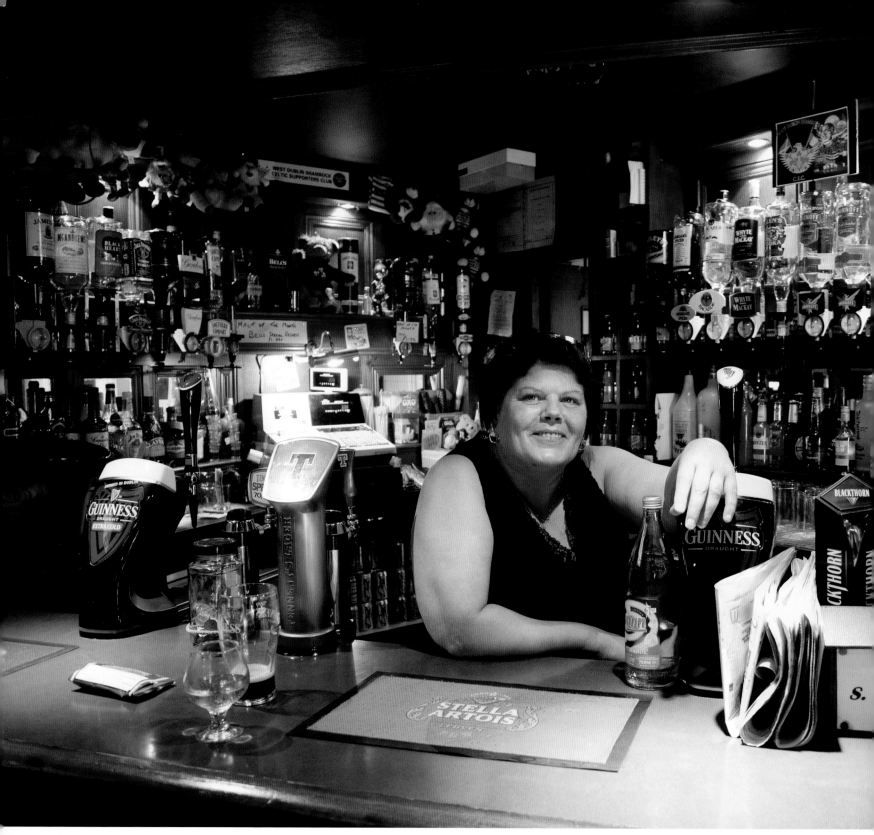

Catherine McIntyre, August 2006

When my wife Gigi and I entered The Whistlin' Kirk near the courthouse, we found a happy patron singing along to the Celtic music playing on the juke box. Ms McIntyre, a pleasant woman who was tending bar, agreed to be photographed when I told her I was doing a book on Glasgow and had photographed The Beatles.

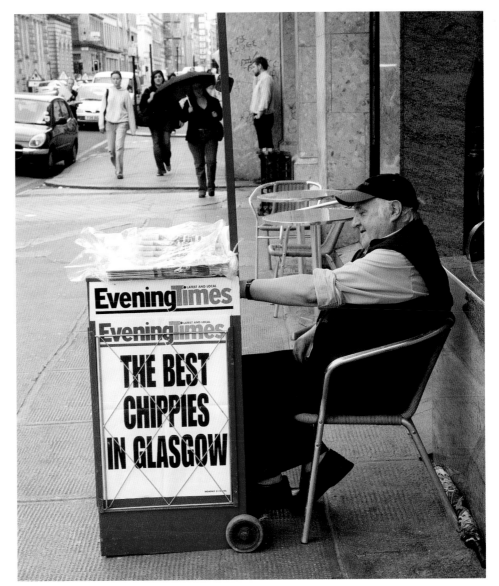

**Newsvendor,
August 2006**

I couldn't resist
photographing the 'Best
Chippies in Glasgow'
poster because, whenever
I return to the city, the first
meal I have is always fish
and chips.

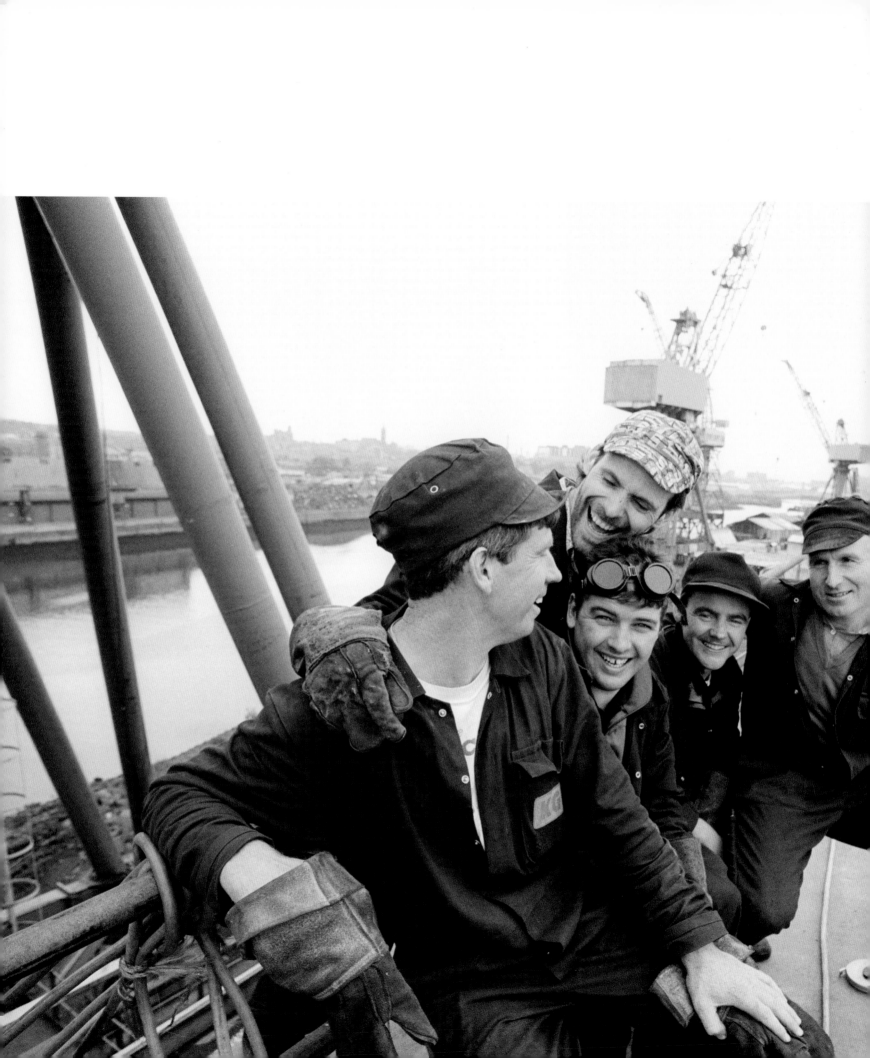

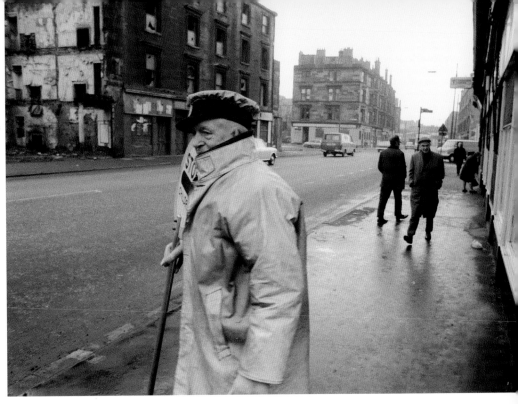

School Crossing, 1972
On a rainy day, the lollipop man stood watch diligently, waiting to guide the young school children safely across the street.

Dock Workers, 1990
Since shipbuilding has always been a huge part of Glasgow's industrial heritage, I wanted to include a photograph of the dockworkers in my book.

East-End Carters, 1972
The carters with their
friendly old horse happily
posed for the camera.
I doubt whether there are
many, if any, carters left
in Glasgow now.

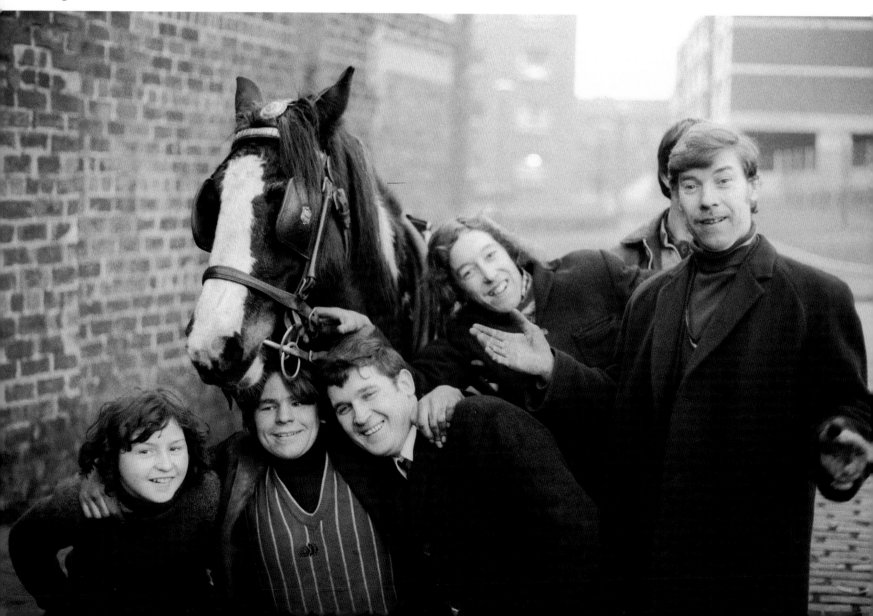

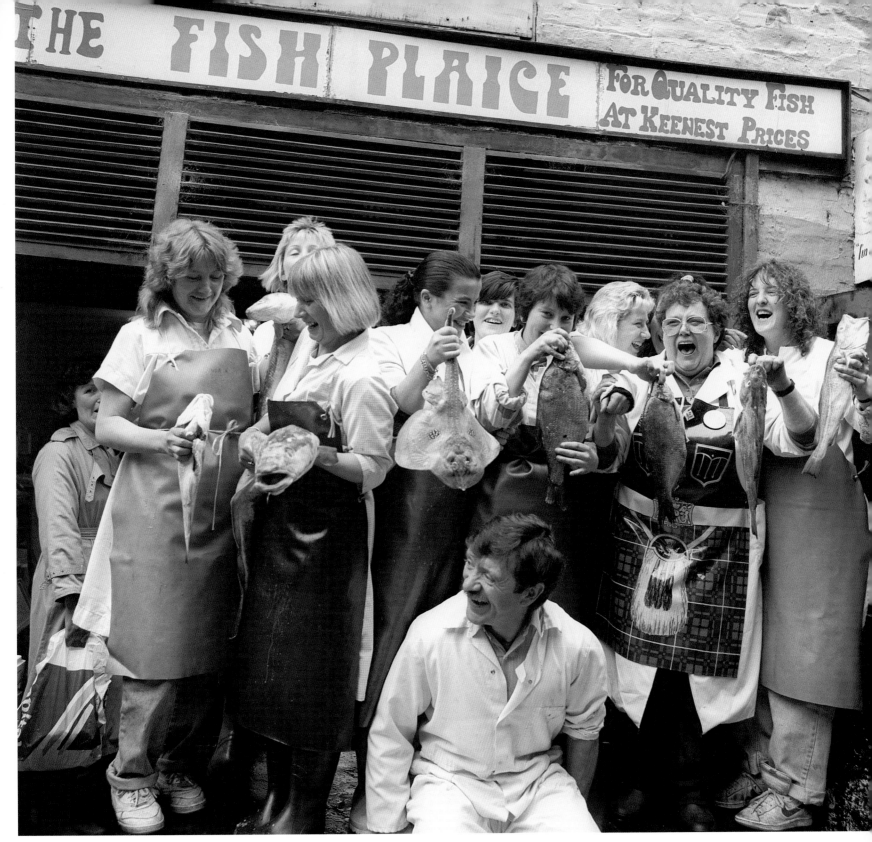

Fish Plaice, 1990

Walking around the fish market, I came across this group who found it extremely amusing when I asked them each to hold up a fish.

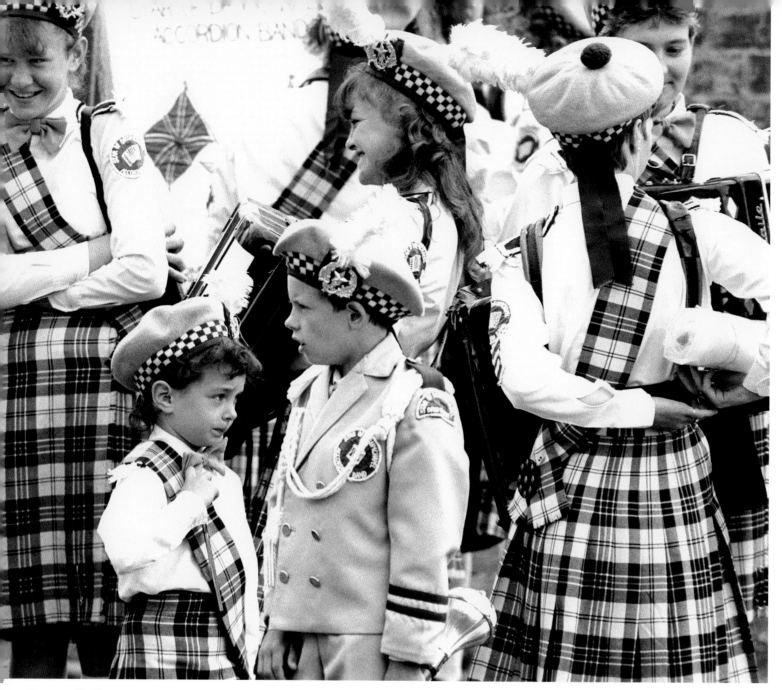

Orange Walk, 1990

The youngest members
of a marching band
were decked out in their
uniforms during the annual
Orange Walk. When the
rain began, the girls in their
tartan laughingly huddled
under a plastic sheet.

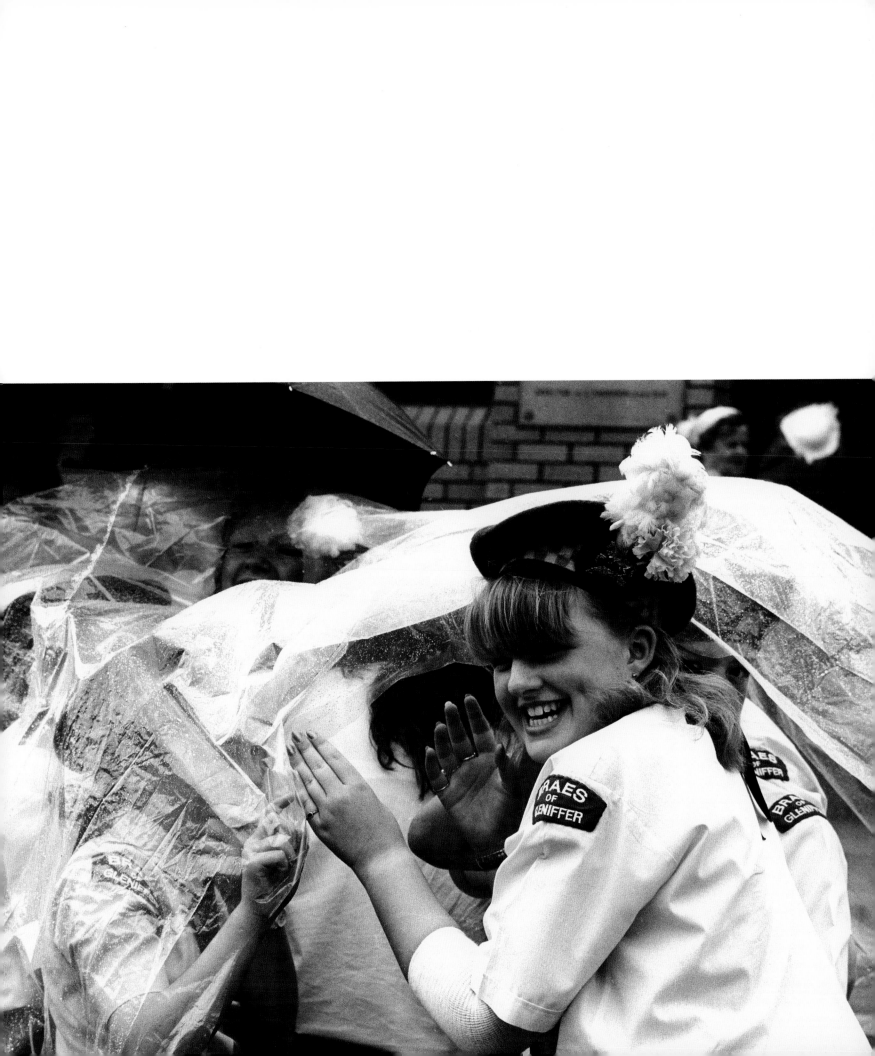

Orange Walk, 1990

Inside the church after the Orange Walk, this young woman concentrated on her accordion. After the parade, this church was filled with Orange Walk participants singing hymns.

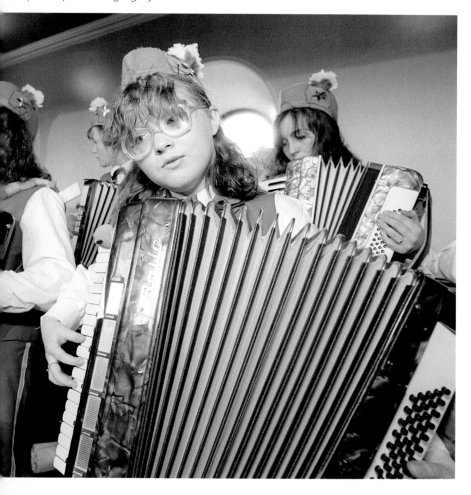

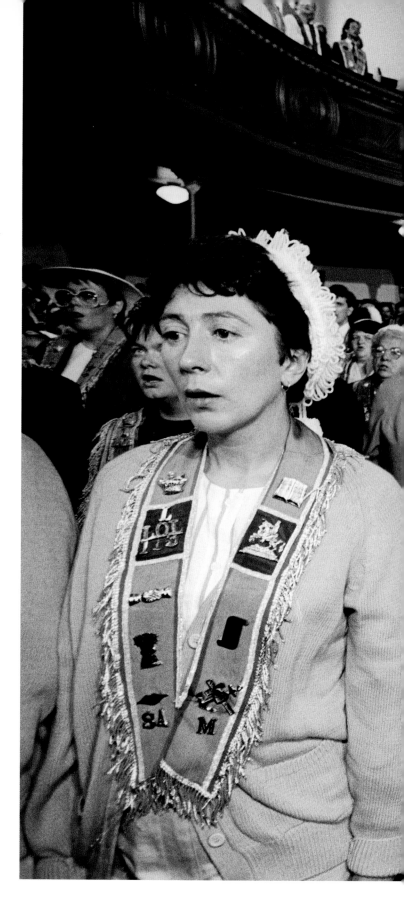

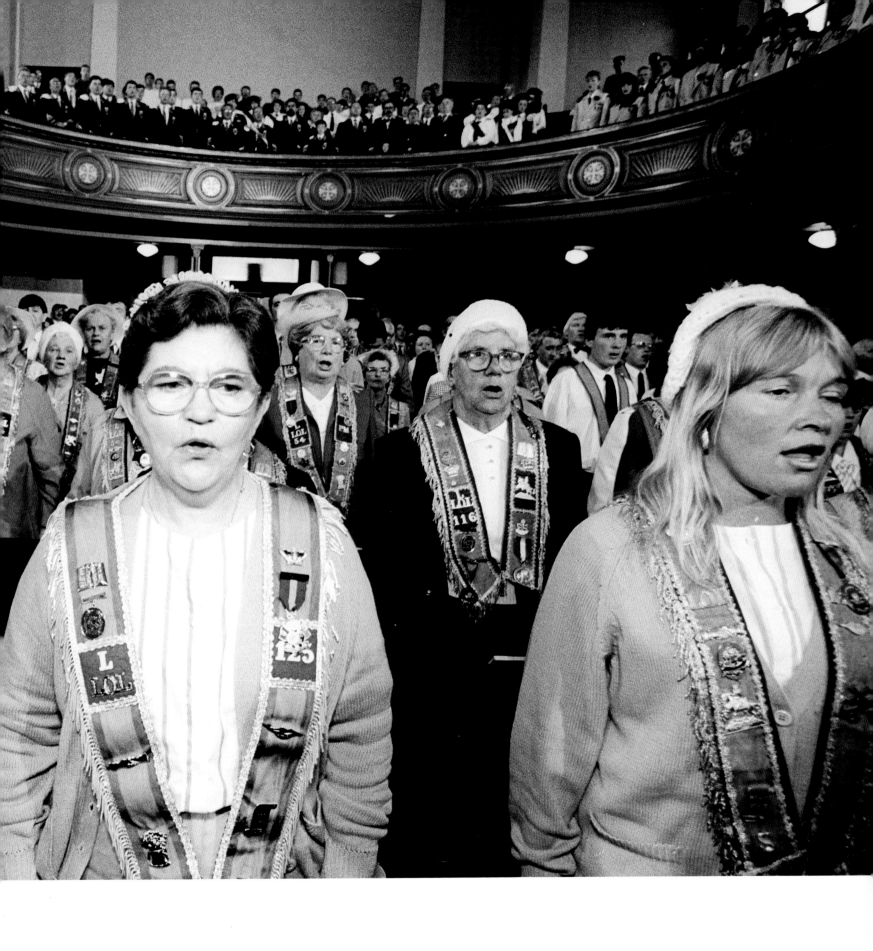

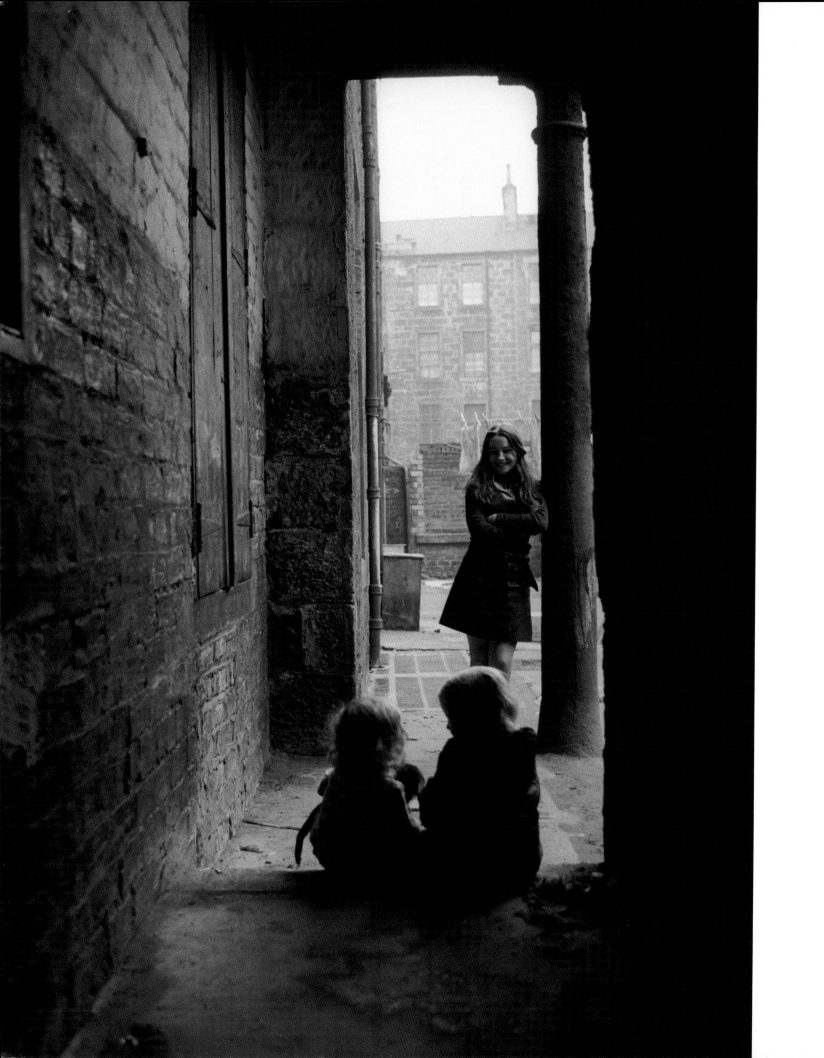

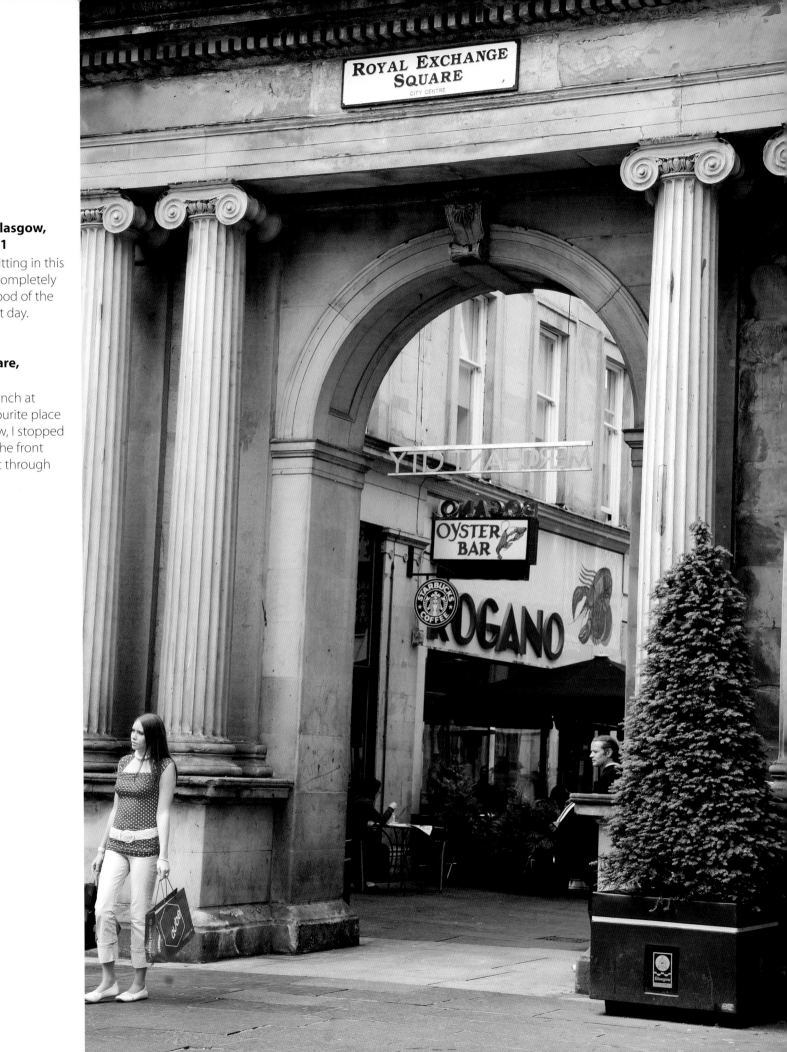

Left:

Southside of Glasgow, November 1971

These children sitting in this shadowy close completely captured the mood of the place for me that day.

Right:

Exchange Square, June 2006

On my way to lunch at Rogano, my favourite place to eat in Glasgow, I stopped to photograph the front of the restaurant through an archway.

ROYAL EXCHANGE
SQUARE
CITY CENTRE

MERCHANT CITY

ROGANO

OYSTER BAR

STARBUCKS COFFEE

ROGANO

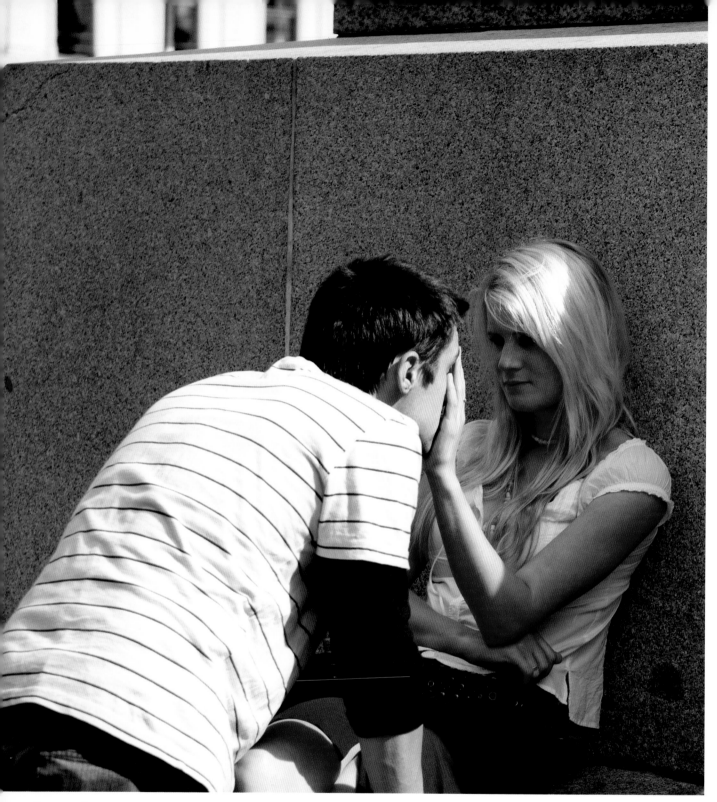

**George Square,
August 2006**

Oblivious to their
surroundings, the young
couple sat quietly,
completely engrossed in
their own world.

**Brunswick Hotel,
April 2006**

The attractive young
woman was turning heads
at the Brunswick Hotel bar
in Merchant City. That night
I was with the 'Razz Girls'
who had stopped by for a
sojourn at the hotel on their
nightlife travels.

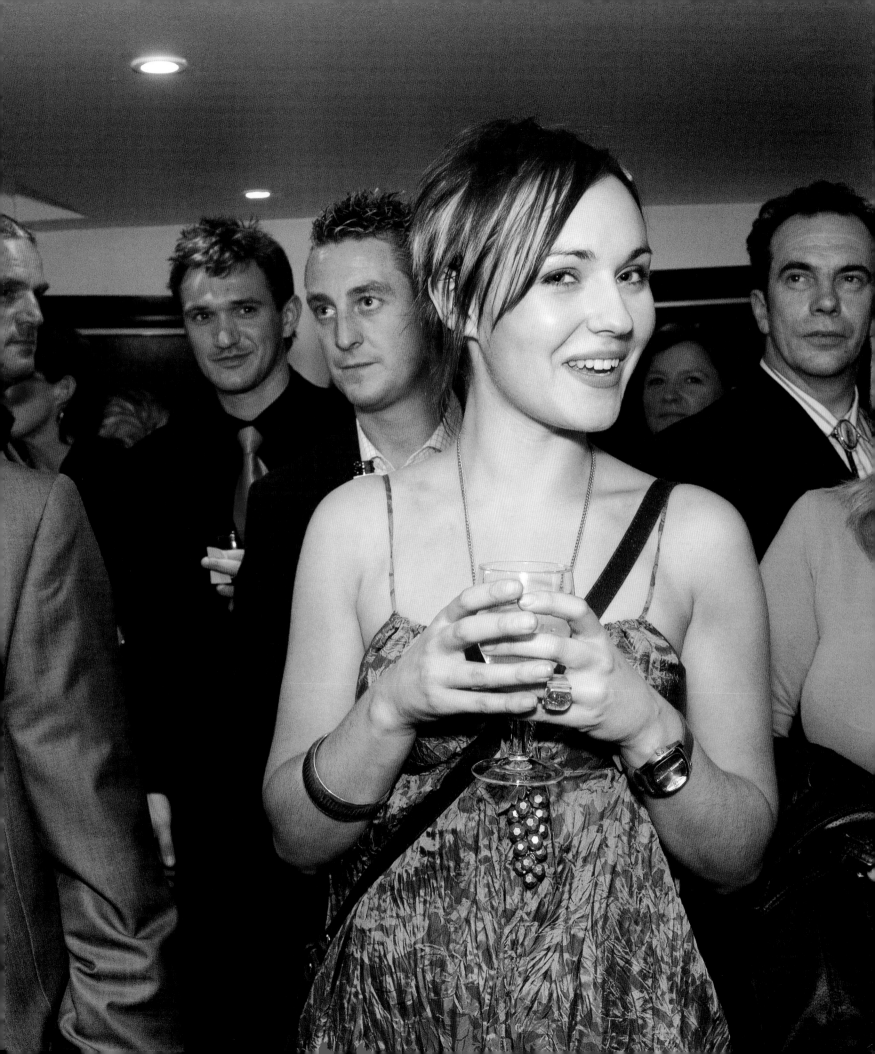

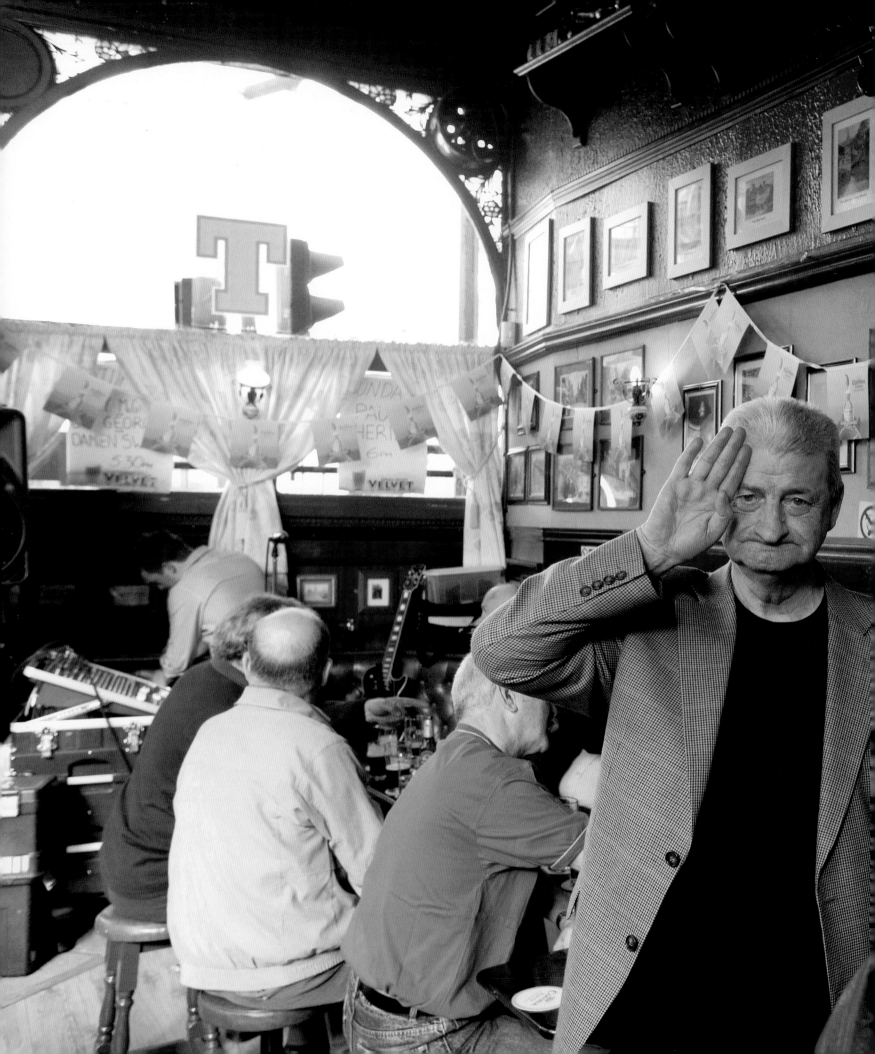

**Tollbooth Bar,
August 2006**

A regular patron welcomed
me with a salute.

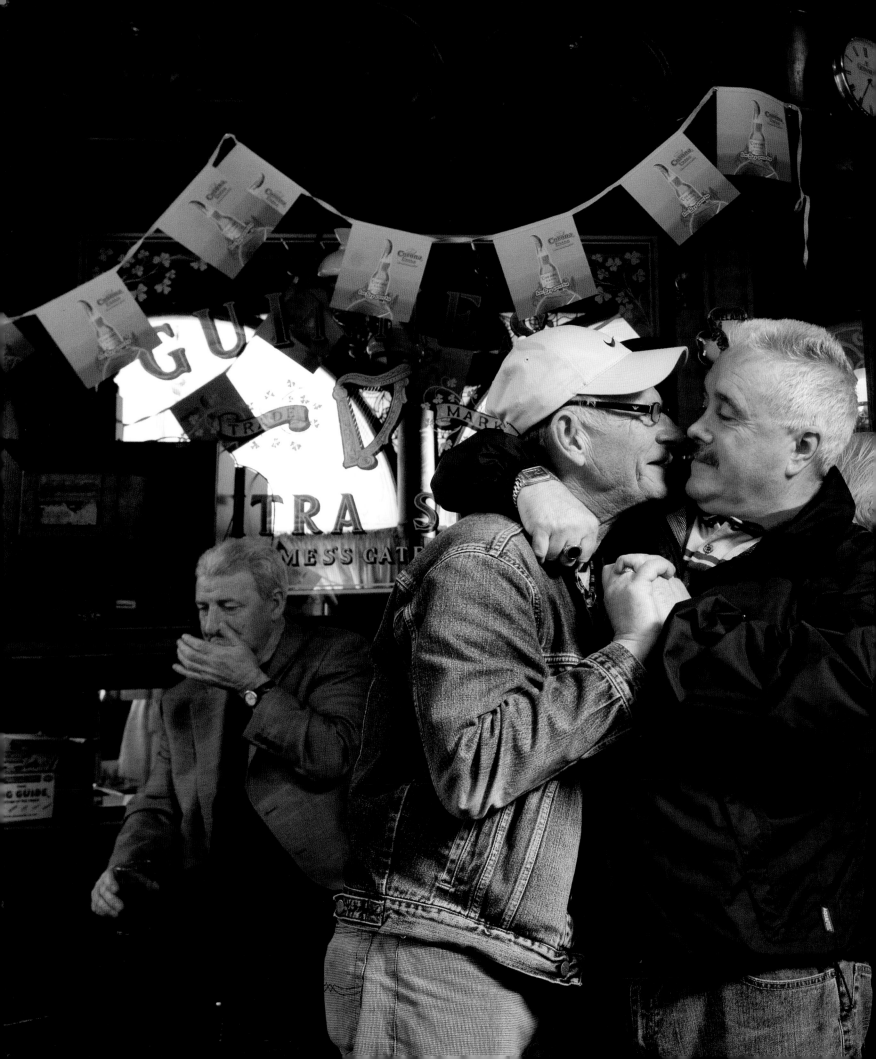

**Tollbooth Bar,
August 2006**

As I began taking
photographs, two happy
friends greeted each other
at the bar.

**Tollbooth Bar,
August 2006**

This view of the bar was
the first photograph I took
when I walked in. I loved
the way the light came
through the window,
the details of the posters
on the wall and especially
the interesting faces of
the patrons.

Clyde Arc Bridge, February 2007

While going over the magnificent new bridge I turned and took this photograph.

Following page:

Glasgow Housewives, 1961

I was living in London when the *Daily Express* sent me to Glasgow for this photograph. There was an energy in these women, these Glasgow housewives, as they greeted the American sailors when they docked in Glasgow. Their submarine was carrying Polaris nuclear missiles. The presence of nuclear weapons on the Clyde was very political and controversial but these women didn't seem concerned about it. They were giving the sailors an enthusiastic Glasgow welcome.

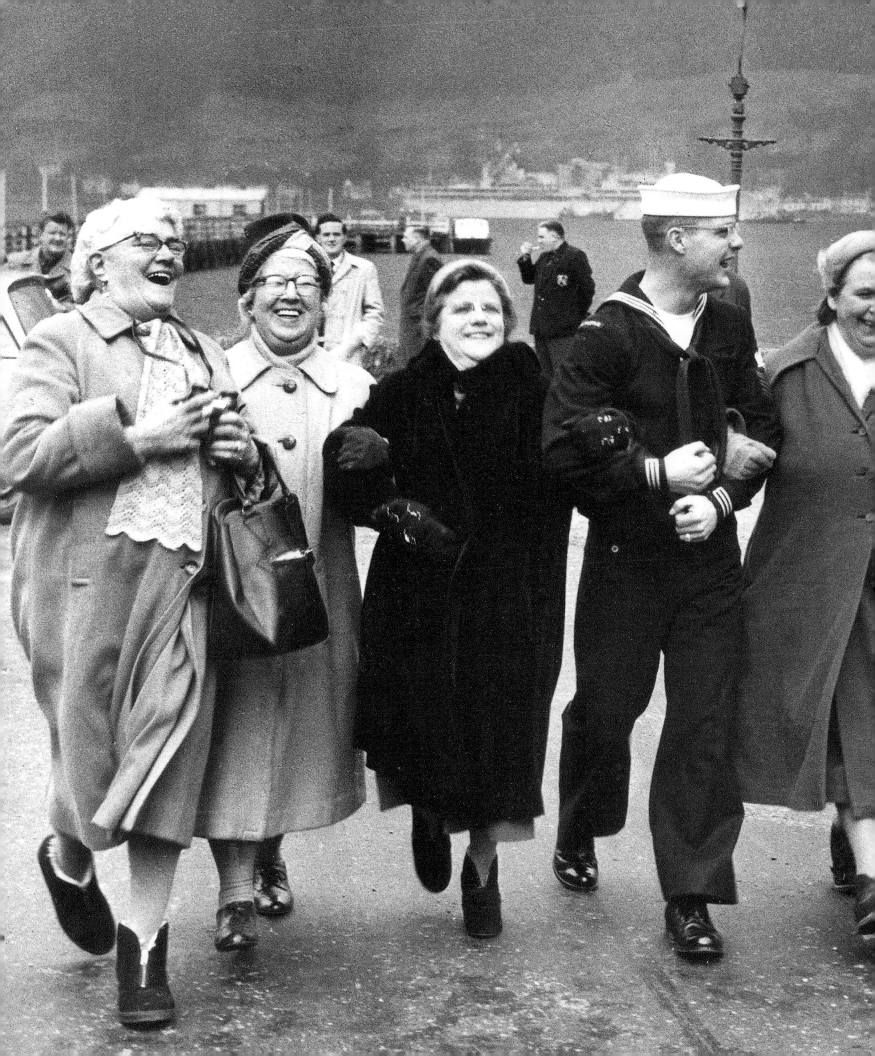